PRO DIGITAL
FASHION
PHOTOGRAPHY

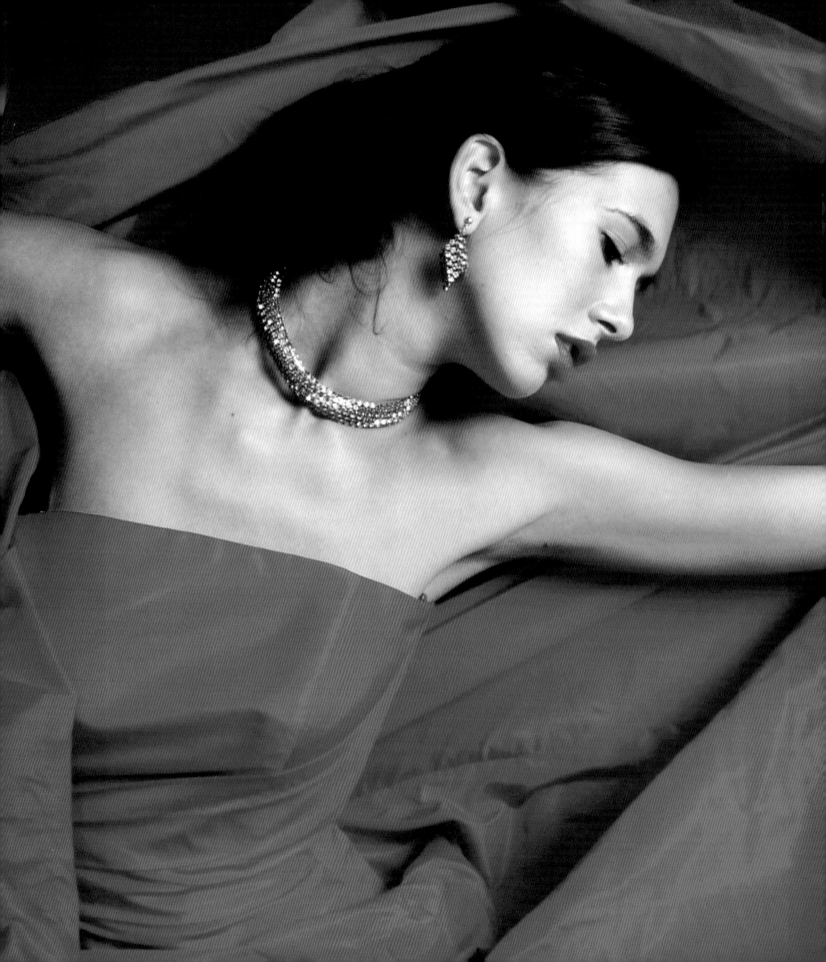

PRO DIGITAL FASHION PHOTOGRAPHY

BRUCE SMITH

-
-
-
-
-
-
-
-
-

FEATURING WORK FROM DAVID LACHAPELLE, BARRY LATEGAN, PEROU & RANKIN

-
-
-
-
-

A COMPLETE REFERENCE GUIDE TO
THE TOOLS AND TECHNIQUES OF
SUCCESSFUL DIGITAL FASHION PHOTOGRAPHY

-

ILEX

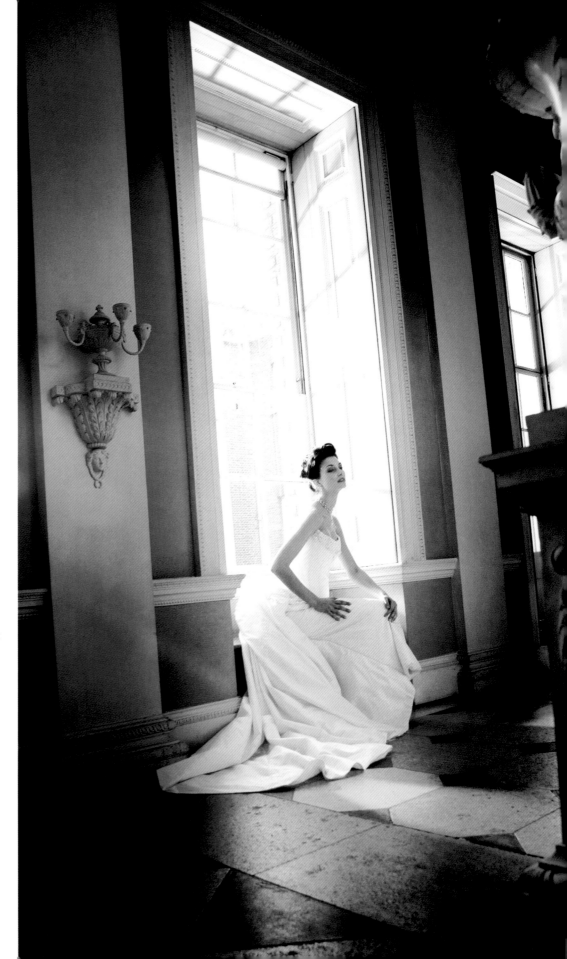

Pro Digital Fashion Photography

First published in the UK in 2008 by

ILEX

The Old Candlemakers
West Street
Lewes
East Sussex BN7 2NZ
www.ilex-press.com

Publisher: Alastair Campbell
Creative Director: Peter Bridgewater
Managing Editor: Chris Gatcum
Senior Editor: Adam Juniper
Art Director: Julie Weir
Designer: Jon Raimes
Design Assistant: Emily Harbison

British Library Cataloguing-in-Publication Data
A catalogue record for this book is available from
the British Library.

ISBN 13: 978-1-905814-38-1

For more information on Pro Digital Fashion Photography,
go to:

www.web-linked.com/fphouk

Printed and bound in China

CONTENTS

INTRODUCTION

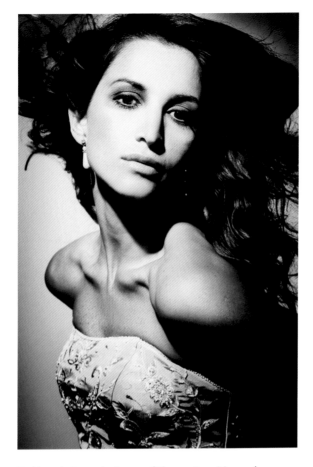

Fashion photography is one of the most exciting and lucrative fields in professional photography. For these reasons, it is also one of the most competitive. The aim of this book is to give valuable insights that will help you break into, and compete in, the business of fashion photography.

I will cover every aspect of fashion photography, including important information on research, preparation, and sourcing models. I will give ideas on looking for studios, as well as interior and exterior locations. I will also talk about equipment and lighting for both studio and location work. I will look at building a team of assistants and stylists, as well as hair and makeup artists.

I also give information on the technical aspects of fashion photography, marketing yourself, and outlets for fashion photographs. And while most of the book is illustrated with my own images, I conclude with different styles of fashion shots, taken by photographers I know and admire.

If you are aiming to become a fashion photographer, this book will give you the information and inspiration you need to see top-level model agencies with your portfolio and allow you to test with the models on their books. If you are already shooting fashion, I hope this book will help to open up different markets for you, so that you can gain commissions from magazines, fashion clients, and art directors.

So, what qualifies me to give this advice? Well, I've had a successful career as a fashion photographer for over thirty years. I have done what many people would love to do; I've traveled the world and photographed beautiful people in exotic locations. I've experienced the excitement, adventure, and fun that you'd expect in this glamorous world, but I've also got a great buzz out of creating stunning photographs. It's a career that has provided constant stimulation and has given me self-respect and respect from other people. I love it.

For me, fashion photography isn't about making models look like shop-window mannequins. It's about movement and vitality, about capturing a mood, a look, a shape, or a line. I believe that the most important thing when shooting fashion pictures is to ensure that you create positive energy between yourself and your model. This in turn feeds the content of your work. Fashion pictures must have content and energy. Without those qualities, you haven't got fashion pictures.

Think about how many fashion images people see, every day of their lives, on TV and the Internet, in newspapers and magazines, and on advertising billboards. Then think how long they spend looking at them. My guess is that most people see so many images that they spend very little time really looking at them. Your job is to make people look twice.

Fashion is about beauty, creativity, energy, and excitement, and this must be reflected in the pictures. But it's also an industry, and the bottom line is that it's about selling clothes. If your pictures make people stop what they're doing and take a good look at them, you will not only have made your client very happy, you will have achieved something special as a photographer.

Bruce Smith
Liverpool, England, 2008

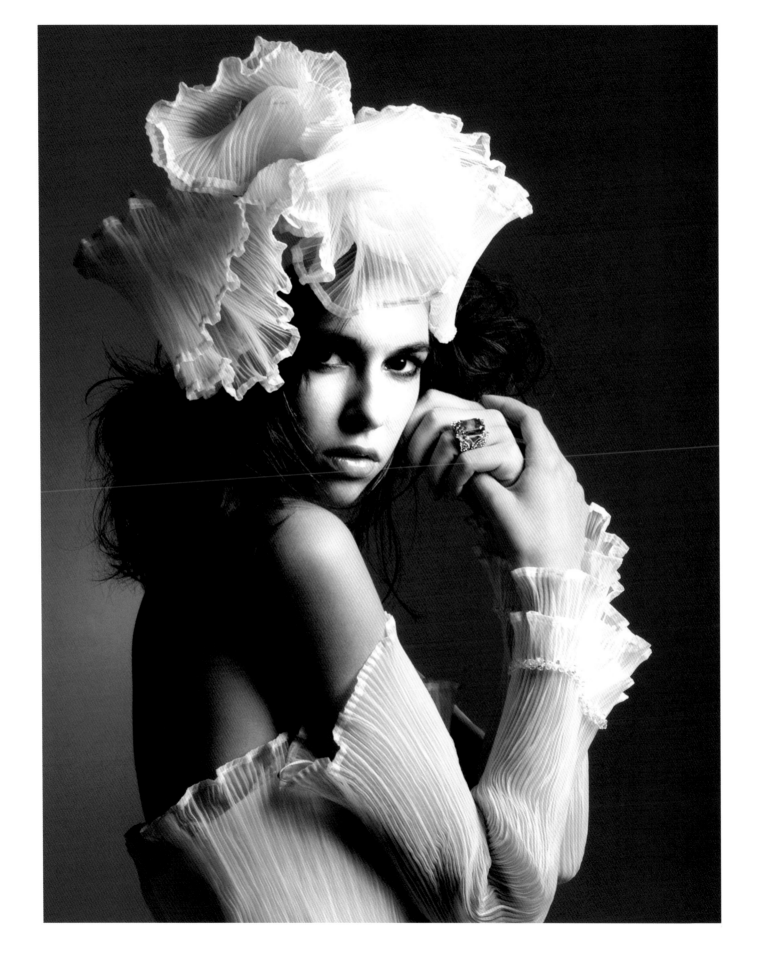

EQUIPMENT

Your equipment is important. Your camera, lenses, lighting, computer hardware, and software, and accessories are the tools of your trade. You have to know how to use them if you want to produce good pictures.

To be a good fashion photographer you need to learn far more important things than the latest technical developments in digital cameras. Yes, there have been some incredible advances in camera technology in recent years and I'm sure there are more to come. As a photographer, you should be aware of developments, but don't get carried away investing large sums of money in the latest and most technically advanced equipment.

Creating great photographs isn't just about the size of your digital files — it's about the content of the pictures. It's about what you do with your equipment and if you haven't got content, your pictures will fail, whatever the resolution of the sensor in your camera.

As a photographer, it's important to understand the type and quantity of camera equipment you need for the images you want to make. That's true whether you're taking your first fashion pictures with a basic camera, or you're a professional traveling abroad with an entourage of assistants and transporting a vast array of kit.

Choosing the right equipment is a matter of practical, creative, and personal choices. This chapter will help you make those crucial choices.

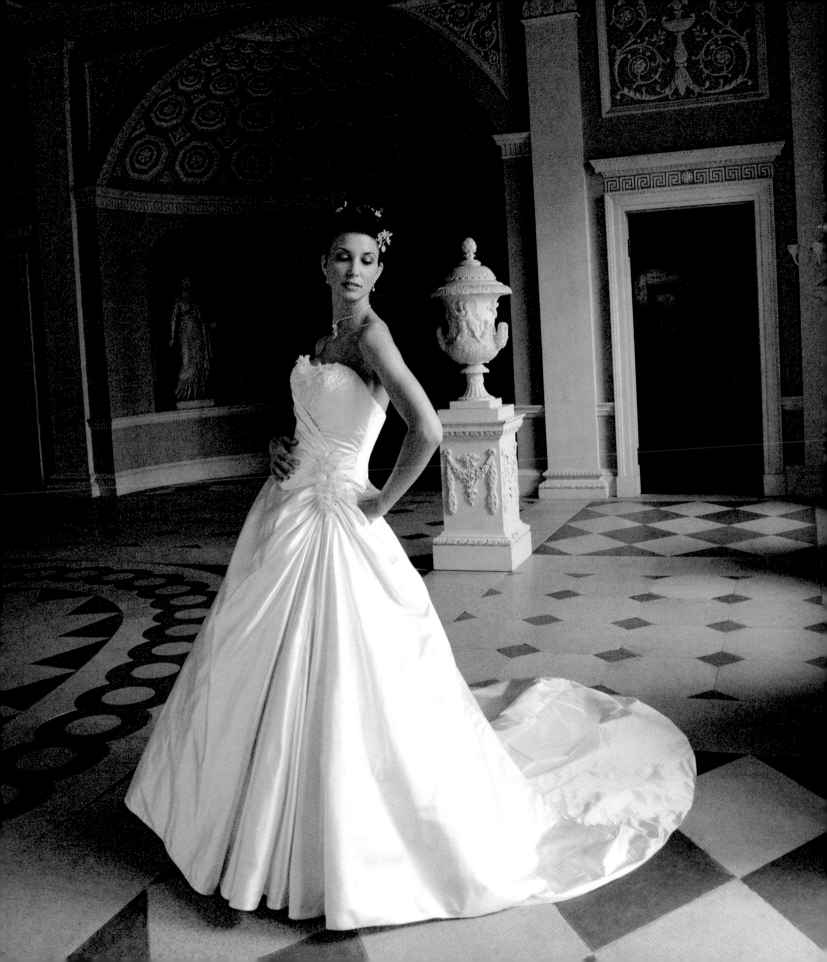

CAMERA EQUIPMENT

Digital SLRs (or DSLRs) are popular among fashion photographers because they are lighter and faster to use than medium- and large-format gear. However, while today's professional level DSLRs produce very large image files, some become frustratingly slow or stop you taking pictures after relatively short shooting bursts. For that reason, I use cameras that allow me to shoot quickly, while providing images of a sufficient size for publication.

For magazines, where the single pages are on average 12in × 8in (30cm x 20cm), you can shoot with entry-level DSLRs that give you a minimum file size of 24MB when saved in the industry standard TIFF format. If you need to shoot for a DPS (double page spread, usually 12in × 16in (30cm × 41cm) you must use a digital body that gives an image size of at least 50MB.

→ MEDIUM FORMAT

If speed of shooting is not so important and you need large image files, use a medium-format camera. They are used by high-end fashion and advertising photographers, especially when shooting magazine covers or advertising campaigns in which the images are used billboard-size. When doing this work, I use a Mamiya 645 with digital back connected to a MacBook Pro with a firewire cable when shooting on location, or my main computer if I'm in the studio. This allows me to see the images immediately on screen, which gives me far more information than the camera's LCD screen.

Personally, I find this camera system very difficult to use for fashion work, due to the relatively slow autofocus, coupled with the long image buffering time. Waiting for one or two seconds between frames can be a disaster if it means I miss the best shots.

LARGE FORMAT

A small number of fashion photographers shoot using large format cameras, both on film and on the digital versions that are available. These cameras take digital backs, but the sensor chips are usually only 60mm × 45mm — no larger than those used in medium format. However, they offer the option of using movements in the lens planes to increase or decrease depth of field and to correct vertical distortion.

LENSES

It's good to have a range of focal length lenses for a shoot. You choose which one to use by instinct at the time of shooting, or to achieve a specific look required by your client.

One of the benefits of using wide angle lenses for fashion is that they allow you to get close to your model, create a rapport, and communicate your direction better, both verbally and physically. They also allow you to get full-length pictures in restricted studio or location spaces. However, while the distorted perspective can be a useful creative effect, it can also be unflattering to the model's shape when shooting from a high or low angle. When using wide angle lenses, it's best to shoot at the model's waist level.

Below: Today's digital cameras, such as the 22-megapixel Mamiya ZD 645AFD II Digital System, give superb quality images. The detachable back makes it possible to use the same camera with a film back, too.

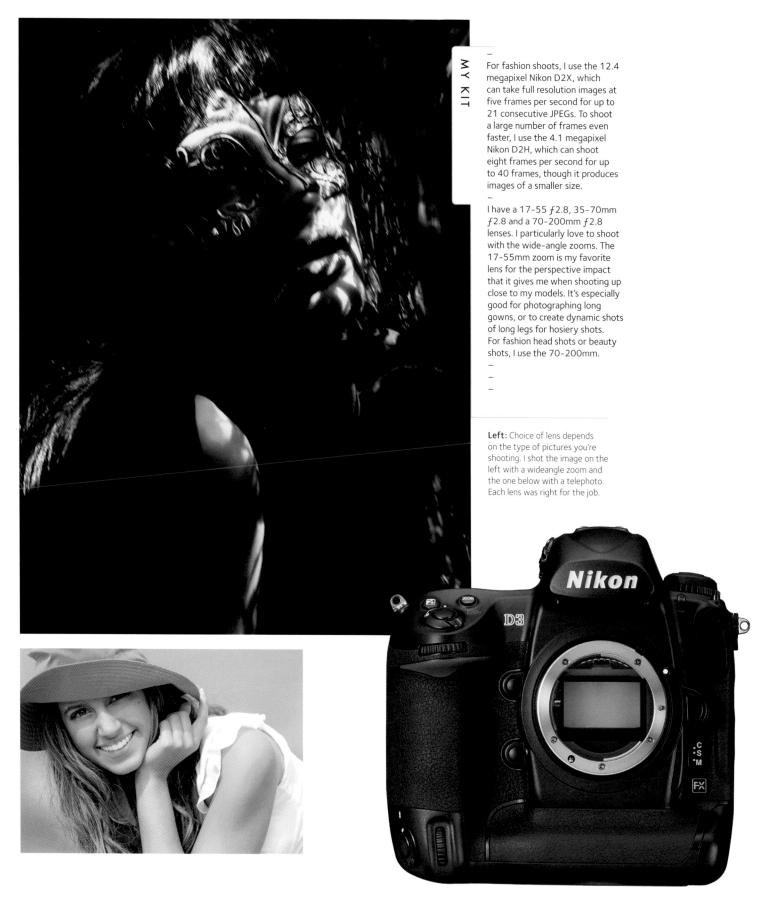

–
For fashion shoots, I use the 12.4 megapixel Nikon D2X, which can take full resolution images at five frames per second for up to 21 consecutive JPEGs. To shoot a large number of frames even faster, I use the 4.1 megapixel Nikon D2H, which can shoot eight frames per second for up to 40 frames, though it produces images of a smaller size.
–
I have a 17-55 f2.8, 35-70mm f2.8 and a 70-200mm f2.8 lenses. I particularly love to shoot with the wide-angle zooms. The 17-55mm zoom is my favorite lens for the perspective impact that it gives me when shooting up close to my models. It's especially good for photographing long gowns, or to create dynamic shots of long legs for hosiery shots. For fashion head shots or beauty shots, I use the 70-200mm.
–
–
–

Left: Choice of lens depends on the type of pictures you're shooting. I shot the image on the left with a wideangle zoom and the one below with a telephoto. Each lens was right for the job.

COMPUTER HARDWARE & SOFTWARE

Before you spend lots of money on computer hardware and software, think carefully about what you will need. It's important to have a fast processor with plenty of storage space, but state-of-the-art equipment is very expensive. Your investment needs to be kept in perspective and relate to your requirements. If you're a professional you will need top-level kit. However, if you're an amateur or semi-pro, you will only need basic hardware that allows for fast loading and processing of images and enough storage space for your image files.

Above and below: Laptops and portable hard drives, for viewing and storing images, are essential items of equipment on today's fashion shoots. A ruggedized drive, like the one below, is a practical solution to the rigors of travel.

→ HARDWARE

As a guide, I'll list the hardware that I use on a shoot. Whether I'm on location or in the studio, I use laptops with two spare, fully charged batteries for each computer. To back up a day's image files. I also have two portable hard drives, each with at least 100 gigabytes of free memory. As a professional fashion photographer, it's your responsibility to return from an assignment with pictures, so losing them is not an option.

On most of my shoots I will use up to 1GB of memory for every final fashion shot and as I may work on up to 25 shots during the day, 100GB of memory is more than enough. If the worst happens and both my computers crash, I have enough memory cards to store a whole day's worth of shots, along with a storage viewer with 40GB of memory.

The freedom of shooting untethered to a computer means using memory cards. These need to be loaded onto my laptop as I shoot. For this I use firewire card readers, which have 1–2 minutes' transfer time for a 1GB memory card. I will take at least ten cards with me for a day's shooting. This means I can have one being loaded, with three or four waiting to go on to my laptop. I also have two in my camera bodies and four spare, in case I need to use more than one memory card for a shot. For a cover shot I will often shoot two or three hundred images, so two or three cards will be used very quickly.

My office computer has a 160GB internal hard drive, with internal CD and DVD readers and writers for burning images to send out to my clients. I also have four external hard drives that I use for storing and backing up the original Raw image files, plus one external hard drive for storing all the final images for my clients. I never store either my own images or my clients' images on the hard drives installed in my computer.

It's important that your monitor is of a good quality and calibrated very accurately to ensure perfect color reproduction. I never use my laptop for any major Photoshop retouching, contrast, or color alterations. Even though the monitor is calibrated, its not good practice to use it for high-end retouching on images that are going to be reproduced with any level of color, contrast, or detail accuracy. That's not only because desktop monitors tend to be better quality, but also the environment my desktop is set up in is better suited to working.

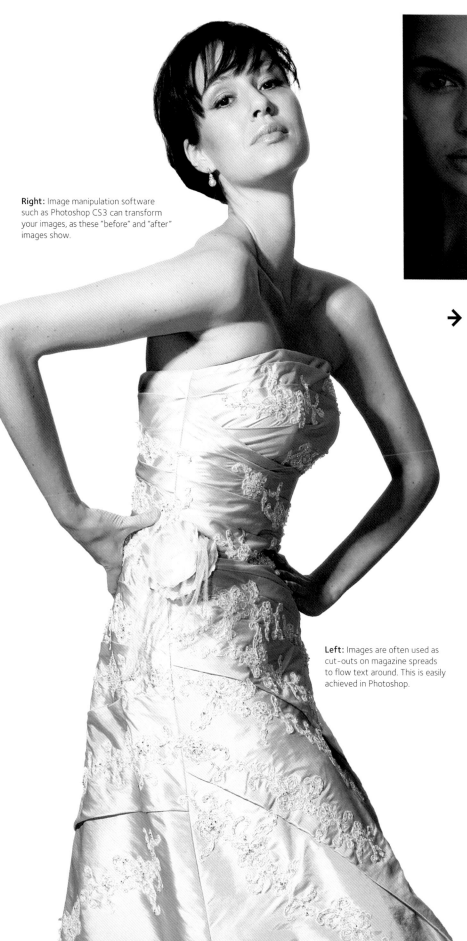

Right: Image manipulation software such as Photoshop CS3 can transform your images, as these "before" and "after" images show.

→ SOFTWARE

Along with most other professional and amateur photographers, I use Adobe Photoshop. This program offers solutions to most, if not all, the retouching and image manipulation processes you will need. If you're just starting out and doing your own post-capture work, you have to be fully confident in the processing program you use in order to get the best out of your images.

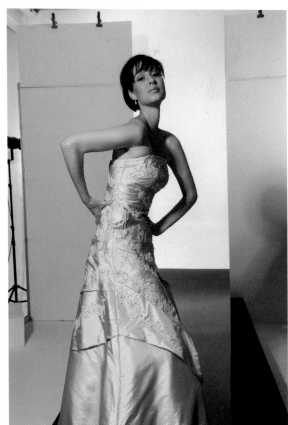

Left: Images are often used as cut-outs on magazine spreads to flow text around. This is easily achieved in Photoshop.

STUDIO LIGHTING

Studio flash lighting is available in two main types. First, there are monobloc flash heads. They have all of their electronics inside the housing and typically run on outlet power. There are some systems that will run entirely on battery power and some that can be used with both mains and battery power.

In most professional studios you will find flash equipment that consists of generators and flash heads. Their main advantage is that you can get a greater power output from the flash heads, and run two or three flash heads from the one generator. Generators tend to have variable settings for power output and various options for recycling speeds.

Below: I like to keep my lighting setups simple, as I think they provide the most effective lighting. This shot shows a simple lighting setup on a set built in a studio.

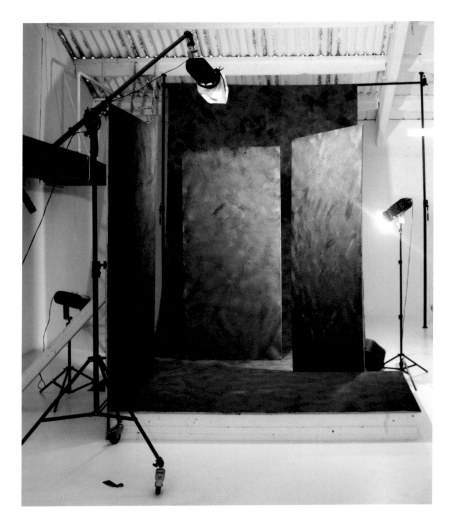

→ You have to use the fastest recycling setting when shooting fashion at a fast pace. If your generators are powerful and when you're shooting with the lowest power output (f5.6 to f11), you can get very fast recycling speeds. When working in the studio, I use 2500 to 3000 watt generators and flash heads. I don't stick to any one flash head brand but mainly use Elinchrom, Bowens, Bron, or Prolight. They are generally very sturdy and can take the everyday knocks and bangs when being moved around the studio or out on location.

WHAT TO BUY

If you are starting out as a fashion photographer and setting up your studio, I would suggest buying a three-head monobloc kit, consisting of one 1000 watt and two 500 watt mono lights, a medium softbox, a beauty dish, and a 65-degree reflector with a set of honeycomb grids. With this setup you can shoot most of the lighting situations you are likely to use.

I would also recommend that you buy a large diffusion screen, plus a zebra gold/white large reflector. They will allow you to shoot on location using available light.

MY LIGHTING KIT

I use a Bron Impact monobloc kit, which includes three 500 flash heads, a 30in × 30in (75cm × 75cm) softbox and various spill kills, reflectors, and modifiers, together with three honeycombs of different sizes, and three small stands.

I also have a three-head Elinchrom kit (500-watt, 250-watt, and 125-watt lights). They are great for using direct on my model, to bounce off walls and ceilings as fill-in, or to use as a rim light or hair light. I also keep a roll of diffusion scrim, a roll of silver foil, and a roll of mirrored plastic for the times when I need to bounce light into shadow areas.

When working in the studio I also hire additional lighting, depending on what I'm going to shoot and how I want to shoot it. This usually includes 2000- to 3000-watt generators, flash heads, modifiers such as an octabox (eight-sided softbox), softboxes, beauty dishes, boom arms, and stands.

There are several brands of lighting kit on the market, but I don't have a preference. I tend to use what's available at the hire store or studio. Lighting is lighting; there's not much difference between the brands, apart from varying types of digital read-out and sliding or digital controls.

To find out how I use this equipment, see the chapter on lighting, starting on page 56.

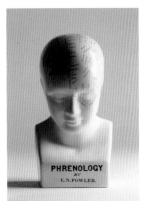
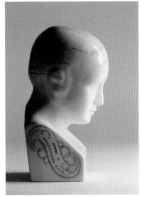
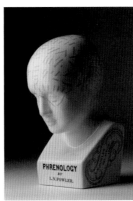

Left: These phrenology heads show the different ways of lighting a face, and how moving the light and subject in a small way can make a big difference.

Below: Reflectors are essential pieces of kit for bouncing light onto your subject, as shown in this daylight studio shot.

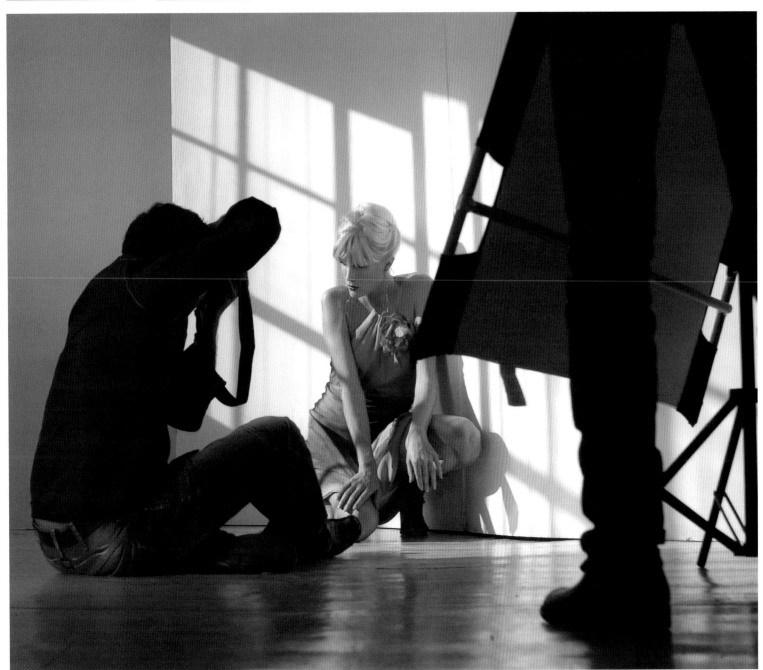

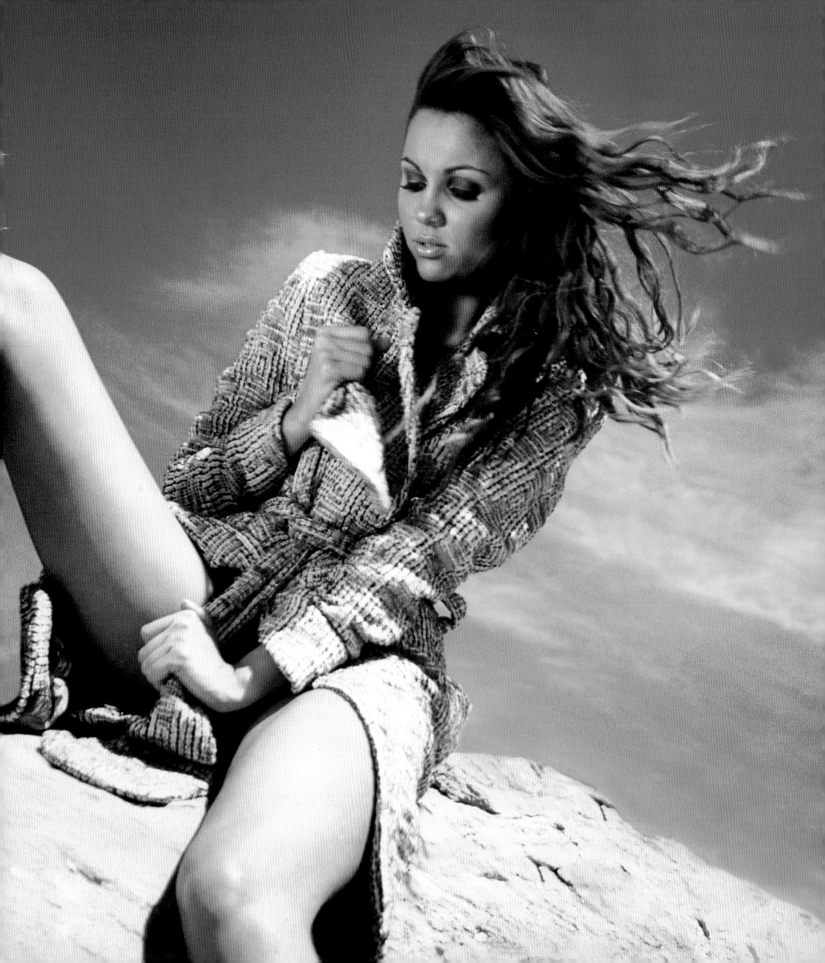

LOCATION LIGHTING

If you are often traveling to locations for shoots, your lighting kit has to be portable and convenient. If you're a professional traveling abroad and you or your client has to pay for excess baggage at 1% of the first class ticket price per kilogram, you have to be very careful about how much kit you're going to take.

I can give an example of what this means in practical terms. A few years ago I was about to do a shoot in Thailand and I had ordered a Balcar battery-operated lighting kit for the trip. Unfortunately it did not arrive in time to be freighted out with the stock of garments that I was going to shoot. The new kit arrived the day before we due were to fly out, so we had to take it with us as normal baggage with us. It cost over £4,000 ($8,000 US) in excess baggage fees.

Left: This shot was taken in a remote location in the South of France. There was no electricity supply and it wasn't practical to take heavy kit, so I lit the model with natural daylight, diffusion screens, and reflectors. The grainy look was added digitally in Photoshop

Below: Diffusion screens, like the one being held in this picture, are essential when shooting on location during the middle of the day. They filter the sunlight and give good, even lighting.

→ MY LOCATION LIGHTING KIT

When I'm on location I take a Balcar battery and mains operated 1000-watt generator that allows for three flash heads to be connected to it. I take three batteries and chargers, one 1000 watt and two 500 watt flash heads with one 40 × 30 inch (100cm × 75cm) softbox and a variety of spill kill reflectors and honeycombs. I also take what I call "bath caps"— small diffusion caps that fit over the spill kill reflectors to soften the flash. I take three medium stands and extension leads for the flash heads.

I take a Bron Impact monobloc kit, consisting of three 500 flash heads with a 40in × 30in (100cm × 75cm) softbox and various spill kill reflectors and three small stands. I also have a three-head Elinchrom kit consisting of a 500-watt, a 250-watt and a 125-watt mono lights. They are great for using direct on a model, or to add light to backgrounds. They can also be used to bounce off walls as fill-in.

I take two on-camera flashguns: a Multiblitz hammerhead flashgun plus a Nikon Speedlight. Additionally, I take two old Manfrotto flash camera brackets, which I use to hold small reflectors when shooting with on-camera flash, plus my collection of diffusers and reflectors.

MY AVAILABLE LIGHT KIT

For shooting with available lights, I use two California Sunbounce 6ft × 4ft diffusion screens, plus two 6ft × 4ft and two 4ft × 2ft reflector frames with white, silver, full gold foil, zebra gold/white, and black screens. I also use a white and a mid-gray white balance card. This allows me to take accurate color readings for white balance and exposure.

If you are doing beauty shots or are working without help, a 40 inch (1m) round reflector is very useful. I use a Lastolite gold and white reflector. Usually reflectors are double-sided — white on one side and gold, silver, or black on the reverse. The vast majority of my location shoots have been shot using just a couple of reflectors and a diffusion screen, but I've been lucky to always have someone helping me to hold them.

When working with inexperienced help, you have to demonstrate what the reflectors are for — that is, to bounce light onto your subject. It's worth spending time experimenting with reflectors yourself, so you know the changes that occur when they are moved. Make sure that your assistant knows exactly where to hold the reflectors. Movement to the left or right, up or down, close or far, all change the quality of light, but the further you are from the model the more movement is needed to make an appreciable difference.

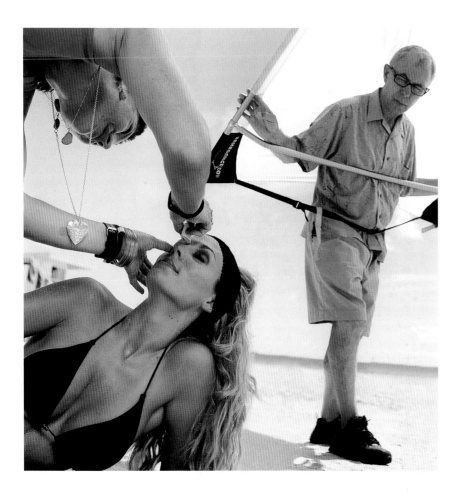

CARRYING CASES AND GADGETS

How you carry your cameras and lighting equipment depends greatly on where you are traveling and how you are getting there. Obviously, if you are in your own vehicle you can load up as much as you can get inside. As long as you have good carry bags and boxes, your kit will be safe. If you are often shooting on location and traveling by air, you need to be sure your equipment is safe from impact, water, and theft.

→ HOW I TRANSPORT MY KIT

I put my cameras, lenses, laptop, and hard drives into an airline hand-luggage-sized camera rucksack that can be used as carry-on. Occasionally, when it has been overloaded with hard drives and cables, I get stopped and asked to repack some of the contents into hold luggage, which is irritating.

I try to keep my lighting kit for location shooting to the bare minimum. This means I can to keep excess baggage payments to a minimum, without compromising my shooting needs.

If I am on a big production that requires mains and battery-powered flash lighting equipment, cameras, computers, hard drives, and cables, my kit will be freighted to a location before I arrive. Alternatively it might prove more practical to hire my lighting kit from somewhere close to my location, depending on where I am shooting.

I have my battery powered flash kit in two large Pelican Cases. These cases are made from high-impact plastic and are very strong, waterproof, and relatively lightweight when empty. They are also air-tight and can be padlocked.

My mains powered flash kits — Elinchrom and Bron Impact kits — are kept their own suitcase-sized case. All of these are lined with dense foam to prevent damage during transit. Lighting accessories such as stands, softboxes, reflectors, and diffusion screens are not easily damaged, so I transport them in their propriety strong soft bags. I wrap any items that may get damaged in towels, to soften any impact.

Left: Lighting stands, umbrellas, and other kit fold away neatly in purpose-made carrying cases. Good-quality cases and bags are vital for protecting your equipment during transportation.

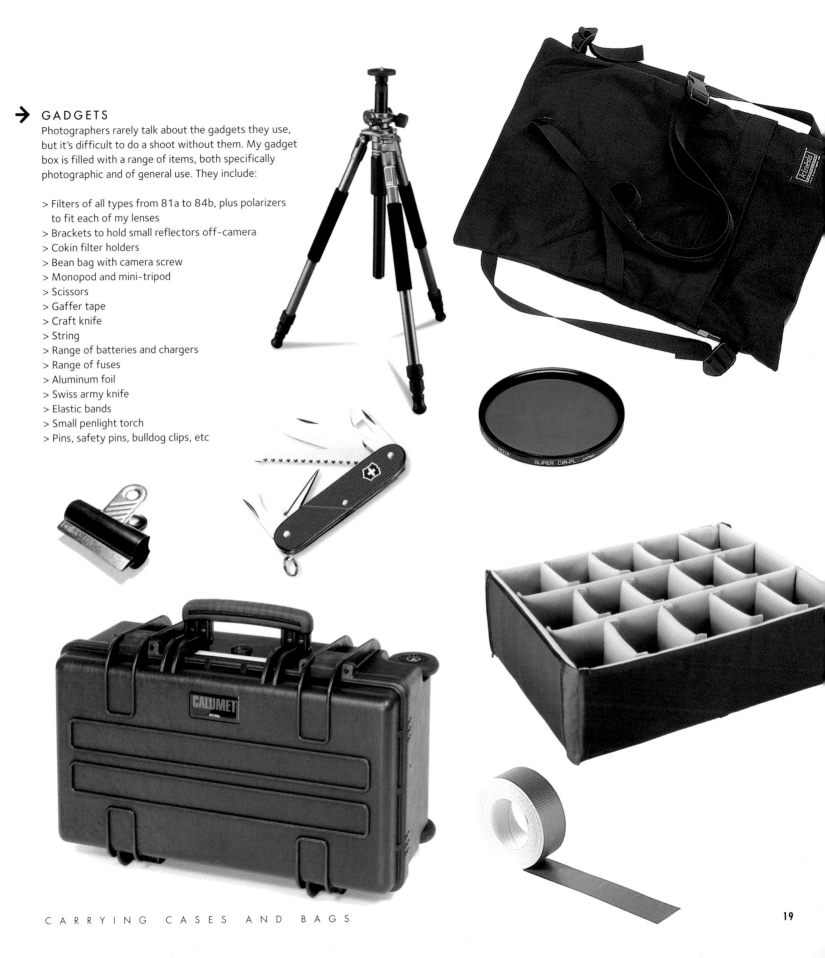

→ GADGETS

Photographers rarely talk about the gadgets they use, but it's difficult to do a shoot without them. My gadget box is filled with a range of items, both specifically photographic and of general use. They include:

> Filters of all types from 81a to 84b, plus polarizers to fit each of my lenses
> Brackets to hold small reflectors off-camera
> Cokin filter holders
> Bean bag with camera screw
> Monopod and mini-tripod
> Scissors
> Gaffer tape
> Craft knife
> String
> Range of batteries and chargers
> Range of fuses
> Aluminum foil
> Swiss army knife
> Elastic bands
> Small penlight torch
> Pins, safety pins, bulldog clips, etc

CARRYING CASES AND BAGS

19

TEAM BUILDING

Every picture I take is a combined effort between myself and my team — it's not possible for me to do it on my own. We often hear about the greatness of famous fashion photographers' work, but in most cases their pictures are great because of the work by other team members on the shoot. It's almost impossible to get great fashion pictures without great models and a team of assistants, hair and makeup artists, and fashion stylists.

When you're starting out, you may have to work on your own with a model for the first couple of shoots. This is fine while you are practicing, but if you want to start shooting at a professional level, you are going to need help. There are always people willing to help assist on a photo shoot, so you won't be short of volunteers.

Fashion photographers need someone to help with their equipment in different ways, such as moving lights and reflectors. They need someone to organize clothes and accessories, and they need someone to take care of hair and makeup so that their models look their best — the way they do in fashion magazines.

Makeup, hair, and fashion styling make your fashion pictures work. You need to find people that know or at least want to learn to help you achieve your objectives.

This chapter explains the different roles of fashion photography team members and how they can enhance your pictures and help you to become a great fashion photographer.

FASHION PROTOCOLS

Fashion protocols can be loosely defined as informal rules for acceptable ways of behaving and dealing with people in the business. Some photographers don't know the proper way to treat their team, models, clients, or assistants. I believe in getting the best out of everyone involved on my shoots, so I have a strict code of practice to which I adhere. I expect members of my team, and my clients, to also adhere to it.

Left: To get the best out of your model, especially when they are partly clothed or nude, you sometimes have to close the set to make them comfortable.

→ CASTING FOR MODELS

When casting through a model agency, or talking directly to models, you should never give the model an indication that you will use them unless you are certain that you will. Instruct your clients the same if they are attending a casting. The model may have been out on castings all day and not offered any jobs. So if you tell that you'd love to use them, they go away with hope and excitement about getting the job. You can imagine how disappointing it feels to be told afterward that you didn't get it. So delay comments regarding your choices until the end of your casting. Then both you and your client will be clear about the model(s) you want to use for your shoot.

A model's features should never be discussed in a derogatory manner. I once went on a casting for models with a client who made unpleasant personal comments to the unsuccessful models. I was extremely angry and embarrassed. Now I brief my clients as to how to behave, so that I don't have to see a model leave one of my castings with tears in her eyes. I believe you should treat people as you would like to be treated.

RESPECT YOUR MODEL

For some shoots, where your model is uncomfortable with your team staring at them nude or in revealing clothing, you may need to create a closed set. This means that you will need to use large screens to build an enclosed set so that nobody but the photographer can see the model during the shoot. And even if a model is comfortable on set in little clothing, it's a big taboo to enter their changing room without permission. So knock on the door before entering and wait for an invitation.

If you want to get the best out of your models, don't do anything that will upset them or cause them to lose respect for you as the photographer. It's all part of generating a good vibe. The same can be said about any member of your team. Show everyone respect and you will gain respect yourself. You will also have a happy team that thrives on positive energy — pictures don't work without it!

→ HOW TO APPROACH A NUDE SHOOT

If you're going to be shooting any level of nudity, whether the models are partly clothed, in lingerie, or even swimwear, you need to explain to the model or model agency exactly what type of pictures you're going to shoot. Don't expect a model to take off her clothes if she has not been informed exactly what's expected of her. If I am doing this type of shoot, I state it very clearly to a model agency. I tell them that I need to see models with experience of this sort of photography and I need to see them nude or in their underwear before I can decide whether I am going to use them. This means that I will only see models that are right for the shoot. This protocol is the same whatever the shoot.

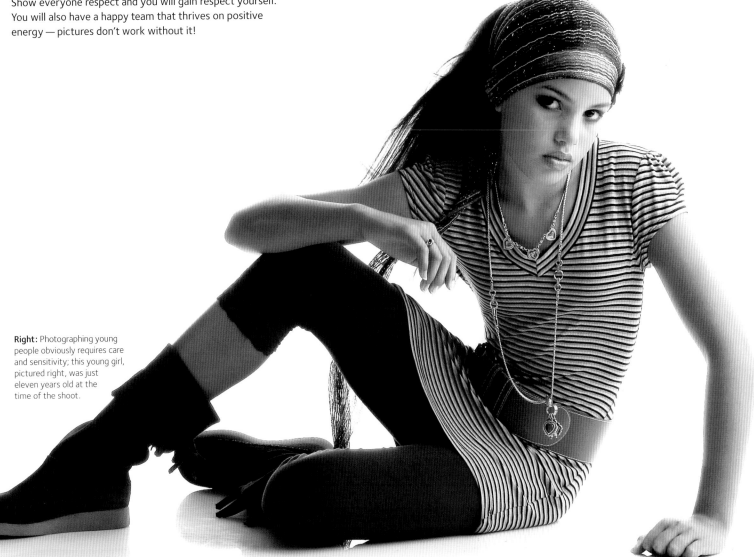

Right: Photographing young people obviously requires care and sensitivity; this young girl, pictured right, was just eleven years old at the time of the shoot.

ASSISTANTS

Finding an assistant is the easiest part of becoming a fashion photographer. If I listed the amateur photographers, friends, and acquaintances that have asked me if they can help with shoots, it would be a very long list. However, finding the right kind of assistant is not so easy.

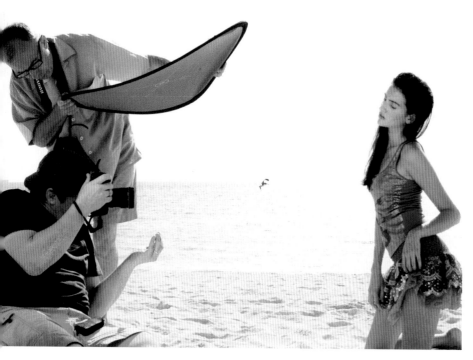

→ If you are in the early stages of building a career in fashion photography, you may need someone to help you do simple things, such as hold reflectors on a daylight shoot. However, if they have no photographic experience, you'll need to demonstrate how reflectors are used to bounce light (see Location Lighting Kit, pages 18-19).

If you are a little more advanced and looking for someone to help you take pictures, it's important that you find someone with some photographic and technical knowledge. One way of doing that is to find a local college or university that has a photography department. Speak to the professors to find out if there is someone in the photography program who would be interested in helping you. At the very least, they will be able to help with basic things as well as the occasional technical problem you may hit.

A professional photographer's assistant is a vital part of the team. They need a broad range of skills and knowledge, plus the right kind of personality.

For instance, a good assistant has to be organized. They have to be able to follow a photographer's instructions on how to set up lighting and to keep everything running smoothly during a shoot. A really good assistant will know what piece of equipment a photographer needs even before they ask for it. They also need to be up-to-date with the latest digital technology. For instance, I rely on my assistant to do all my digital image transfer for me, so they have to understand the system I use.

An assistant also has to have the right personality — they have to be helpful, willing, tolerant, and good at dealing with people, particularly models and clients. An open personality is very important.

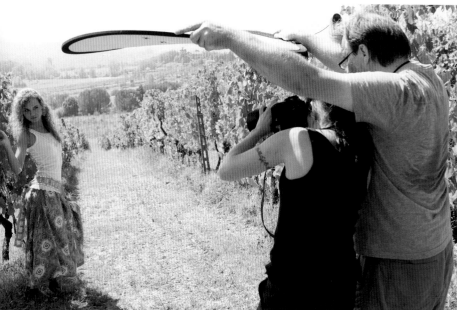

Left: Assistants are vital on a professional shoot. Their duties include holding diffusion screens and blocking lens flare with a reflector, as here.

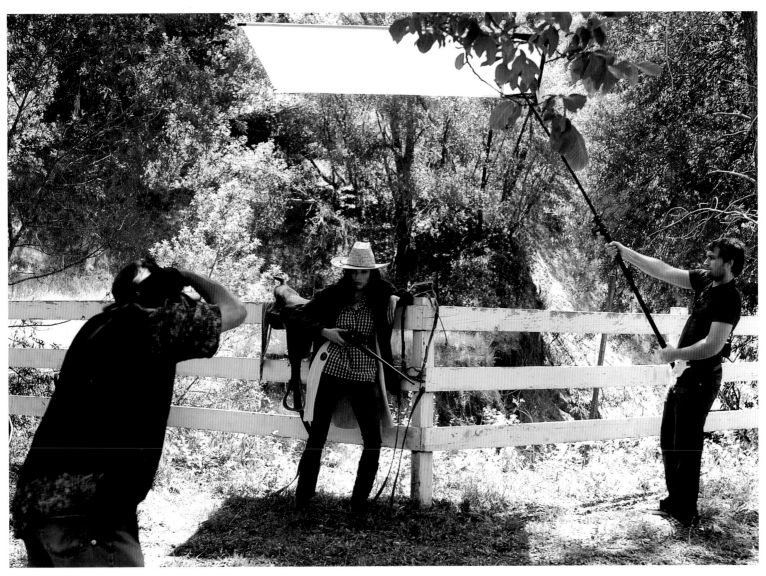

Above: Shooting during the middle of the day I will often shoot using the Californian Sunbounce sun swat. It gives a lovely soft light great for shooting fashion it also helps to separate your model from the background because the background must be overexposed. It's essential to have a good strong assistant to hold big, heavy screens like this.

Left: My assistant, helping on set by taking a light reading. Assistants can also help by standing in for the model while you're setting up a shot.

→ AN ASSISTANT'S DUTIES

The role of a professional fashion photographer's assistant essentially involves helping the photographer in any way necessary. Although I personally wouldn't ask an assistant to do all these things, here's a brief list of the kind of duties an assistant can expect to be asked to do:

> Scouting trips to check out locations prior to a shoot

> Setting up lighting to the photographer's specification

> Building sets

> Arranging transportation of kit

> Booking studios

> Carrying kit and holding reflectors during the shoot

> In the photographer's absence, assessing models when they arrive at the studio on spec

> Digital transfer or loading of the photographer's images onto computer

STYLING

To photograph your models at their best, you will need to find good hair and makeup artists. Often they do both and sometimes they also do fashion styling. If you are lucky and there are model agencies in your local area, they will have a selection of stylists on their books or be aware of ones they can recommend to you.

→ HAIR AND MAKEUP ARTISTS

Most commercial fashion images show flawless, simple, and natural makeup. You need a makeup artist who is able to even out the model's skin tone and flatter facial features. When meeting or working with a new artist it is also important that they know a little bit about lighting and how it affects the final shots.

For example, a good artist will know that you cannot use a reflective base when shooting ring flash as it will cause the flash to leave 'hot spots' or white patches all over the high points of the face. They should know that colored gels will often alter the colors they choose on the model. Asking questions about their knowledge of photography when you meet with them is a good way of knowing how they will cope on set.

On the day of the shoot, you need to give precise instructions on the way the makeup should appear. Makeup colors should match the garments. If you are working with a makeup artist who has not done photography makeup before, tell them that the model's skin preparation is as important as the mascara. A good base makeup should match the general skin tones of her face, neck, chest, arms, and legs. The makeup has to be very well smoothed and blended, and slightly heavier than it would be for normal use.

If your model has bad skin, politely tell them to drink plenty of fresh boiled water for two or three days before the shoot. Make sure their fingernails and toenails are well-groomed. Hair needs to be healthy and shiny. Your model should arrive at the shoot early with hair that's been washed and conditioned and a face without makeup. Applying the makeup professionally will normally take one to two hours.

If you are planning to shoot on location, set a meeting time to allow for makeup to be done. Ask them to complete all of the foundation makeup and put heated curlers in the model's hair before you head out to your location. The finishing touches, including dressing the hair, can be done at the location. Make sure the appropriate facilities are available.

FASHION STYLISTS

As a professional fashion photographer, you will need to work closely with a fashion stylist. Fashion stylists are responsible for the style and mood for a shoot. They select and set up the appropriate props, fashions, accessories, and occasionally even select the models with the right look to fit the theme of the shoot.

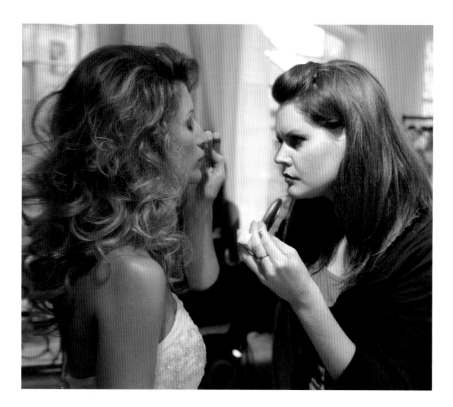

Left: A makeup artist applies the finishing touches before a shoot is about to start.

Top: Fashion stylists work with photographers to select clothes, props and accessories on a shoot.

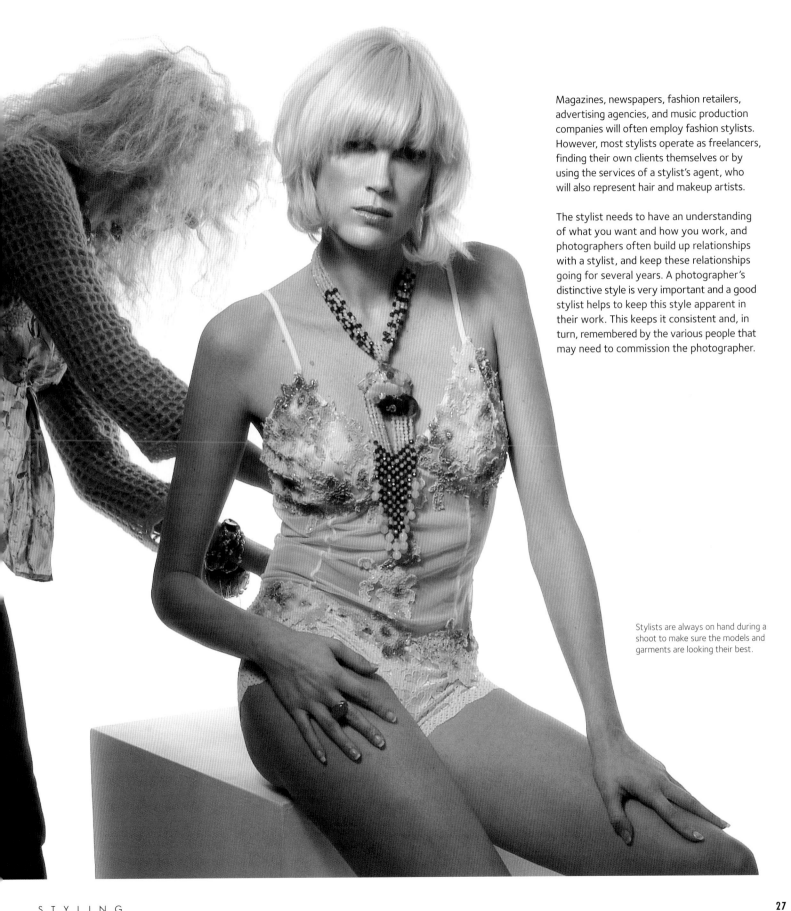

Magazines, newspapers, fashion retailers, advertising agencies, and music production companies will often employ fashion stylists. However, most stylists operate as freelancers, finding their own clients themselves or by using the services of a stylist's agent, who will also represent hair and makeup artists.

The stylist needs to have an understanding of what you want and how you work, and photographers often build up relationships with a stylist, and keep these relationships going for several years. A photographer's distinctive style is very important and a good stylist helps to keep this style apparent in their work. This keeps it consistent and, in turn, remembered by the various people that may need to commission the photographer.

Stylists are always on hand during a shoot to make sure the models and garments are looking their best.

SOURCING MODELS

Model agencies, casting agencies, acting agencies, or dance schools are very good sources for finding models with whom you can shoot tests. Contact these agencies and arrange to see them with your portfolio. They may not be helpful at first, so you need to explain very clearly your objectives for shooting fashion, beauty, or portrait pictures. To explain your ideas, you can use your own photographs, or tear sheets from magazines. If they seem unfriendly and over-protective, they are only doing their job in looking after their models.

→ If you do not find any agencies in your town, look a bit further afield. Even when an agency is 50 miles away from your local area, they may still have models on their books from your town.

If all this does not help you to find models with whom you can work, there are several web-based agencies or model and photographer interest sites that you can find models. You should be aware that there may be adult images on some websites. They won't be very graphic but there will certainly be topless and nude images. If you are offended by images like this, you will have to find your models elsewhere. At times, photography does call for undressed, or partly undressed models for ads and fashion stories, so it's part of a photographer's job to occasionally produce images of this kind.

New models will always need pictures to get started. Local photographers usually shoot these as paid tests (paid for by the model), or more often on a TFP (Tests for Pictures) basis. This is a fair exchange: you get models to shoot, and they get new pictures for their portfolios.

For your first test shoots, your models can perhaps be found among your family and friends. They will be forgiving of your uncertainties, and will always be grateful for nice pictures of themselves. A useful tip, when you're new to fashion photography, is to always give prints or CDs of images to those you shoot, and to your team.

CHOOSING THE RIGHT MODEL

If you are starting out, shoot as many different types of model as you can. Over time, you will gain an idea of the kind of models you want to shoot. When you're shooting for a particular purpose — for advertising, editorial, or catalog work, for instance — you have to choose the right model for the job.

Models come in all shapes and sizes, and the way they look leads them to specialize in particular fields. You wouldn't use a glamour model for shooting high fashion; nor would you use a catalog model for an editorial shoot. They would have the wrong type of look and give you the wrong sort of poses for the shoot. Your model will make or break your pictures, so be selective.

Left: This cover for a catalog illustrates how the art director will pick out the essential elements of your photos and incorporate them into a cohesive design. In this case the predominant color is cream.

Agency or photographer interest websites are a great way to find models. They include sample images and indicate the kind of work that the model has done and is prepared to do. Try www.modelmayhem.com, www.net-model.com, or www.onemodelplace.com

Above left: Whilst shooting this shot I had a great piece of music playing in the studio. It really helped to get some fabulous shots full of movement and good energy from this model, sourced from Oxygen Models in London.

Above: I found this model on the Model Mayhem web site. At first, as a testing photographer, you may find it difficult to get good models from agencies. Sourcing carefully using sites like Model Mayhem is another route to some great talent to shoot with.

TESTING FOR MODELS

Testing is a crucial part of a model's career. A good agency will always encourage its new models to test, as this has two added benefits for the model. One is that s/he gets to practice in front of the camera, which builds up their confidence, and it also builds up their portfolio.

Agencies are always looking for skilled new photographers who are testing. If they are meeting a photographer for the first time, their portfolios might not have the high fashion or beauty pictures that they expect to see. However, they will always encourage anyone they feel has the right ideas, lighting, and a good team of makeup artists and stylists.

If they decide to use a photographer, they will explain what they need for the model's book and weigh that against what the photographer wants to do. Somewhere in the middle they end up doing a test with which everyone is happy. It is a trial-and-error situation and sometimes agencies can end up with a test where none of the pictures actually get used. This isn't a disaster, however, as the model has only invested their time.

When a test comes back to the agency and it isn't up to standard, a good agent will tell the photographer why the picture couldn't be used. They may say that the makeup wasn't nice, the hair looked wrong, or the clothes didn't suit the model. The photographer should be open to criticism and not take it personally. In the end it all helps toward getting the right pictures for everyone.

Agencies don't like models to pay for tests unless the photographer is a known person within the industry and the model is guaranteed at least three to five pictures that can be used for their portfolio.

The fashion industry operates on a who-knows-who basis and word of mouth is always the best way of promotion. Anyone who is new to fashion photography should try to keep an open mind and never be afraid of asking for advice and encouragement from agents or models. A model's job is to know how to pose and sometimes photographers should encourage the model to move freely and get the feeling of shoot, rather than constrict it too much. Another trick is to shoot the first 10–15 pictures without expecting any results as this will allow the model to get warmed up.

Model agencies are always happy to see good and enthusiastic new photographers. Send them some samples of your work and they will decide if they are happy to allow you to test with their models.

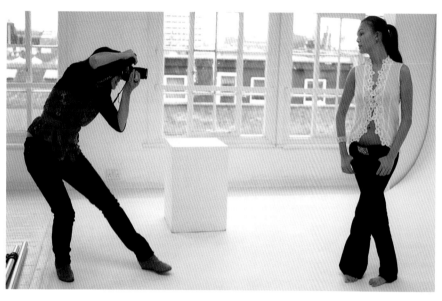

Above: Model test shoots simply have to show the model at their best. Simple sets or backgrounds are ideal.

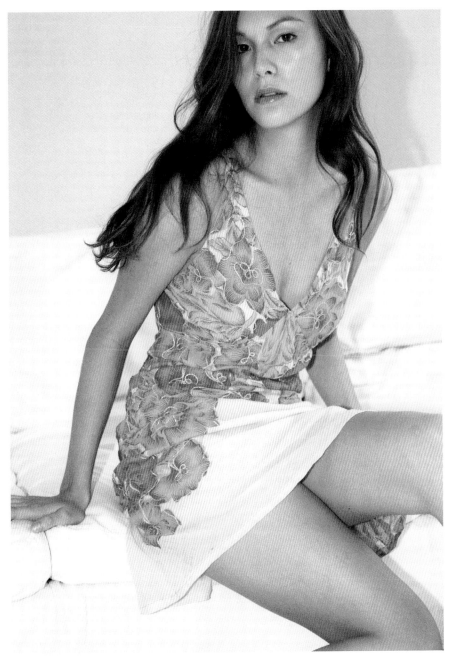

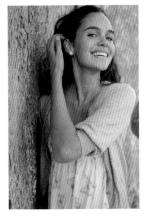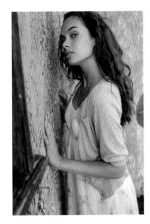

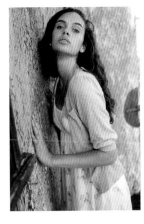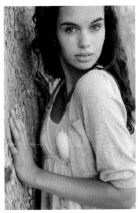

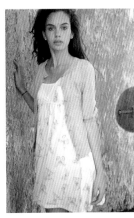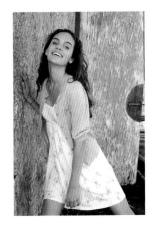

Left: Models need a variety of pictures for their portfolios. This is the same model shown in the images on the far left, styled in a different way.

Above: This test shoot, showing the model in a variety of poses in simple clothes and against a complementary background, is perfect for a portfolio.

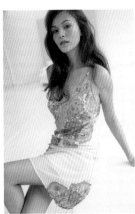

PRE-PRODUCTION

Fashion photography is all about creating a fantasy. It's about having an idea in your head, taking a number of elements, and making that idea come to life in a photograph. For that reason, fashion photography at the professional level demands a higher level of organization than almost any other type of photography.

Whatever the job, your pre-production should be equally thorough. Try to think of every fashion photography project as a kind of jigsaw puzzle with elements that have to be put in the right place at the right time. Only then will it fit together and make a complete picture.

The first part of the jigsaw is the clothes you're going to shoot. After the clothes comes the story. Then there are the choices you make: are you going to shoot on location or in the studio? What type of studio or location? Do you need to build a set? If you're on location, what time of day is best to shoot? What equipment will you need? Are you going to shoot with continuous lighting or flash?

You have to make sure that your team know what you're going to do and how you're going to do it. The very last piece of the jigsaw is the live energy you put into the shots when you're taking them.

The purpose of this chapter is to look at all the elements of pre-production and examine the ways that you can prepare for a shoot. The more thoroughly you prepare, the more likely you are to get great pictures.

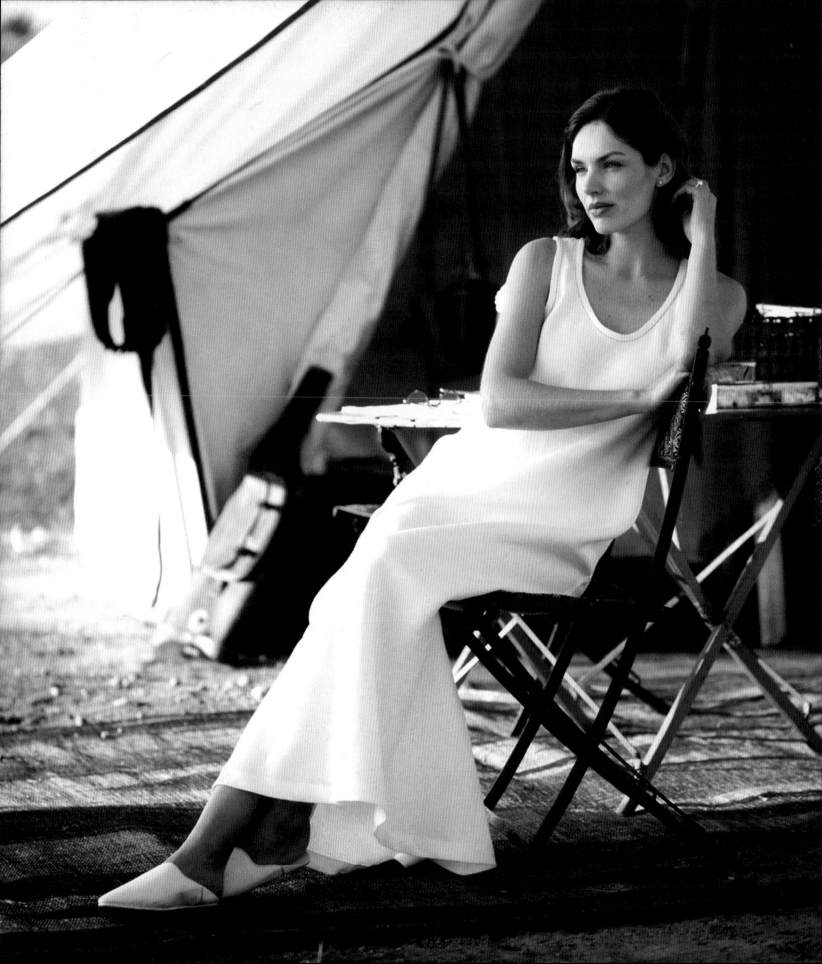

ORGANIZING A FASHION SHOOT

Below: Choosing locations can be a team effort. This shot looks like it was taken in the jungle, but we found it while walking through back streets in Miami.

Below right: Organizing fashion shoots is a team effort in which knowledge, expertise, and creative ideas are shared.

First of all, you need find out or decide why you are shooting the pictures and what objective you want them to achieve. How do you want the pictures to look? What atmosphere do you want to convey? At this point, I ask my client which of my pictures inspired them to commission me. Do they want some thing similar or different? If they want something different, I need to see the kind of images they have in mind.

→ MODEL SELECTION
If you are working for a client, ask them about model fee budgets. This is very important, as it determines which agency and what level of model you can use. You should also find out how many shots are needed. If you have more than 10 shots to do in a day, you will need more than one model.

RESEARCH THE STUDIO OR LOCATION
Studios come in different sizes and shapes, so you have to choose a studio that's best for the images you have to produce. Locations vary greatly and all will reflect different atmospheres, so you have to find out what atmosphere your client expects. Locations may be free, but most, if privately owned, will charge fees to use them.

EQUIPMENT NEEDED
Think carefully about your equipment and make sure you have everything you need for the job you're doing. If you're shooting on location, keep your equipment as simple as possible. You have to travel light.

ASSISTANTS
Make sure you have an assistant who knows what they are doing, and ensure they are fully briefed on what you are going to do.

FASHION STYLIST
For a second meeting with a client you will need to present them with a storyboard showing your ideas. It's a good idea to bring in a fashion stylist to help prepare for this meeting. Fashion stylists help plan the visual appearance of the image, select accessories, and arrange for garments to be delivered on the day of the shoot.

HAIR & MAKEUP
Should you use your favorite hair and makeup artist, or does the client have other ideas? They may have worked with someone else and may want to use them.

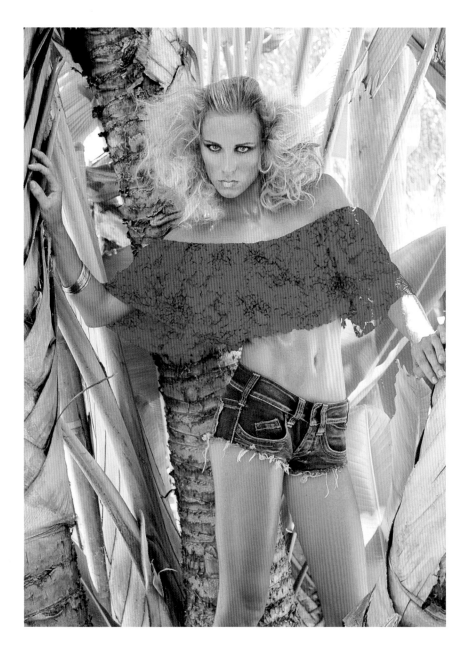

Left: This shot looks simple, but took a lot of organizing. We wanted to create a 1930s style scene, so had to get props from several sources.

Below: This atmospheric shot required the patience of the model, who was lying just where the waves were breaking on the beach, as well as my using a fast shutter speed and keeping my balance!

→ LIGHTING

Do you have enough kit to produce what the client wants, or do you need to hire extra items? This can amount to more than your day's fee. If so, make it clear to your client that you require an extra budget.

SET/BACKGROUND

If you don't want to shoot with a plain background, try textured metal sheets or rough timber. Alternatively, you can build your own set. It's amazing what can be achieved with materials from a DIY store, some props, and some imagination.

PICTURE USAGE

Fashion photographs are used for a variety of purposes. From the outset, you need to know in what ways the client intends to use the pictures, how long they are going to use them, and where they will use them. This will determine the fee structure for the whole team. For details, see Image Usage, page 170.

Above: Fashion photographers have to be aware of the market in which they want to operate. By looking carefully at a range of books and magazines, you'll get an idea of the kind of images these publications expect, and how they are used.

If you're preparing for your first assignment and about to do a test shoot, take a good look at the fashion magazines on the market. They are a good source of ideas, so you should look at as many as you can. There's an enormous variety of magazines on sale, all carefully aimed at specific audiences. From looking at a broad range of magazines you will get a good grasp of the various different markets for fashion within the industry and the fashion scene in general.

→ Start selecting the ones that appeal to you personally, so you can plan the kind of photographs that you want to shoot. Look at fashion spreads and the advertising images for fashion, or fashion-based products such as perfumes and cosmetics. Over a relatively short period of time you'll see new styles emerging. The fashion business is fast-paced, and changes every four to six weeks.

Build up a collection of tear sheets (pages torn from magazines) showing images you would have been proud to have taken. The best way to learn is to try to emulate the work of other photographers whose pictures you admire. Look at the lighting, the locations, the clothes, the models, the rhythm, and the tempo of the shots. Try to understand how the photographer created these images. As you start to shoot your own pictures, you will learn how to create different kinds of image. Eventually, your own personal style will emerge.

If you want to shoot for magazines, your work has to reflect contemporary styles, but also show elements of something different and new. Every shot you take should show your flair and passion for photography and fashion. This takes time to develop, and the best way to discover is to explore.

When you have collected a good selection of tear sheets, you can start making up a fashion story of your own. You may like to start with a color, then theme your pictures around it. Pick tear sheets that have the poses, lighting, models, and locations you like. The most important thing is making the story hold together. Think in spreads, then sets of spreads. Most fashion stories have four, six, or eight pages, so your story should be at least four pages long — for example four fashion shots, one per page.

If you are just starting out as a photographer, you may not be familiar with studio lighting. This will develop as you learn by experience. For your first shots, I would suggest using only daylight, because getting bogged down in the potential problems associated with studio flash can be frustrating and hamper your freedom to shoot.

FINDING YOUR SPECIALISM

Most professionals specialize in certain areas of fashion photography, such as beauty, fashion for catalogs, advertising, or editorial. You will find your interests develop towards certain types of fashion photography.

As a new photographer, it is unlikely for you to be commissioned to shoot an advertising campaign. However, if you have lots of good pictorial fashion stories in your portfolio (or "book"), you may be asked to shoot for a magazine. You may be paid little — or perhaps even nothing — for this work. Nevertheless, magazines are great places to have your work displayed and you should grasp the opportunity to showcase your interests, style, and skill.

When you present your portfolio to potential clients you will stand a better chance of being commissioned to shoot if your book relates closely to the client's area of work. So, well before you even try to make an appointment, you should thoroughly research the particular market that you would like to shoot for.

TIMES OF DAY TO SHOOT

If you're planning to shoot using natural daylight, the prime times to shoot fashion are in the early morning and late afternoon. Ideally you should aim to photograph during the first two hours after sunrise and the two hours before sunset. When the sun is low in the sky, the earth's atmosphere refracts the light rays and makes the light appear softer. It also filters out some of the blue wavelengths, leaving mainly middle and higher wavelengths of light (yellows and reds). The resulting warmer quality of light gives the model's skin a healthier-looking tone.

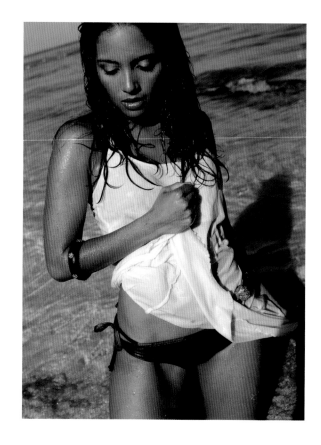

MID DAY LIGHT

This was shot at the height of mid day, the worst time of the day to shoot, this meant I had to place my model with the sun right behind her to avoid nasty contrasty sunlight hitting her face. The shot was from a 400-shot swimwear catalog I shot in Australia.

MID MORNING LIGHT

This shot illustrates the use of early morning light. It was taken at around 8 AM on an Australian west coast beach. You will see that the light is bright and crisp, but not unflattering on the model's skin. The light-colored sand acts like a reflector to soften the shadows a little. The whites in the garment are clean, but the shot still has warmth.

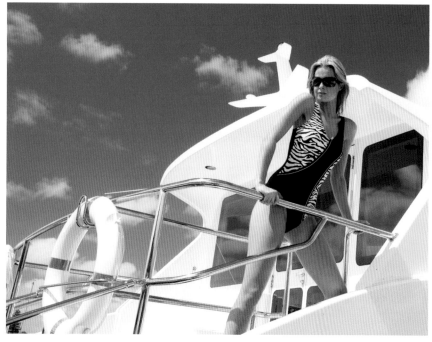

 It's good to work at either end of the day because of the light's direction. As the light is coming from low down in the sky, it will be hitting your model from the lower side or the front. This is flattering light, unlike the light you get around the middle of the day.

If you shoot late in the morning, or early in the afternoon, you'll find that direct sunlight from high in the sky is harsher, and creates nasty shadows under your model's eyes. One way of getting flattering pictures at these times is to shoot with your model in the shade. In that situation you can bounce the sunlight using reflectors or diffusion screens.

However, in some fashion assignments, the warm tone of the light in early morning and late afternoon can cause problems. For example, when shooting fashion catalog, the color of the garments needs to be very accurately reproduced in the pictures. This can be corrected by using the custom white balance setting on your digital camera (see manufacturer's instructions). This will neutralize the color temperature of the light hitting your model and the garments; it will be easier to set a custom while balance if you shoot a neutral colored gray card.

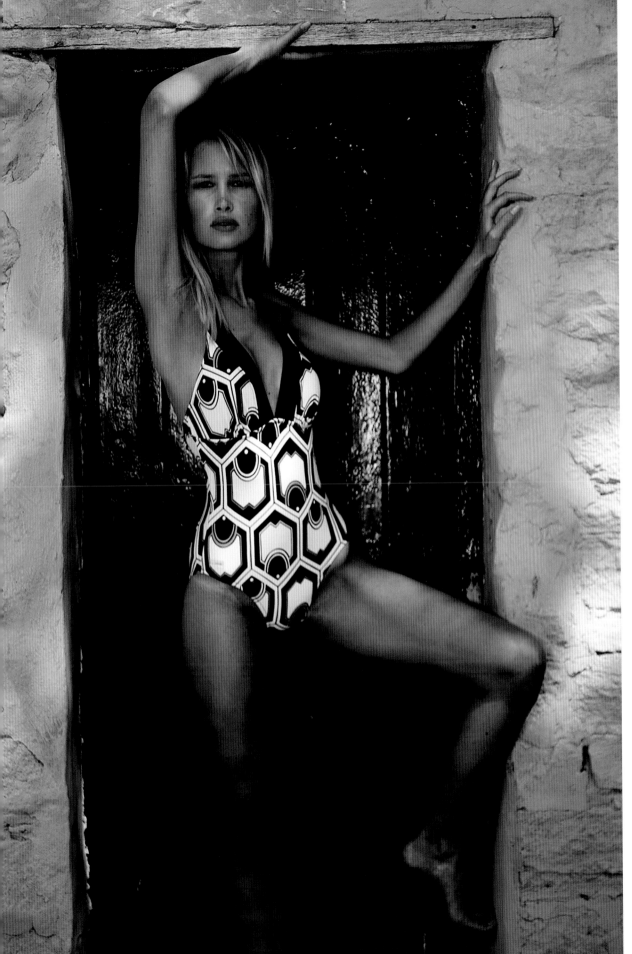

LATE MORNING LIGHT

I made use of the doorway to frame my model, it was shot during the late morning. There was a large tree just off the shot to the right which created a lovely soft dappled light. When shooting a large catalog you can not afford to only shoot at best light times of the day such as early morning or late afternoon, so making use of shaded locations is a must.

LATE AFTERNOON LIGHT

It is still important when shooting interiors with available light to shoot at the right times of day. This was shot for a couture designer in Dubai — we used a polo club house as our location. This was shot making use of the late afternoon sunshine coming through very grand windows that faced the west, where the sun was setting.

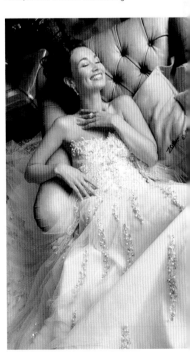

INDOOR LOCATIONS

Choosing an interior location for a shoot can be a long process, and it's one you should consider carefully as it's vital to your shoot. The location has to fit the atmosphere you want in your pictures. For instance, bridal wear looks fantastic in a stately home, while modern clothes look great in a contemporary apartment. Contrasts between clothes and locations can also work well.

→ These are some of the questions you need to consider when selecting an interior location:

> Do you need permission to shoot there?

> Can you get access at the right time of day?

> Are there rest rooms and facilities for models to change and be prepared for the shoot?

> Do you need to use supplementary light and, if so, is there a convenient power source?

> Does the location offer the atmosphere you want?

> Are backgrounds free from obstruction?

> Are members of the public likely to get in the way?

Buildings make great locations for fashion shoots, both as interiors and exteriors, and there are many available for photographers to use. Start by looking around your locality at buildings that are open to the public. You will usually have to ask permission from whoever owns the property and explain why you're doing the shoot.

If you are just starting out or building a portfolio, you should clearly say that the pictures will not be published or used for other professional purposes. If you are shooting commercially, you may need a permit and/or written permission to shoot. In many locations you will have to pay a location fee, calculated on a daily rate.

Using building interiors offers benefits, such as the weather not being crucial to the success of your pictures. Large windows offer plenty of natural light with which you can work. However, buildings can appear very different at different times of the day, so once you've chosen a location, consider the best time of day to shoot there. What direction is the light coming from and at what time of the day?

When you're looking at potential locations, make sure you have a compass and a notepad with you. Draw a sketch with this information, so you know the best times to shoot the best parts of the building. When I'm scouting out a location, I will usually walk through it in the direction that the sun will travel when I'm going to do the shoot. This helps me anticipate the best parts to shoot and the time of day I need to be there to get the best possible light.

In most cases, you will usually need to supplement the available light with continuous tungsten or flash lighting. You may need to use battery-powered systems of the kind made by Bowens, ProFoto, and others.

Keep notes and snapshots of any potential locations that you come across, even if you're not actively looking for them. I keep all of the pictures that I have taken of locations from reconnaissance trips that I have done over the years, so I can refer to them if a client needs one. You never know when you'll need a location, so always be ready to scout out a great place to shoot.

LOCATION-FINDING COMPANIES

There are many location-finding companies that can help you find just the right location, such as period buildings, modern buildings, and high-tech buildings. Every possible choice you may need can be found. However, all location-finding companies charge a finding fee, or they take a percentage of the fee from the location owner.

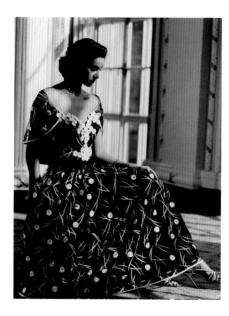

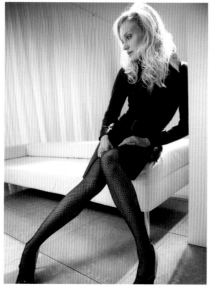

Left: This hoisery shot was taken as part of a series of packaging images, shot in a luxurious loft apartment in North London, was lit with a mixture of daylight and HMI continuous lighting.

Far left: Locations should add atmosphere and context to the shot, without being a distraction from the main subject

Right: Selecting the right location is vital to the success of a shoot. I love shooting in grand and elegant places, like this English country house; it is especially appropriate for bridal wear.

Above: You have to be aware of the times of day when rooms are going to have the best light. I arranged to take this shot when sunlight was streaming through the windows.

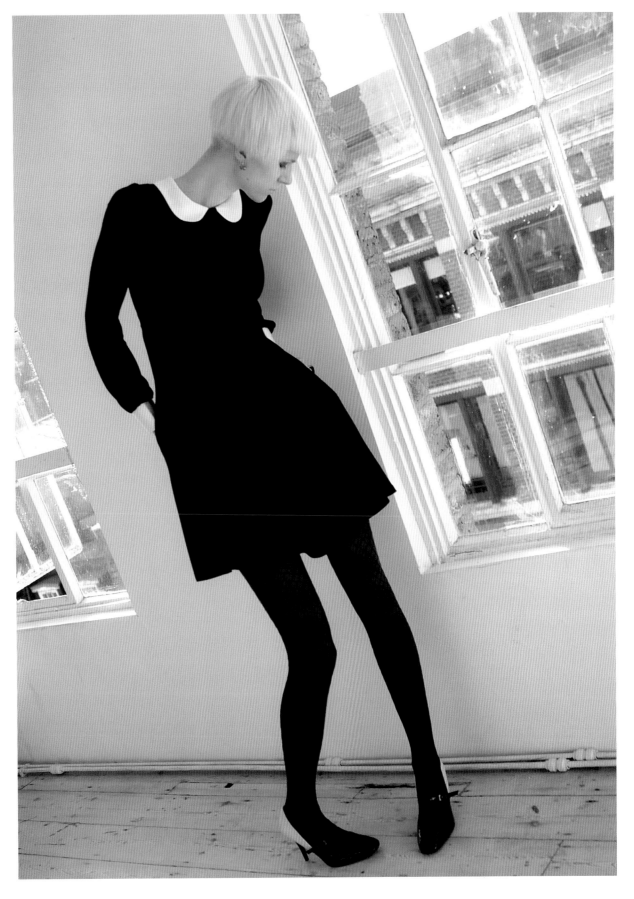

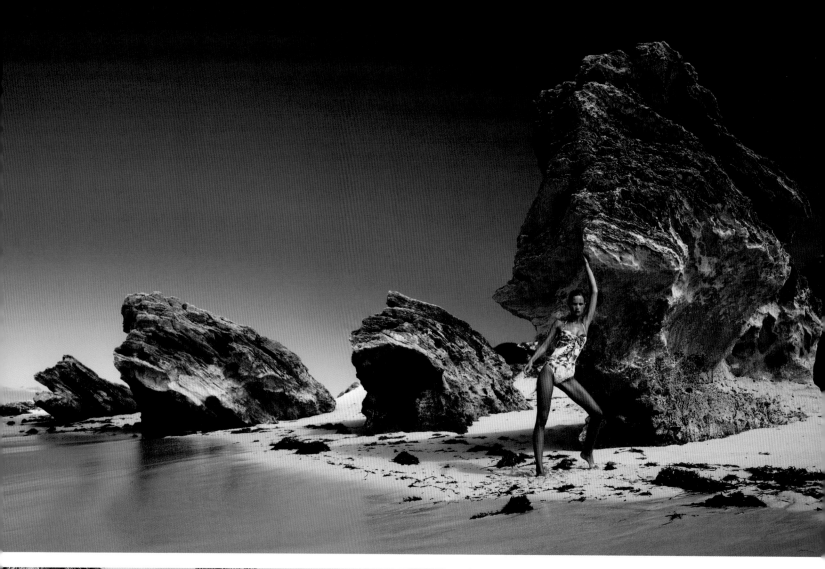

Abovet: I used this fantastic beach location with the rocks as an integral part of the picture.

Left: This is another, very different, beach location. It has areas of sunlight and shade and would make a great place for a swimwear shoot.

OUTDOOR LOCATIONS

Outdoor locations offer an enormous number of possibilities for your pictures, but you must choose carefully. Much of what I've said about selecting indoor locations can also be applied to outdoor ones. The location has to be right for the story you're telling and the mood you want to create.

When you are considering particular locations, you need to narrow your vision to concentrate on what's essential for the shoot. In particular, you need to consider what you want in the background of your pictures. You don't want things that are going to take attention away from your subject, such as complicated shapes or distracting colors.

For instance, I once had a brief from a client that we had some very ethnic-style clothes to shoot, with fabrics in ochers, browns, and greens, with lots of beading. The client wanted a "travel" feel to the pictures and the theme for the pictures was a combination of "safari" and "ethnic." So we decided that the ideal location would be Kenya. However, it was only when I had been on a reconnaissance trip to Kenya that I could visualize exactly how we could use particular locations to showcase the clothes.

The principle of checking out a location before the shoot is the same whether you're going to Kenya or some local woodland. When you're on a reconnaissance trip, take some snaps of likely places to shoot your models. As a fashion photographer, you should consider the style and colors of the clothes you're going to shoot, and how they are going to look in those locations. What is your story about? Urban fashions in urban areas? High fashion in sophisticated surroundings? Sometimes, a contrast can work very well. Why not shoot high fashion in urban areas, or vice versa?

As with choosing an interior location, you will have to consider the direction of the light at the time you will be doing the shoot. You have to think about the best time of day for sunlight, or light that may be bouncing off buildings. Are there areas of shade that you could use for shooting in the middle of the day? Will you need reflectors or diffusion screens? Make notes about the best angles from which to shoot. Look through your camera's viewfinder and consider how these viewpoints would work in your pictures. It's a good idea to shoot test images, making use of different amounts of depth of field. Try showing the background sharp, or blow it out of focus. Compare the results.

If you're moving around to different outdoor locations, plan your time carefully so that you are in your locations at the right time to catch the best light for your pictures (see Managing Your Time, pp. 122-123)

Left: Sky, sea, and sand make a simple but perfect combination for swimwear shots. The very pale sand in this shot also kicked up extra light onto the model's skin.

NORMAL STUDIO

A studio can be created in any good-sized room. If you are starting out in fashion photography, and you have the space, you could set up a studio in your home. If this is not possible, check whether there are any studios in your area to hire. If you're on a tight budget, do you know a photographer who is kind enough to let you use theirs for a small charge, or in exchange for assisting them on their shoots?

I often shoot at home, as it's comfortable and convenient for me. Photography is not about where you're shooting, it's about what you're trying to create. However, one of the most common mistakes among testing photographers is to shoot a model dressed in a classic style against a modern setting. You have to choose the right setting for the mood, and attention to detail — even down to the style of wallpaper or skirting boards — is very important.

→ SHOOTING AT HOME

To set up a home studio, all you need is a big floor space and a high ceiling. Obviously if you have a small home it's more difficult, but you don't need very much space to shoot portraits and beauty pictures.

If you are shooting in your home, there are various ways in which you can make interesting sets, using furniture and basic items you may already own (see Set Building, pp. 50–51). You can shoot very successfully by just hanging up a large piece of material as a backdrop. If you have got a big space, you can use paper backdrops, available from your local pro photo store. These are 9ft (2.75m) or 4ft 6in (1.47m) wide rolls of paper, supported on a 10ft (3m)long pole on two medium stands.

If you're starting out and are going to work with electronic light, it's worth investing in a mid-range set of monobloc lights. Most of the time in my own work I only use 500-watt and 250-watt lights. I'll bounce them off the ceiling or walls, or put a softbox on them, or a diffuser, or modifier. If you're doing testing work, you'll want to shoot on location. In that situation, I'd recommend buying monobloc lights that will work using battery power.

However, when you're choosing a room for a studio, whether you're working with electronic light or not, you should remember to pick one that has plenty of natural light coming in. Daylight can be the best form of light for photography.

HIRING A STUDIO

Hire studios come in several forms. At one end of the scale there are small studios, mainly aimed at the amateur glamour photographer's market. They have pre-built room sets and usually provide models from which you can choose.

Next, there are larger studios for hire that are aimed at the professional photography industry, designed for shooting still life or portraits. There's often more than one studio for rental in the same building. Walls are painted white, black, or dark gray. They are great for shooting fashion.

Left: A big studio space is a great place to work, but you can work in different-sized spaces. This tight shot could be achieved in a very small space.

There are also huge studios available for projects that require a lot of space, such as furniture catalog shoots. They have infinity coves and are big enough to photograph cars or even trucks. I love to shoot in coved studios; they give you more space and freedom to make your images, and can be lit in a variety of creative ways.

If you're a rookie photographer looking for a studio, try to find a studio that has kit included in the price, as hire kit can be very expensive. A perfect sized fashion studio is an empty space, 25ft wide × 50ft long × 15ft high. It's what you do with your equipment — backdrops, stands, and lighting — that counts.

Above left: Simple pieces of studio kit, such as wind machines, can add that little something extra to a shoot.

Above: The wind machine adds a sense of movement to the pictures you capture. This is where you'll really benefit from a camera with large memory buffer so you can keep shooting without the camera stopping to catch up.

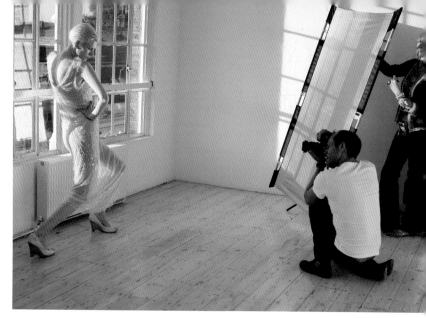

Right: Using natural daylight means that particular areas are lit best at different times of the day. You have to be flexible where you shoot.

Below: Open-plan daylight studios are often converted warehouses. You can shoot in various areas, according to the light.

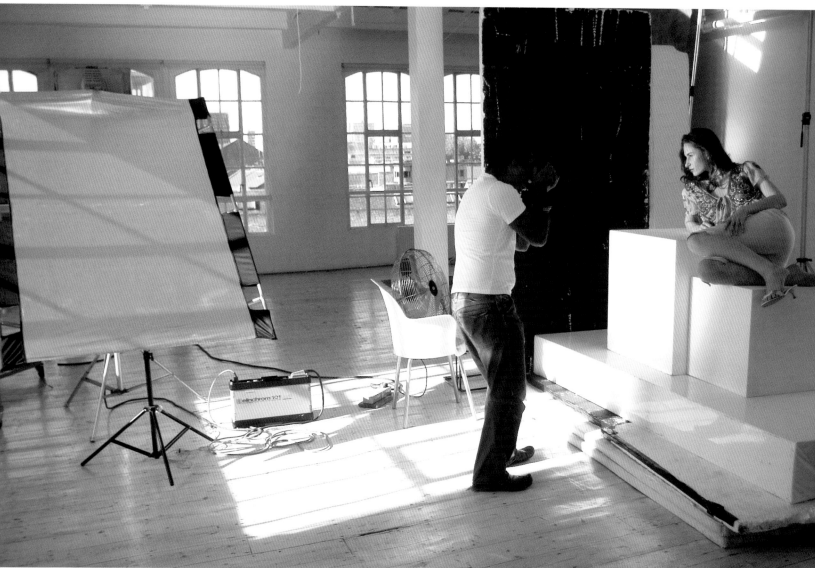

DAYLIGHT STUDIO

There is no better shooting environment than an open studio space with natural daylight streaming in on a sunny day. The light is flattering and your models will look wonderful. The only drawback is that the quality of light you're going to get on a particular day is unpredictable. If it's a cloudy, dull day, you may have to revert to using strobe studio flash or continuous light. If you don't own this lighting you will have to hire it, so it's advisable to budget for hiring lighting, just in case you need it.

Above right: When shooting a model with natural daylight coming from behind, you'll need to bounce the light back with reflectors.

Right: Net curtains on windows act as a wonderful diffuser and soften the light on your model.

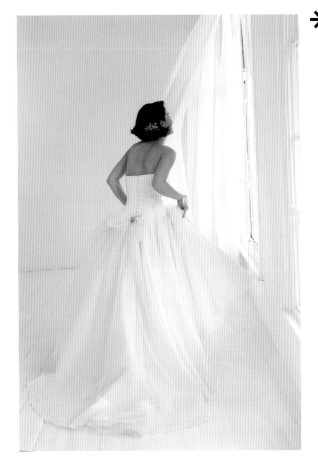

→ Daylight studios come in a couple of variations. Some are just plain studios with large south-east, south, and south-west facing windows. Others may be on the top floor of a building and have big skylight windows.

These studios offer very little in the way of backdrops, apart from background support systems for putting up either paper roll backgrounds or fabric background. They may also offer a fixed or mobile infinity cove. Infinity coves can be simply a large white wall and floor, without corners, and usually about 15ft wide and 12ft high. Alternatively, they can be a complete 3-sided room and ceiling, painted white and with rounded radius corners.

There are also "lifestyle" open-plan daylight studios, which are built inside old warehouse or school buildings. You can usually shoot anywhere in the studio. Most have very big windows and interesting architectural features to give your shots the look you would find in "lifestyle" magazines.

As with ordinary studios that are for hire, you pay a set day rate to shoot in these studios, which can amount to a lot of money. You will also pay extra if you hire lighting, use background supports stands, or any other gadgets. You even pay if you use the studio's paper backgrounds or if you ask the studio assistant to help. You will find a fridge stocked up with things to eat and drink. If you help yourself to them, you will also find them on your bill. So prepare yourself for an expensive shoot, especially if you have used anything extra supplied by the studio.

BACKDROPS

Taking good pictures is about making good choices. When you're choosing a background you have to think what you're going to do in the pictures and how you're going to do it. Your background can be sharp or out of focus, it can show elements that create an atmosphere, or use textures, or it can be pure color.

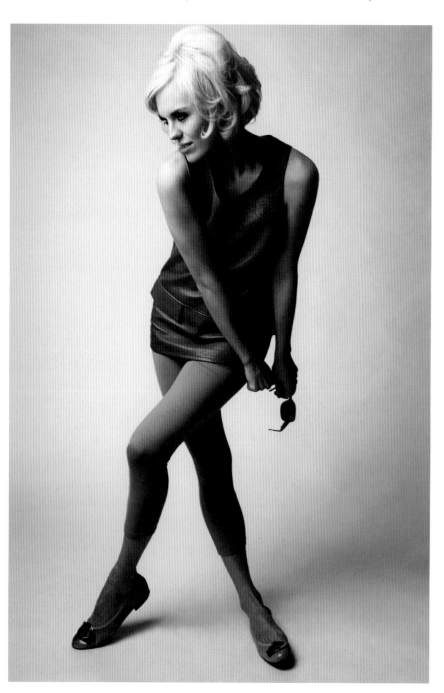

Left: This simple gray backdrop keeps your attention on the model and gives you good separation between the model and background.

→ If you're starting out as a fashion photographer, take a look at other fashion photos and see how the backgrounds relate to the subject. Do the colors complement the colors of the clothes and make the pictures consistent, or do they contrast with them? How would the same clothes look with a different background?

If you use your imagination you can create backdrops out of any material you want. You can use simple colored paper rolls, which are available in a range of colors and sizes from your local pro photo store. You will also find painted textured canvases with many colors and patterns from which you can choose. Canvas backdrops can be plain or mottled colors with painted textures, or can show particular scenes. They can be hired from theatrical backdrop companies or bought, ready made, from your local pro photo store.

Alternatively, you can use things like textured metal sheets or laminate boards, bought from your local hardware store. For example, I once took some nude shots in my apartment using some 8ft × 4ft (2.4m × 1.2m) rough-sawn timber in the background. The wood gave me a lovely texture with which to work, and it contrasted beautifully with the shapes and textures of the model's skin. I have also used plain brick walls, perhaps painted a different color, or curtain material. In my studio, I keep a box full of old curtains in several different colors and patterns; you never know when they can become useful.

If you don't want to work indoors, you can take your model outside and look for texture and color. If I'm on a reconnaissance trip for a shot, I take pictures of textures and colors. I shoot with them sharp or out of focus, all the time considering how they would look with the clothes I'm shooting. The most important thing is to choose a backdrop that suits the shots you want to take.

Above: This backdrop, painted in dark, mottled colors, provided a nice contrast to the white gown.

Left: A section of the painted backdrop used in the above shot.

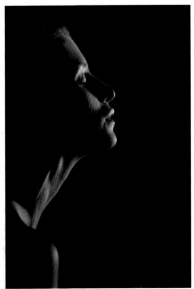

Above: In contrast to the image on the left, this shot shows the different effect of shooting against a white background. The softened shadow around the model comes from using ringflash.

Left: A piece of black cloth and a spare use of lighting is all you need to create moody shots like this one.

SET BUILDING

If you're adventurous and want to move beyond colored and textured backgrounds, you can build your own sets. All the materials you'll need can be bought cheaply from your local hardware store or timber merchants. Add a dash of imagination and flair and you will be surprised at how much your fashion pictures will benefit from a relatively small amount of effort.

→ When shooting fashion pictures, you're often cropping quite tight, so it's not necessary to build a complete room set. Sets can be quite small, perhaps consisting of a fake window or a couple of corner panels to create the illusion of a model being in a room.

Some very effective sets can be created with just a few large 8ft x 4ft panels of rough cheap timber and some 2in x 1in planed timber to use as a frame. You can build a basic L-shaped set out of two flat boards for walls, or three if you want a floor, and simply paint them or cover them in wallpaper.

If you're thinking of making your own set, you have to plan it carefully. It's often useful to build a scaled-down model of your set in cardboard. This will help you plan how to shoot the images, and will be useful if you employ a set builder to do it for you. Having some basic carpentry skills of your own, or a friend with those skills, is a definite bonus.

It's worth remembering that your set doesn't need to be in sharp focus; you can use it out of focus and simply give a suggestion of background colors and shapes.

Building sets is all about making your pictures more interesting for you and your client. It's about using your imagination to create something more eye-catching and individual than you would if shooting against sheets of colored paper.

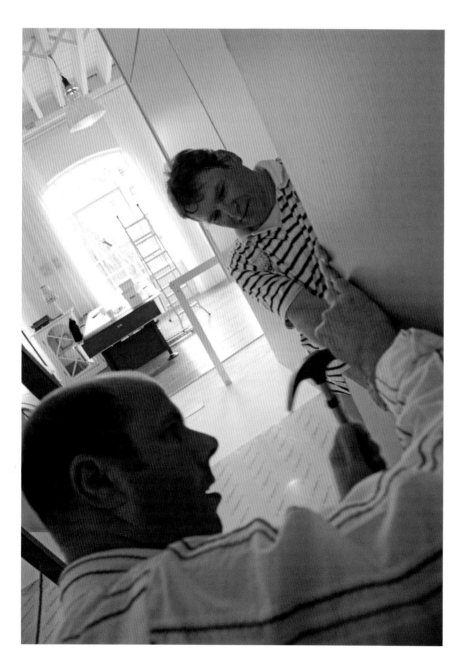

Left: Very effective sets can be created with a few simple panels and some imagination. More complicated sets can be created by professional set designers.

Right: This shows a typical studio set using a mottled fabric background attached to wooden panels and used as a backdrop on a rail.

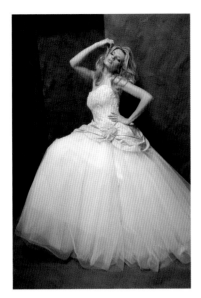

BRIDAL WEAR SHOOT

The painted set that I built for a bridal-wear fashion shoot was made with materials bought from a hardware store. I put it together in about four hours on the day before the shoot, for a very reasonable cost.

First, I decided how I wanted the set to look and did a rough sketch for the design. Then I built a scaled-down model from cardboard. This enabled me to get the sizes and positions of the panels worked out before I started building. I bought four 8ft x 4ft pieces of block board timber, which is cheap building material used in timber-framed houses. I painted it gray and added a black mottled effect with a paint roller. Then I drilled and screwed stays, made from 2in x 1in planed timber, on the back to support it. Together with a canvas backdrop that became a simple but effective set for the shoot.

–
–
–

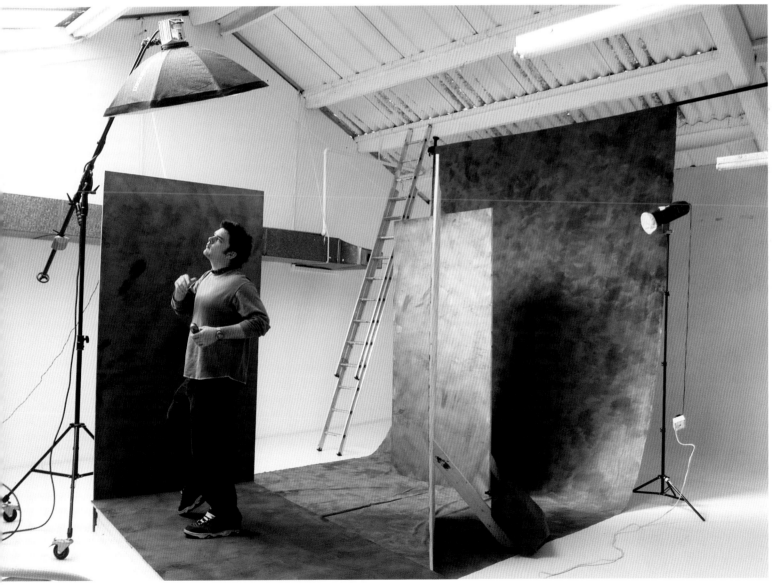

PROPS AND ACCESSORIES

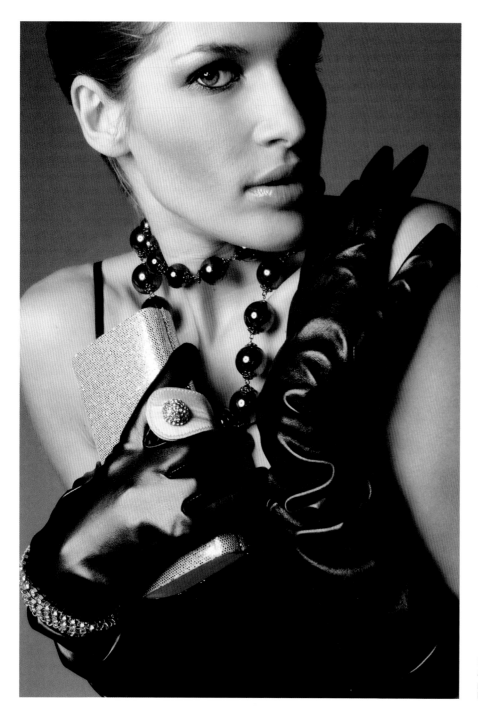

Props and accessories can make or break a fashion shoot. Giving a model something to do, or something to sit on, can give a picture life and meaning. Pictures shot against a plain backdrop can work very well, but adding some imaginative scenery using props and accessories can add a whole new meaning to your images.

Professional fashion photographers rely on stylists to source props and accessories on a shoot. Stylists obtain them from prop houses or have them in their own collection of items. However, if you don't have that resource, you have to work your pictures around what you can find for yourself. Borrow items from friends and relatives, or rummage through junk shops, flea markets, and yard sales. You may find something that is exactly what you need for a particular shoot, or something that provides the initial inspiration for an idea.

Left: The gloves, bag, and necklace are all accessories that help make a picture work. They are sourced by beauty stylists on professional shoots.

"FEMME FATALE" SHOOT

This image, which I shot in my apartment, was created by making a set and sourcing the right clothes, props, and accessories. Essentially, it was created out of nothing and inspired by a 1950s-style dressing table, which I used to set the basic theme for the finished shots.

Added to my dressing table, I built a C-shaped panel out of 2in × 1in (5cm × 2.5cm) timber with a dozen small light bulbs and holders screwed onto it. I then painted it with flat black paint. I put the home-made lighting rig around the mirror to make it look like a star's dressing room table at a theater.

The story for this shot was about the fantasy life of a "Femme Fatale" showgirl, and I had to create the right atmosphere. To set the scene, I asked my stylist to find lots of women's dressing table items, such as perfume bottles and make-up brushes. I also asked her to find a decorative screen, over which she could place a black and red kimono. She sourced the beautiful lingerie, plus the hats and various other accessories, from a designer. All these items helped to make it look like an authentic dressing room scene and complete the look that I wanted to achieve.

The final essential element was great a model that could act out the role of the showgirl, and I found her at a top model agency.

The only lighting I used came from the light bulbs around the mirror. I took the shots using a high ISO so I could shoot with the light from the light bulbs. This results in digital noise that is very similar to film grain, especially with the help of a Photoshop filter.

The success of these shots resulted from the efforts made by myself and my stylist. Deciding on the theme and finding the right model were important, but those extra touches added by the props and accessories made the shots extra special.

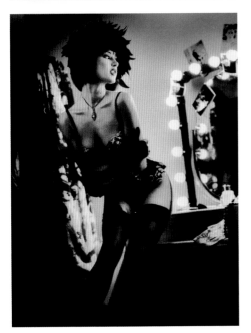

Right: The accessories in this picture help to create an atmosphere and tell the story. In this case I was trying to create an image of a 1930s archaeologist.

PREPARING FOR A SHOOT

Once you have assembled your team, you need to have your ideas ready to show other team members. You should do that even if you are shooting fashion photography test pictures for your portfolio or a model's portfolio. The best way to do this is with tear sheets from magazines, along with sketches and your own photographs to use as examples. It's best to brief all team members at the same time, so every one has the same information.

→ ### CLOTHES
If you have not already got the clothes for the shoot, ask your stylist to take some photos of the items you're going to use. If you're new to the fashion business and shooting "test" pictures, you must ask the client to bring along a variety of items of clothing from which you or your stylist can select. Avoid bold colors, stripes, and patterns, especially those of a particular style that will be out of fashion in a year.

PURPOSE & THEME
Before you brief your team, give them an idea of what your story is about. This allows them to be prepared and contribute to the meeting. Write a brief but informative storyline. You should decide the purpose of the shoot. Is this story intended to sell garments, accessories, hair products, or cosmetics? Is it a portrait session? You must decide why you're shooting the pictures and plan your shoot accordingly.

You also need to set a theme, whether it's about color, different types of fabric, texture, or a certain type of print (e.g., stripes, flower prints, or animal skin, perhaps leopard or zebra).

STORY BOARD
Take every aspect of the proposed shoot seriously. Make notes, draw pictures, have as many sketches, marked pages of books and tear sheets as you can find. You should also shoot snaps of the products that you plan to photograph, along with snaps of accessories. All of the elements, such as the model, location, styling, garments, hairstyles, make-up, products, accessories — and, most importantly, your style and approach to your photography — have to fit together, or your story will be fragmented.

Make up a storyboard of cuttings and tear sheets that show poses, type of model, type of location, type of lighting, style of makeup, and style of hair. These don't have to be the same as the ones you're using, they simply have to reflect the mood and feeling for your pictures or story. You need to get the story over to your team. They will want to know what you want, so you have to be prepared.

THE BRIEFING
Treat this briefing as an open discussion, a brainstorming session about photography and about the story you have in your mind. Your team members must be on the same wavelength. They will want to be, or already will be, established in the fashion business and will want new pictures in their portfolios. They will have thoughts and ideas of their own, so listen to them and let your ideas develop and blend.

After this meeting, you will have finalized your story in as much detail as possible. Therefore, when you do your shoot, both you and your team members will be clear about your own personal contribution.

SHOOTING ORDER
Before the shoot, you, as the photographer, must make a decision on the order you will shoot the images. Plan to start with a simple one. This will be the benchmark for the rest of the shots. They must all fit together to form a cohesive whole in terms of look, style, and atmosphere, and so should the garments and accessories. The more decisions you make before your shoot day, the more you can concentrate on the photography.

Left: An open discussion between you and members of your team will help to talk through ideas and thoroughly prepare for a shoot.

LIGHTING

Photography is all about lighting. Without light, you don't have pictures; you don't have color, brightness, shade, contrast, or texture. In order to understand photography, you have to understand light and ways of manipulating and controlling light.

This chapter is devoted solely to lighting techniques for fashion photography. I have illustrated my descriptions with my images and, where necessary, simple-to-follow diagrams. I hope they will inspire you to practice for yourself.

I will describe every type of lighting that you're likely to use in fashion work. It will include direct sunlight, continuous light, and studio flash. I will look at techniques of shooting with bounced light, direct light, diffused light, and fill-in flash, plus shooting with diffusion screens and reflectors.

There are many ways in which you can light your fashion pictures. There are no rules, just the choices you make, good or bad. The more good choices you make, the better you become as a fashion photographer.

I will talk about the lighting I use in my own work, but you need to practice and adjust the way you personally work with light. This will help you develop your own methods and techniques. When you are proficient at lighting, you will be able to develop a style that is distinctively your own.

STUDIO FLASH

The main advantage of working in a studio is that you have total control over your lighting and backgrounds. Unlike working on location, where you are restricted to using the equipment that you can transport, you have your full armory of equipment at your disposal. You can use a variety of lights, softboxes, modifiers, umbrellas, beauty dishes, reflectors, and diffusers.

→ You can choose your backdrop from a wide variety of colors and you can build your own sets if you wish. You don't worry about wind blowing your model's hair around or the sun being in the wrong position. The disadvantage is that some studio work can look stilted and staged. I personally prefer working with daylight, but fashion work often involves using strictly controlled studio conditions.

Studio setups can be complicated or simple. It's your choice. I like working with simple setups with only one or two lights. The shot on the right, for example, was taken using a very basic lighting setup, using a 500 watt monobloc light and a medium sized softbox. I set up the light to one side of the model, slightly above her and pointing down to light her face. The light was quite close to her face, giving a contrasty effect, and making it stand out from the greater range of tones visible in the dress.

Left: This shot of a model in the studio was taken using a modified studio flash in which I had used silver foil as a baffle in the flash head, to diffuse the light. There are also two lights behind the panels in the background.

Below: It pays to double-check the background is evenly lit to be white, as well as the Perspex floor. You will have a reflection in the floor this will help to ground your model, so that they do not look like they're floating in mid-air.

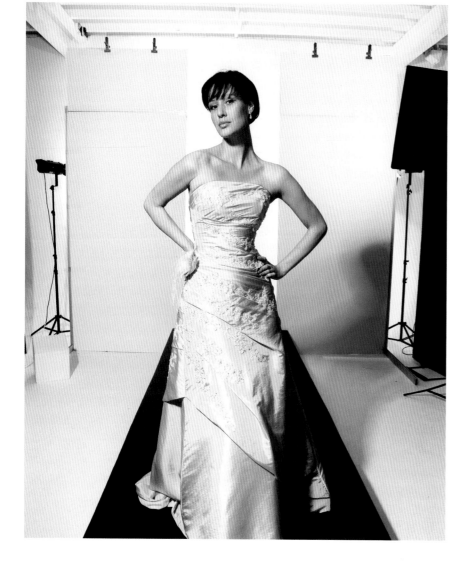

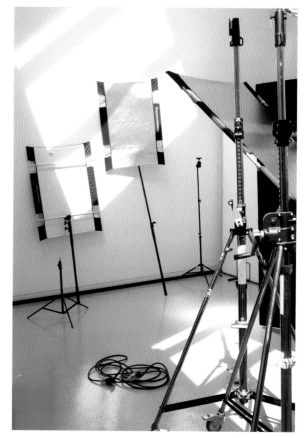

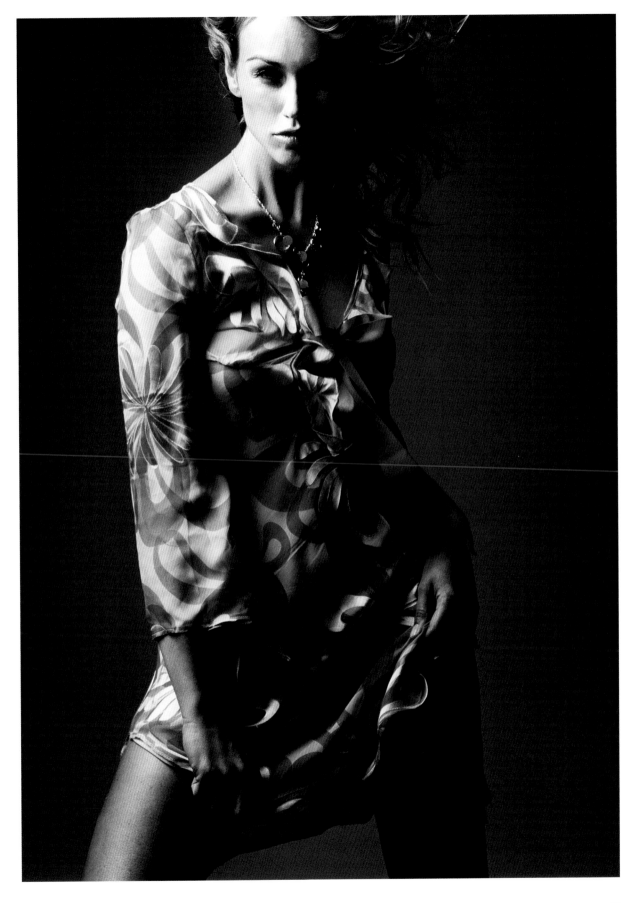

Right: You can make your studio shots as simple or as complicated as you wish. I like to keep things simple, as I believe this approach helps create the most effective shots, and this is a great example.

THE CLEAN, WHITE BACKGROUND

Every fashion photographer has to be able to set up a clean, white background. Look in any magazine or catalog and you'll see pictures shot against a "clean white." For example, the designer may wish to use cutout pictures of models to run copy around and use in a creative way on the page. They don't want a cluttered or colored background for those pictures.

→ You may think that setting up a clean white background sounds a simple task. But achieving clean, white background from front to back is one of the most complicated lighting setups you are likely to do. It has to be arranged with a scrupulous attention to detail. When I teach studio lighting classes, we spend the first two days working on getting a clean, white background for the shots.

One of the good things about using a clean, white background is that once you have it set up, you can light the subject any way you like and it will always remain the same. The picture of a girl on this page was shot using an Octa light as the main light. It's quite soft light but I've given it a punchy edge by using a black 8ft × 4ft poly board to the left of the model. If I had used a white poly board, it would have filled in the shadows.

On the next two pages, I explain exactly how to set up a clean, white background.

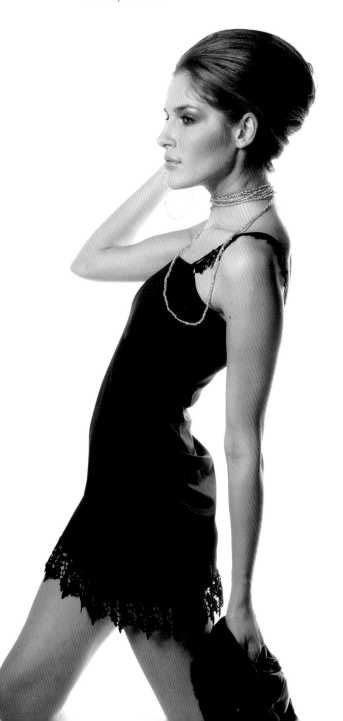

Left: Being able to master the technique for a clean white background is an essential skill for any fashion photographer.

Below: A simplified version of the lighting arrangement. Note that there are four lights pointed at the screen behind the model.

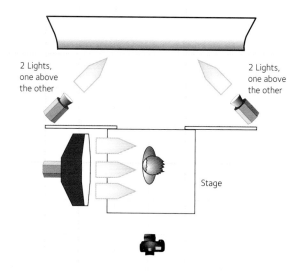

2 Lights, one above the other

2 Lights, one above the other

Stage

LIGHTING

Right: This model was photographed using ringflash on the camera. It gives a bright, even illumination which goes well with the clean white background.

THE CLEAN, WHITE BACKGROUND

HOW TO SET UP A CLEAN WHITE BACKGROUND

EQUIPMENT

4 flash heads all of the same power output

4 small softboxes or 8in reflectors

2 medium lighting stands

2 bow claps with spigots

A 9ft (2.7m) wide white roll of background paper, at least 15ft (4.5m) long

1 8ft × 4ft (2.4m × 1.2m) sheet of clear or opaque plastic polythene sheet (Perspex)

1 8ft × 4ft sturdy table top, with legs around 2ft high

4 sheets of 8ft × 4ft × 2in (2.4m × 1.2m × 5cm) polystyrene boards, one side white, the other matte black

→ METHOD

1. Set up the 9ft (2.7m) wide white paper backdrop as high as your studio will allow, ideally 15ft (4.5m) high. Aim to have at least 4ft of clear space on either side. Allow the bottom of your background paper to run a couple of feet along the surface of the floor.

2. Set up a low tabletop, one that's at least 8ft (2.4m) wide by 4ft (1.2m) deep and about 18in to 2ft (45–60cm) off the ground. Place this table about 8–10ft away from the background, parallel to the backdrop. Place a spare piece of white background paper on the table top covering it all.

3. On top of this place the 8ft × 4ft sheet of clear polythene or Perspex, making sure it's very clean on both sides. Use gaffer-tape to stop it moving around.

4. On either side of the table top, at the back corners, place one of the sheets of polystyrene. Arrange them so that the side that is painted white is facing the backdrop the matte black faces the table. It should stand vertically, running parallel to the line of the back of the table top.

5. Now make a mark low down on the floor at the center of the backdrop. From this point, mark two lines that are exactly 45° to the backdrop, one to the right and one to the left. At the point on this line that's around 8ft (2.4m) away from the backdrop, place one or two medium light stands

6. Set the height of each stand to 6ft. Place the bow clamp 3ft from the floor. Place a flash head on the top of each stand, plus a head on the spigot/bow clamp. All should be pointing directly at the middle of the backdrop, set at exactly the same height and angle (45°) and the same distance from the backdrop. It's very important to set this up equally on both sides.

7. Turn all the flash heads on at full power. Take a reading in the middle of the backdrop with your meter's back touching the background paper and pointing the invacone toward the front/middle of the table. Take a reading. Adjust the flash heads' power until you get a reading of ƒ16.5. Now take readings in all corners of your background paper. The objective is to have an even flash reading with no more than one-tenth of a stop out at any point on the background.

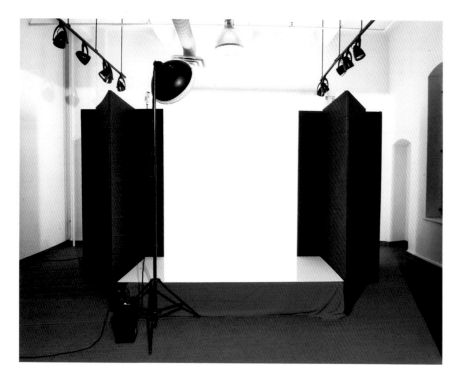

Left: Setting up your equipment in this way, and carefully following the method I describe, will give you a clean, white background to your shots.

8. Now position yourself with your camera set to 1/125sec at *f*11, facing the background with the table in front of you. Stand approximately 10–15ft (3–4.5m) from the near edge of the tabletop, dead centre. Looking through your viewfinder, frame a perfectly vertical shot so you can only see the white background, but get all of it in as well as the top of the table. Don't worry if you have a little of the black polystyrene boards in the frame. Take five bracketed shots at *f*8, *f*8.5, *f*11, *f*11.5, and *f*16.

9. Transfer these images to your computer and examine them closely to make sure your background is evenly exposed, giving you a perfect white picture at *f*11. Look at the darker exposures too; they will show you if it's unevenly lit. You don't want extreme light or dark points. Look at the bottom of the shots; you should also have a clean, white table top.

10. Now you are ready to set up your front or main key light (I like to use a large Octa light). Set up your key light high up and from the side of where your model will stand or sit on the polythene-topped table. Place it as close to your model as you can, before it comes into frame.

11. Stand in the middle of the table top, facing the camera position, to take a flash reading pointing toward the camera position. You need to set the power of the main key light to give you *f*11. At this point, place a lighting stand on the table top and take a shot at the same five bracketed exposures. Examine them on the computer to make sure you're getting a very sharp image of the stand, without any light flaring or wrapping around from the background lighting.

12. Finally, double-check that your background is evenly lit to be as white as the Perspex floor. You will have a reflection of the stand in the floor. This reflection will help to ground your subject, so it does not look like it is floating in mid-air. And the background to your shots will be perfectly clean and white.

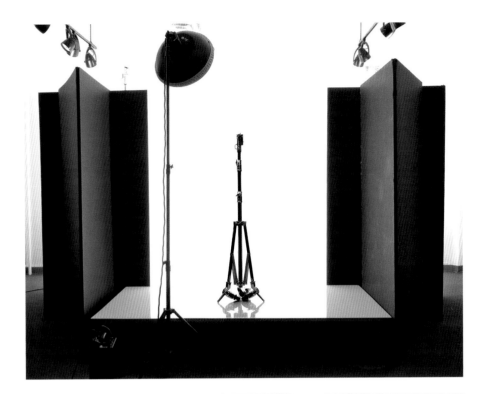

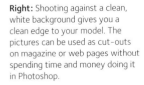

Right: Shooting against a clean, white background gives you a clean edge to your model. The pictures can be used as cut-outs on magazine or web pages without spending time and money doing it in Photoshop.

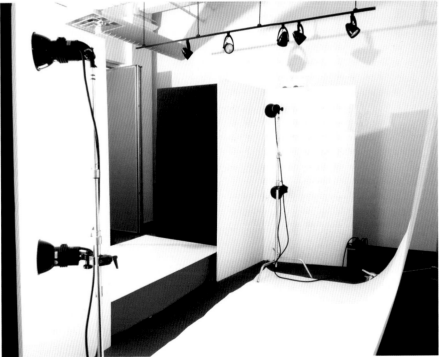

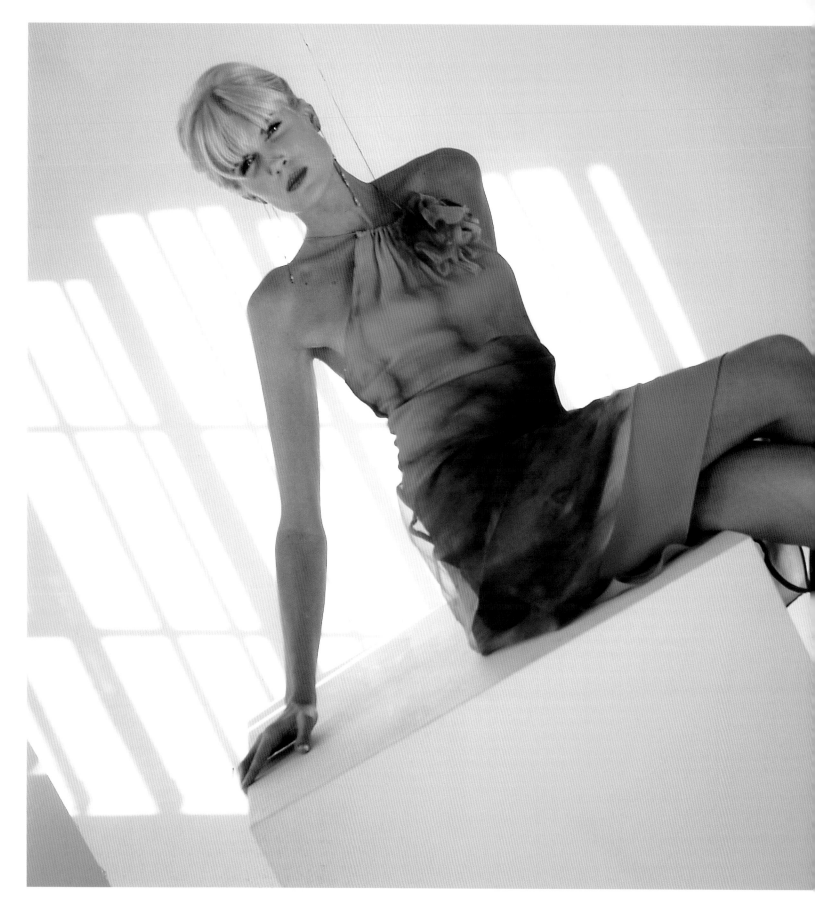

LIGHTING

DAYLIGHT STUDIO

Daylight studios have natural daylight coming in through large windows or skylights. For me, you cannot beat using natural daylight, so these studios will often be my preferred option. Shooting with available light is quite liberating. You simply place your model in the best natural light, reflect or diffuse the light, and shoot. There's no electronic flash to cause technical issues such as sync-cables not working, fuses blowing, or slow recycling times.

→ However, when you're using a daylight studio (see pp. 46–47), you're using a light source that varies in intensity and changes throughout the day. You will usually need to control it, especially when it is strong sunlight. You can diffuse it using scrim over the windows, or you can position your set/model so that you can bounce and soften the direct sunlight using reflectors. Flare can also be a problem, so shoot with a lens hood.

You have to work out the best times of day to photograph your models in different areas of the studio. For example, the lovely shafts of sunlight on the wall in the background to this shot add to the atmosphere, but an hour later they would be in a different place or gone altogether. Be careful with your exposure when there are bright sunlit areas in the frame. Take an incident light reading from the dress, or a reflected light reading from the model's face.

A lot of daylight studios are equipped with mobile infinity coves (a curved backdrop with no obvious edge), and you can simply move them around to areas with the best light. You can try mixing natural daylight with a continuous light source, such as HMI's. This light can be used direct, diffused, or bounced to great effect. However, I find that using natural light and reflectors is the best method, and that's what I did to light the model in this shot.

Left: Shooting in a daylight studio is great for "lifestyle" shoots and bright, natural-looking images. You'll often need to use reflectors to bounce the daylight where you want it, as I did in this shot.

DAYLIGHT STUDIO WITH FLASH

The natural daylight coming into a daylight studio may be all you need for a shoot, particularly when supplemented with modifiers such as reflectors and diffusion screens. However, if you want to work in any part of the studio, or daylight levels are low, you may need to supplement daylight with flash to brighten your shots a little.

→ To add a little fill-in flash in this situation, set up two low output heads, with 125-watt or 500-watt power output. I always tend to shoot at around $f4–f8$ to isolate my garments from the background. I keep that aperture constant and adjust my lighting rather than my camera settings.

In the picture to the left, the daylight coming through the windows has been softened with some net curtains. I have set up the flash heads and bounced the light from a wall or a ceiling. This avoids the fill-in flash coming up at the model and creating an unflattering light. I have taken the highlight reading from the ambient light, then set the power output so that I'm working at 1½ to 2 stops under the highlight reading.

For example, if I have selected camera settings of 1/125sec at $f5.6$, I set the power output on the flash head to give a flash reading of $f3.3$ or $f2.8$. Using low power on your flash allows you to work more quickly, as it recharges much faster. Accuracy is important; if I set my power at just one stop below the highlight reading, it will be bright enough for people to see that I've used fill-in. At 1½–2 stops below, the flash will be effective but untraceable. Here, the flash has given a very subtle lift to the shadows on the girl's face and on the dress.

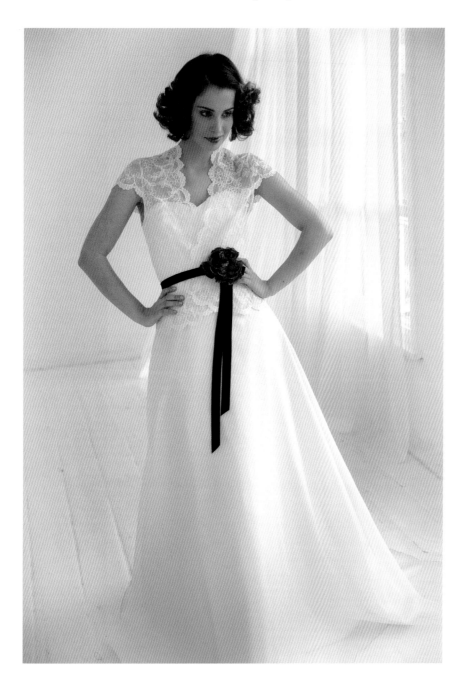

Left: These were both shot in the same daylight studio at different times of the day. This shot was taken in such a way that the lighting from the windows had the majority of the effect.

Right: This shot was taken allowing more of the fill in flash exposure hitting the model. If I had not used fill in flash the background would be very bright and the models front would be in shadow.

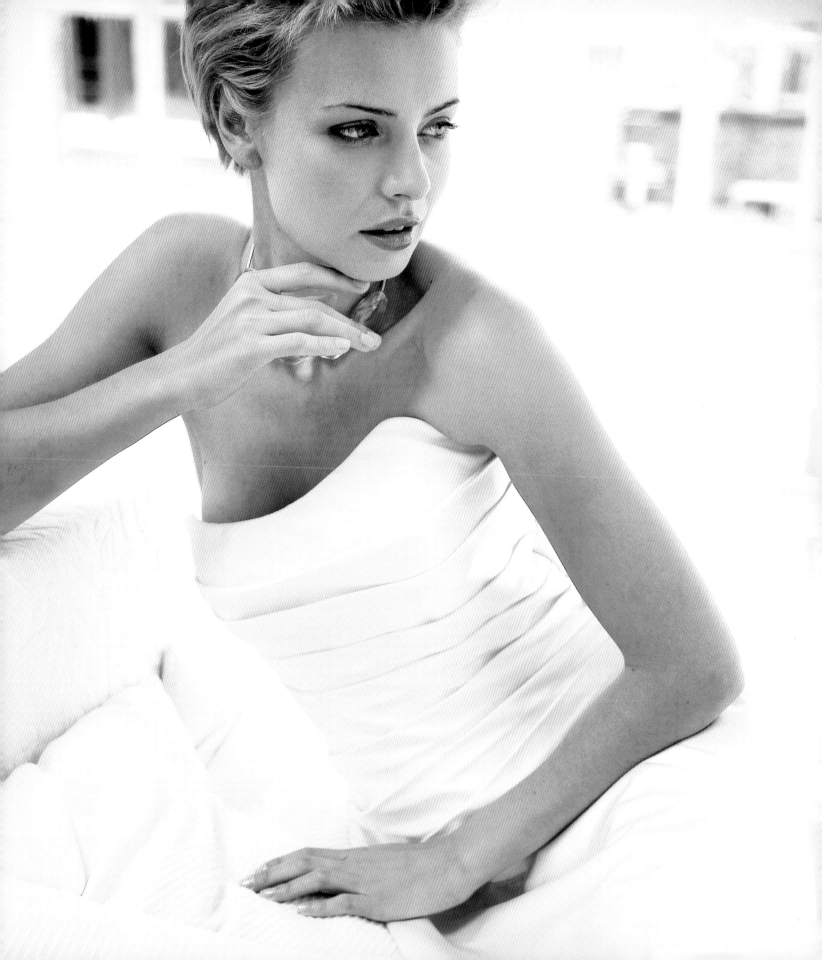

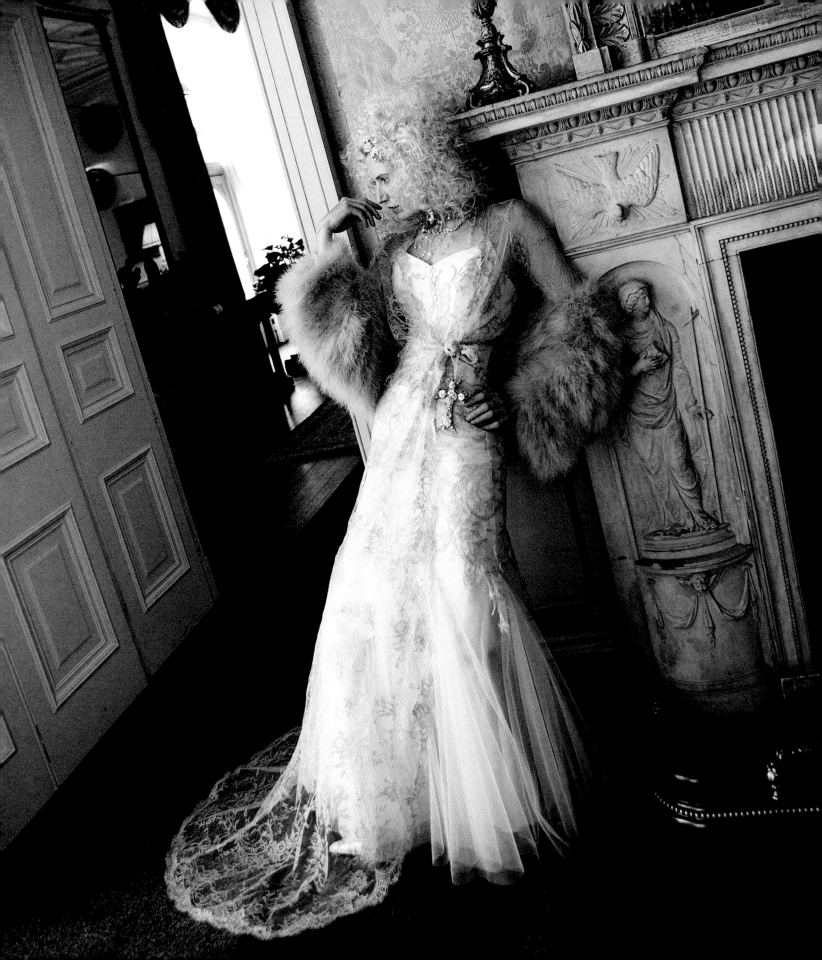

INTERIORS WITH FLASH

When the light is too low to use in an interior location, you need to use a location lighting kit (see pp. 16–17). The aim is to set your lights up so that you get a replication of what daylight would be like. You can use just one light, either to create an ambient light on the areas behind the model or to light the background. You can use that light directly, or bounced from ceilings or walls.

→ Alternatively, you could use a snoot to highlight a certain area. The main source light on your model could be a ringflash, or an open head inside a reflector, a softbox, or a beauty dish. Personally, I don't ever shoot with umbrellas. I think it's the most horrible-quality light that there is. If I'm mixing soft light through windows I might use a shoot-through umbrella and put that in the same spot as the windows. That gives you a nice replication of what daylight would be like.

There's a little daylight in this interior location picture, but it's predominantly lit with flash. I have used one flash head bounced from a wall that's out of shot to the left of the frame. This has lit the wall behind the model. Without the flash, that wall would have gone into shadow. Then I have used a second light that was coming from behind my left shoulder, bounced from the ceiling and onto my model.

Left: I used a small compact flash attached to my cameras hot shoe with the flash head pointing to bounce off a window with net curtains just of the shot to the left. This gave a soft, natural-looking window light on the model.

Below: This was part of an editorial shoot, produced in a London hotel. I had to work out which were the best rooms and the best times of the day to get the best light. I had to use fill-in flash for all of the shots, this I bounced of nearby walls and ceilings to create as natural-looking lighting as possible.

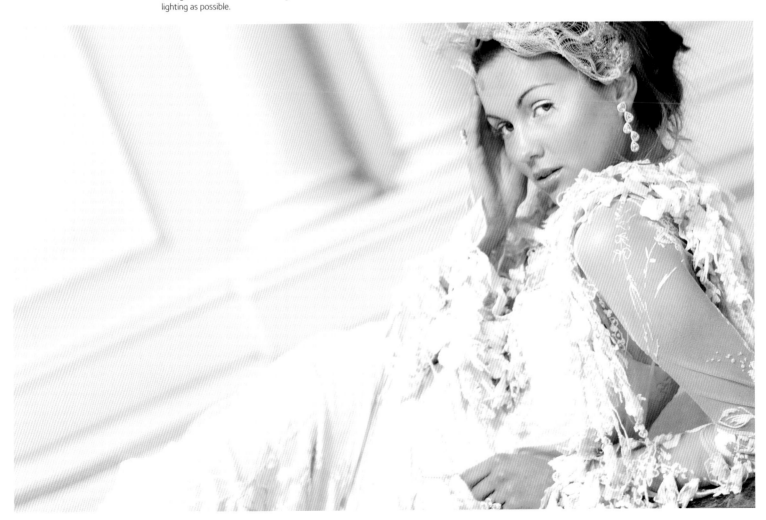

INTERIORS WITH DAYLIGHT

Shooting your model in an interior location using only available light will usually give a soft and flattering look to your pictures. Even shafts of early morning light, which can be quite hard, are softened by passing through windows that aren't particularly clean, or by net curtains. Also, if you're shooting at an old property, you'll find that old glass diffuses the light more than the glass in modern houses.

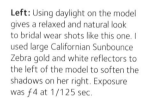

This light is great for creating a mood. The disadvantage is that it's inconsistent and changing all the time. Furthermore, the softness and relatively low power of the light makes it difficult to get great depth of field in your shots. I often work at ƒ4 or ƒ5.6 in this situation.

You also have to remember that the light is moving all the time, so you have to work in specific areas at specific times. If you're working at a location for the whole day, plan your shooting schedule according to the light's direction at different times of the day. Shoot in east-facing rooms in the morning, south-facing rooms in the middle of the day and west-facing rooms at the end of the day.

This image was taken at the end of a day's shoot. It was simply lit with daylight from the window and a reflector on the left hand side to bounce light onto the model. I didn't use fill-in flash to light the background as I wanted to retain some darkness in the shadow areas to give the shot atmosphere. At the same time, I wanted to position my model so that she facing the window and being lit with flattering light.

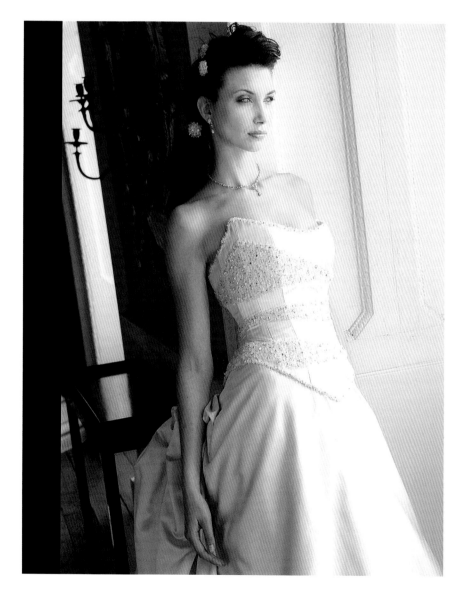

Left: Using daylight on the model gives a relaxed and natural look to bridal wear shots like this one. I used large Californian Sunbounce Zebra gold and white reflectors to the left of the model to soften the shadows on her right. Exposure was ƒ4 at 1/125 sec.

Right: When you're anticipating good shooting locations, bear in mind that the sun will be higher in the sky at midday so the direct light will travel downward as in this shot. To get the mood I exposed for the sunlit part of her face, and used a couple of reflectors to fill the shadows Exposure ƒ5.6 at 1/125 Sec.

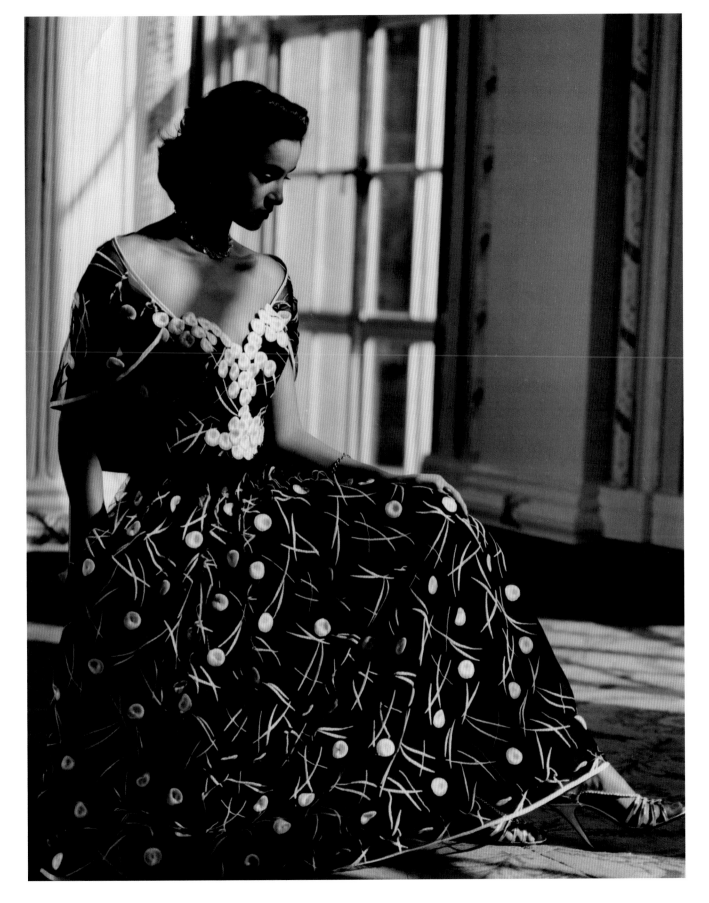

INTERIORS WITH DAYLIGHT

INTERIORS WITH DAYLIGHT AND FLASH

When you're shooting interiors with daylight (as with using a daylight studio) you sometimes need to supplement the natural light with flash lighting. You can use flash as fill-in on your model, or purely for lighting the background.

→ In this picture, the predominant light is daylight. The model is wearing a Vivienne Westwood dress and I photographed her in a corridor at the Grosvenor Hotel in London. However, the daylight wasn't strong enough for me to simply use reflectors to light the dress. Therefore I used a small 250-watt flash head, which I used with a reflector on it and

bounced it off a white vaulted ceiling. I took a reading from the light coming through the window and set my flash at two stops under the ambient reading. This has lifted the shadows and enabled me to get all that detail in the folds of the dress, without losing the natural look given by the daylight.

It's worth remembering that when you're shooting a fashion story using a mixture of lighting sources, you should ensure that the lighting setup is consistent in all the shots, whatever location you're using. If you're aiming to shoot 12 shots and you light all the pictures differently, they will look like 12 shots from 12 different stories and your collection of pictures will lack continuity.

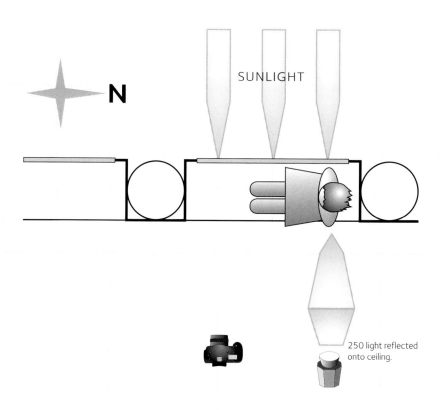

SUNLIGHT

N

250 light reflected onto ceiling.

Right: I took an ƒ4 at 1/50 sec reading from the light coming through the diffused windows. I placed a flash head high up opposite to the window, bouncing off a vaulted ceiling. I set the power very low to give me a flash reading of just ƒ2, which was taken by my model, pointing the light meter toward the source of the bounced flash light.

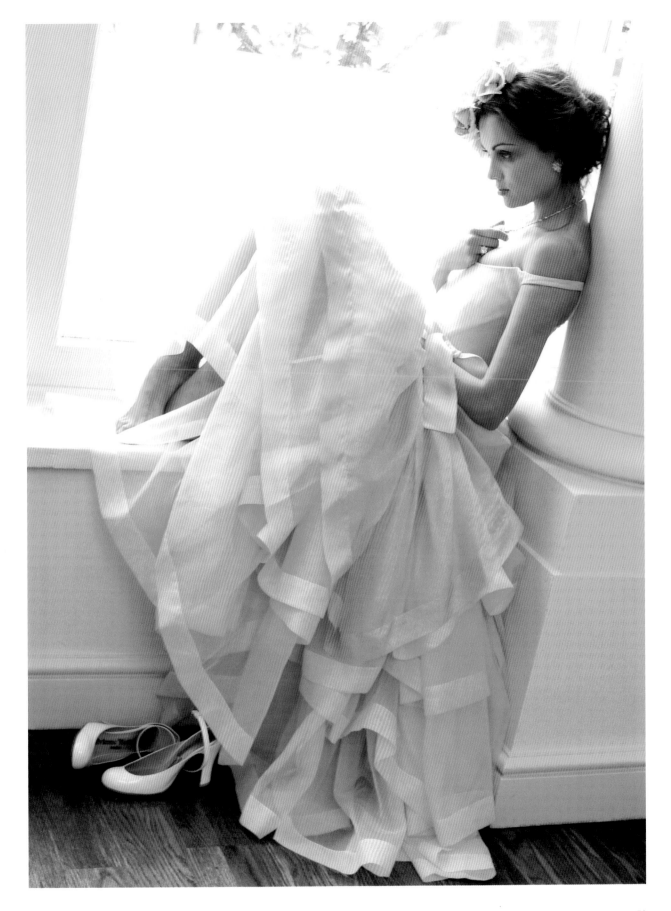

DIRECT SUNLIGHT

You can use direct sunlight as side light, back light, or front light. As I said in the section on Times of Day to Shoot (pp. 38–39), the best times to shoot using sunlight are at the beginning and end of the day. In the hour or two after sunrise and before sunset, you've got more UV haze and mist in the air and the light is more diffuse. You can make this light even more flattering by using diffusion screens or reflectors to manipulate the light (see pp. 84-85).

→ Early morning sunlight gives a beautiful, warm, crisp light on your model. It's still flattering but there's a bit of zing to the pictures. Sunlight's still giving a warm light at the end of the day, but the light levels are starting to drop. If the levels are getting too low, you can use a hammerhead flashgun off-camera, or a travelite, and bounce it off a gold or zebra/gold reflector at low power as fill-in. You should take a reading from your highlight and use the flash at 1–1½ stops down. That makes your fill-in flash look like sunlight.

This picture of a model against a blue sky background was taken in the late morning with direct sunlight coming from directly behind me. I'd usually say that you should avoid shooting at this time as you can have hard shadows where you don't want them. It's a dangerous time to shoot. However, in this case I wanted a harsher light with vibrant colors, which I have accentuated with a polarizing filter. I used foil and gold reflectors to bounce light onto her face and soften the shadows.

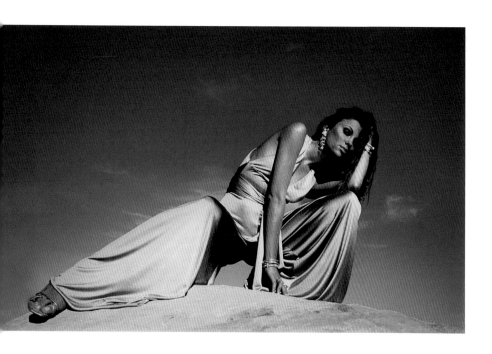

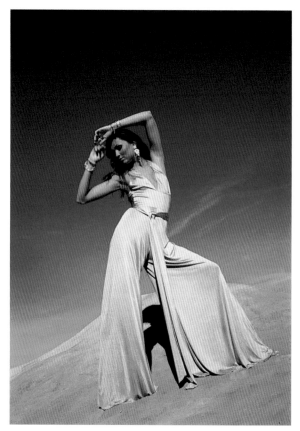

Above & right: It's important to keep your fashion images looking similar in technique and style if your shooting a magazine fashion editorial that's needs continuity so the pictorial story flows and holds together.

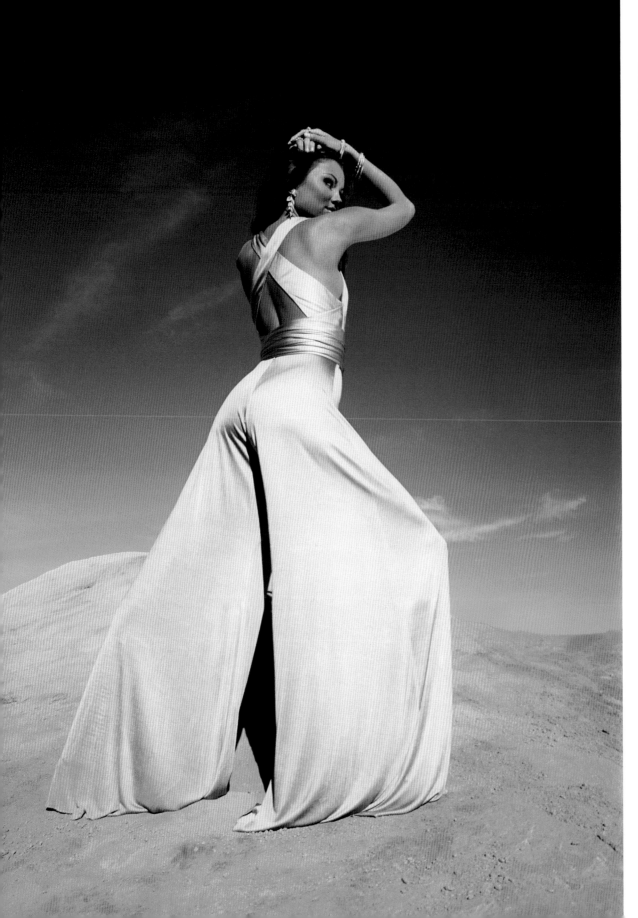

Left: For this shoot I shot every outfit using the same gold foil reflectors, a polarizer on my lens and kept my exposure values as close as I could for each shot. These shots were all taken with mid-day sunlight hitting the front of my model with a gold foil reflector (being held by my assistant down and to the right of my camera position), bouncing some light into any shadow areas. The deep blue sky and enriched tan on my model are effects created when shooting through a polararizing filter.

BACK-LIT SUNLIGHT

Using the sunlight to backlight your model can give an eye-catching and sometimes dramatic effect in your pictures. However, you have to be careful to get your exposure right. If you took a general reading from the scene, the sunlight would have a major influence on your exposure. Your model, and everything else in the foreground, would go into silhouette.

→ You also have to watch out for flare in your lens, which can be cancelled out by using the correct lens hood for your camera or asking your assistant to use something to block out the sunlight on the camera. Alternatively, if possible, shoot from a shady position — under a tree, for example.

I shot these images at around 2 PM, when the sun was high in the sky. The scene was entirely backlit through the gate, with sunlight coming slightly from the left. I took my exposure reading from the shadow area, to ensure I got the correct exposure on the model's face and clothes.

Using this exposure also ensured I got a nice "halo" effect as the girl's hair burned out from behind. I asked an assistant to hold a small reflector above the lens to cut down on flare.

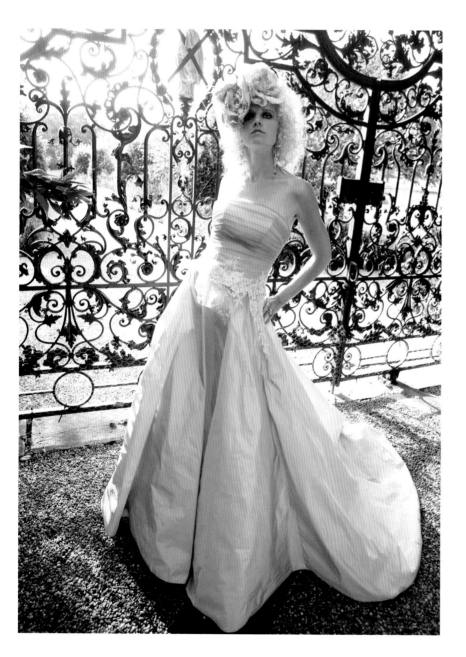

Left: The halo effect on my models hair is created by shooting with the sunlight directly behind and above my models head. You can use reflectors to bounce some light onto the models front or you can simply expose for the lighting hitting your model's face, this means the back lighting can burn out detail especially when shooting digitally, as their response is linear.

Right: You need to be very careful — a symptom of shooting back lit is a high risk of lens flare — so a lens hood or an assistant holding a flag to stop the sunlight hitting the front elements of your camera lens is very important

LIGHTING

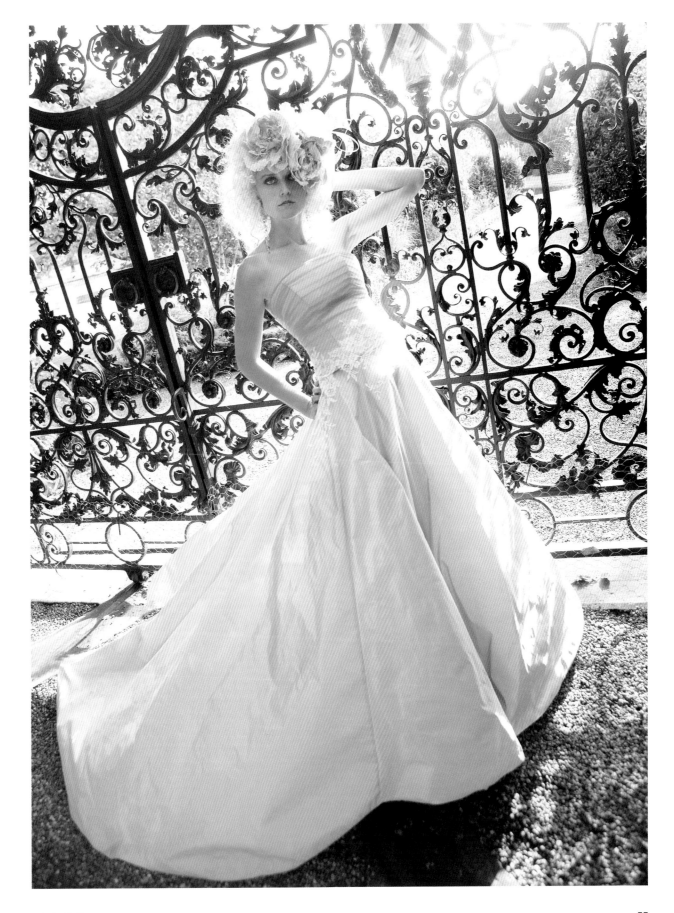

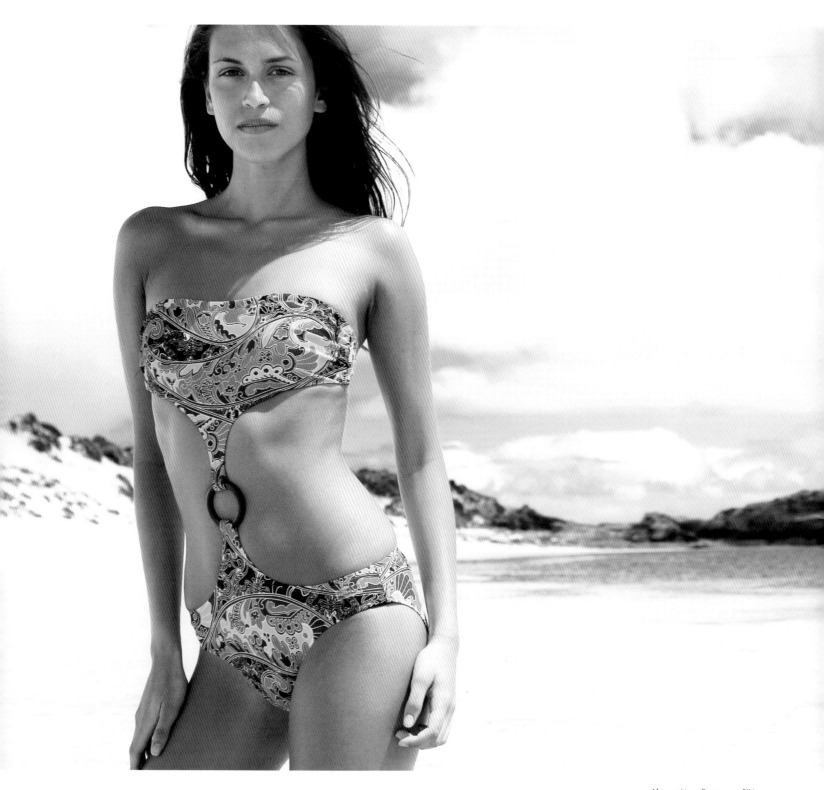

Above: No reflectors or fill in was used deliberately to create great contrast. I asked my model to walk into and out of the water then to roll around in the surf directing her as I shot. Exposure was ƒ5.6 at 1/500 sec.

SIDE-LIT SUNLIGHT

Below: This was a spur-of-the-moment shot taken on a Malibu beach California. Shot with late-afternoon sun side lighting my model. I exposed for the sunlit highlight areas rather than risk burning them out. This rendered the shadow areas very dark, but created a great moody lighting.

You can only use sunlight to sidelight your model at the beginning and end of the day, when the sun is low in the sky. It can be quite a harsh light, so if you don't want the shadow areas to go very dark, you can choose to supplement the sunlight with fill-in flash or reflectors (as I have on many other pictures in this chapter). As with other lighting situations I've described, you have to make sure you're exposing for your highlights, to ensure you're not burning them out.

→ Sometimes you can make a creative choice not to fill in those shadow areas. This shot, for instance, was taken only using the side-light from the low morning sun. I photographed the model, who was drenched in seawater, as I walked backward along the beach in front of her, shooting all the time. I made a creative choice to give a gritty, sexy look to the pictures and those dark shadows give the picture a more earthy mood. If I had wanted a less contrasty look I could have softened it with reflectors or fill-in flash. Using a wide-angle lens, as I have here, has added to the shot's impact.

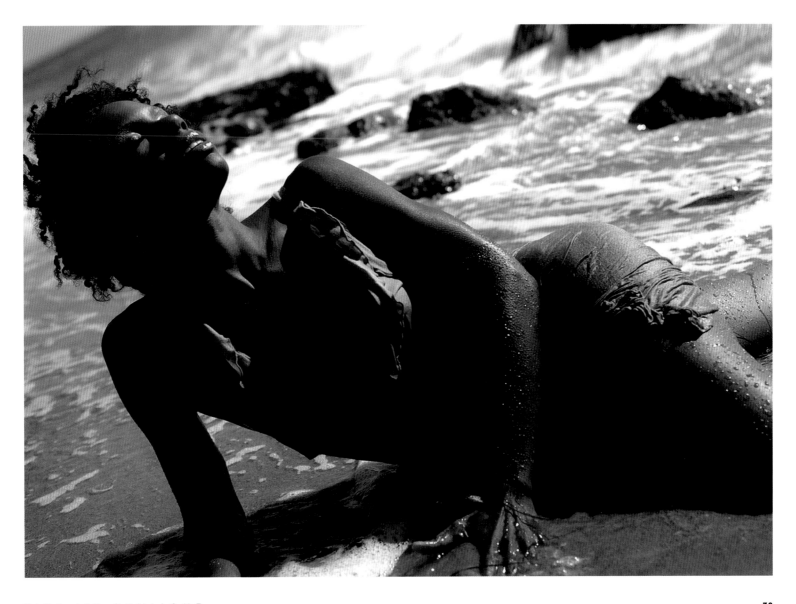

FRONT-LIT SUNLIGHT

As with side-lit sunlight, you can only use sunlight as a frontlight on your model at the beginning and end of the day, when the sun's low down in the sky. The quality of light at this time is shown in this shot, which was taken for a swimwear catalog. It was shot at about 9 AM and although the light's quite soft, there's enough brightness to give the picture a contrasty edge.

→ The shot was taken on a west-facing beach with the sun behind me and to the right. One of the good things about working with the sun behind you is that you get a nice blue sea and sky. If you shoot with the sun in front of you, both sea and sky would be recorded in paler shades of blue.

I started the shoot off with the model kneeling on the sand, and then she gave me a variety of shapes — arms up, down, and by her side, looking at the camera, then left and right. As she changed her position I was watching how the light was playing on her body. In this picture, the sun's full on her face and not throwing any shadows across it. At the same time it's bringing out the texture in her skin and drawing attention to the subject of the picture, the bikini. Some people might object to the tilted horizon in the background, but I chose to shoot it that way.

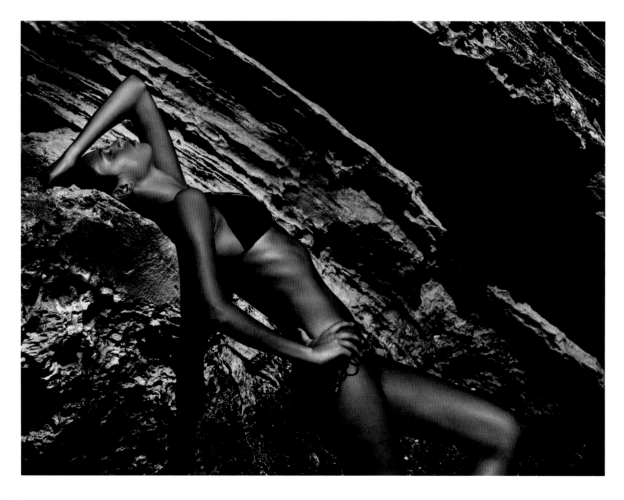

Right: When working in this situation, you have to watch where the light is falling on your model. Ask her to change position if the light's unflattering.

Left: Although there has been a degree of digital enhancement, the luscious black rocks were the main reason for this choice of location. They provide a great textured background that complements the bikini's dark color well.

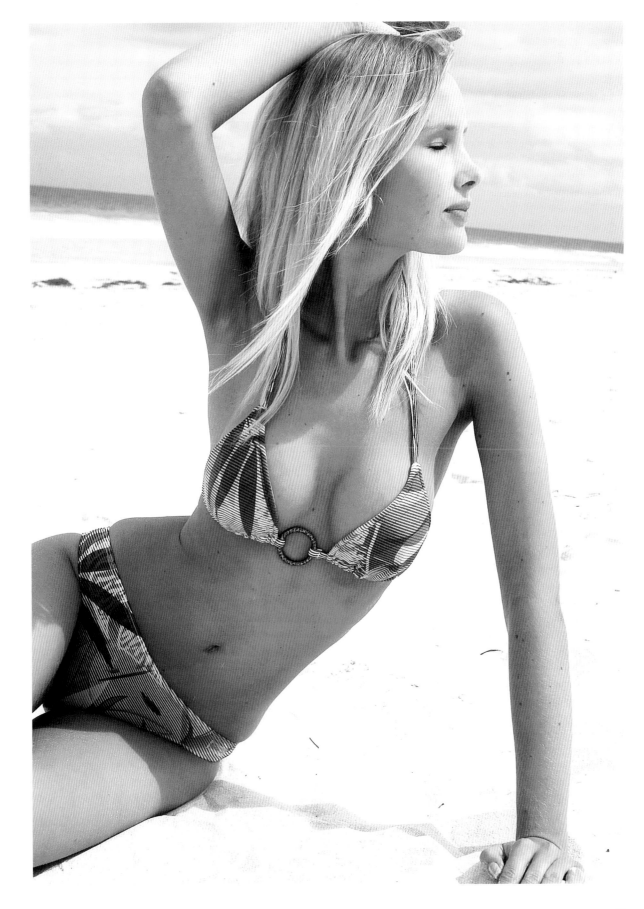

SHOOTING IN SHADE

In the past, shooting in shade required slow shutter speeds, risking camera shake. The other option was to use a high ISO setting that resulted in prominent film grain in your pictures. Today's DSLRs allow you to shoot with quite a high ISO setting without sacrificing too much quality. Even so, if you're working in shade you may have to supplement the light with reflectors or fill-in flash. It depends on the brightness of the shade you're working in, and whether there's light bouncing from other surfaces nearby, such as light-colored walls.

→ This picture was taken under a canopy on the veranda of an English stately home in overcast weather. The light was poor and I was working with the aperture wide open. As you can see, the light is soft and flattering to the skin. If I'm shooting in the shade and it's quite dark, I brighten it by slightly overexposing the image. The soft quality of the light means you don't have to worry about losing shadow or highlight detail. If the light's still too flat in your images, you can punch up the contrast in Photoshop at the post-production stage.

Shooting in shade gives a slightly blue-colored light, so make sure your white balance setting is correct for these conditions. I look at shooting in shade with reflectors on the next page.

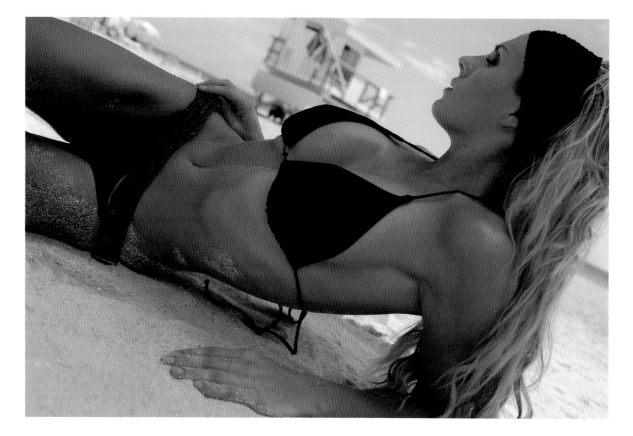

Left: Sometimes it is necessary to impose artificial shade using a screen. You can then shoot your subject without blown highlights and deep shadows.

Right: This shot was taken in a shaded corner, using diffused light.

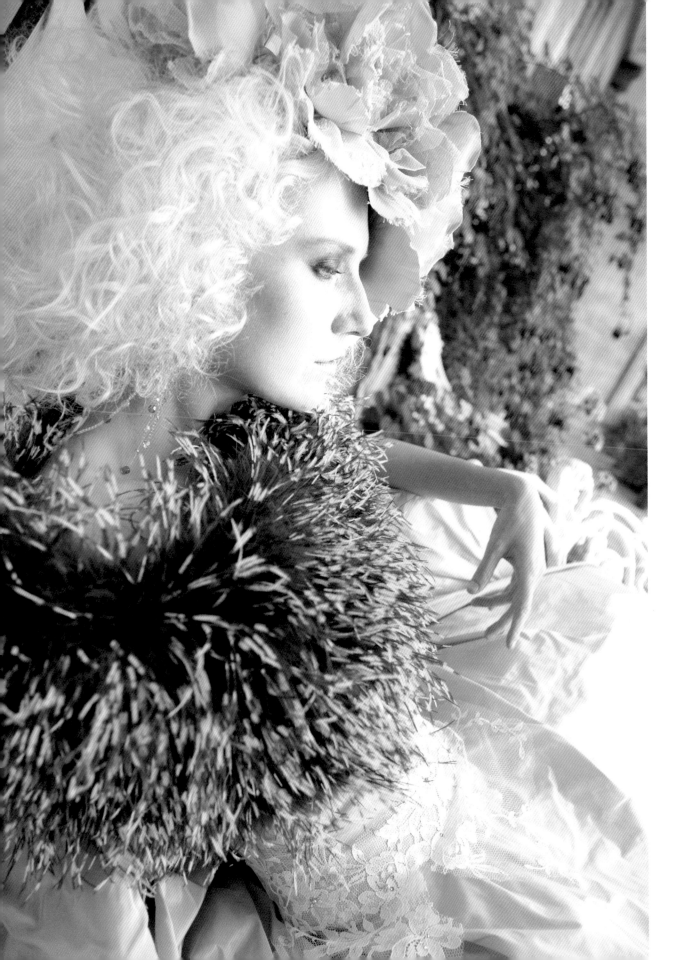

SHADE AND REFLECTORS

One way of avoiding problems with top light during the middle of the day is to put the model in the shade and bounce the sunlight with reflectors (see Direct Sunlight, pp. 74–75). This particular shot was taken late in the day, when the sunlight was going and I wanted to get some more pictures before the light went completely. The sun was quite low down in the sky.

→ I chose to put the model in the shade of a tree rather than put her out in direct sunlight, which would have been a little harsh on her face for the effect I wanted. I was aiming for a soft and sensual quality, so I used a reflector to bounce some sunlight back in again.

In this situation you can use zebra, white, or silver reflectors to brighten the model's features. Each gives a slightly different quality of light. I chose a round gold foil reflector to give a bright but warm and natural-looking light. The sunlight was coming in from the right and I was able to angle the reflector so that the light was hitting the model straight on the face with no under-eye shadows.

Right: Bouncing late afternoon sunlight gives a flattering effect on your model's features. The warm westerly light is enhanced by a zebra reflector that creates a very pleasing shade.

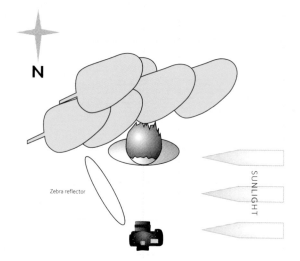

N

Zebra reflector

SUNLIGHT

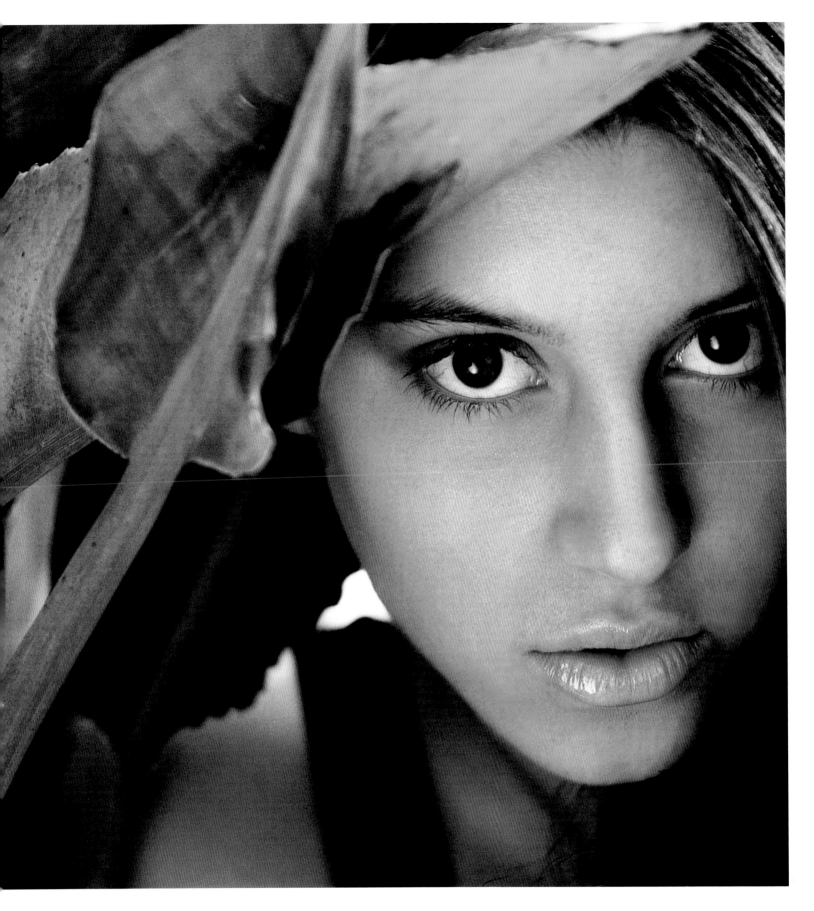

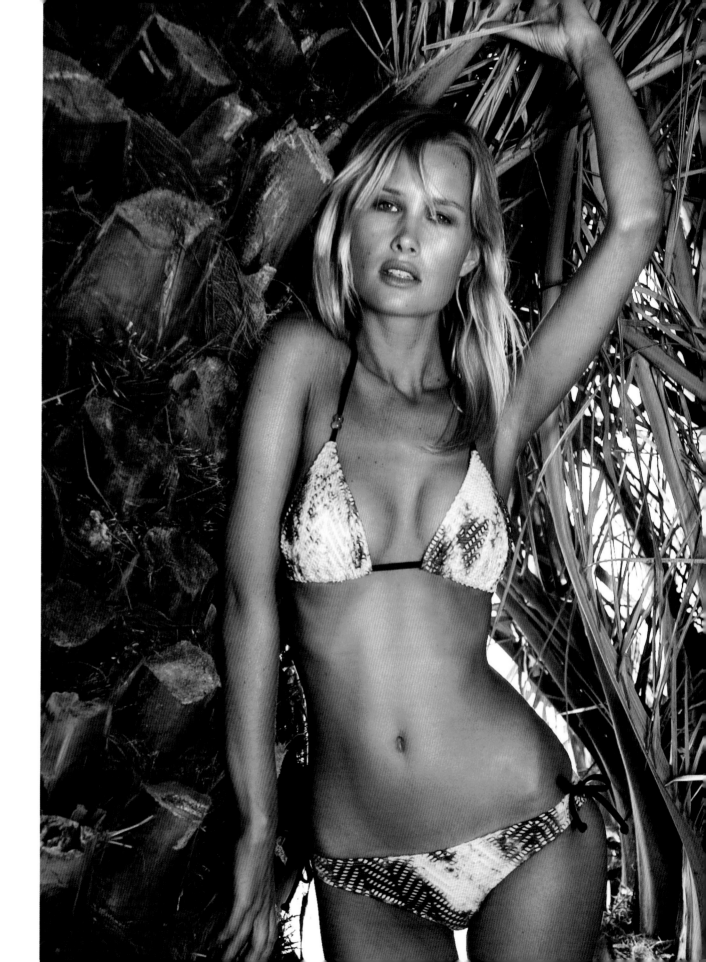

FILL-IN FLASH

When people use the pop-up flash on their cameras to compensate for falling light levels, it gives out a powerful light and turns the background dark. You can immediately see that fill-in flash has been used and it kills any atmosphere that might have been there.

→ Using obvious fill-in flash sometimes works as a creative effect in fashion photography, such as when you're shooting against the sunset. In that case, the image is inevitably lit more with a flash exposure than a daylight exposure; without it, the model would be a silhouette against the sky. However, because my own general principle is to create images that look like they have been taken with natural light, I don't want it to be obvious that I've used fill-in.

In the picture on the left, the model was underneath a palm tree where the light levels were too low to get the shot I wanted, even if the light was supplemented with reflectors. I knew I had to use flash, but I wanted it to be subtle and to look like evening sunlight. I held my camera in my right hand and a hammerhead flashgun in my left. Then I bounced the flash at low power from a gold mini reflector that my assistant was holding at a 45° angle to my model. This has lifted the light levels but retained the exotic atmosphere in the scene.

Left: For me, the art of using fill-in flash is to make it virtually undetectable. Looking at this picture its not obvious whether flash was used or just reflectors like the shot on page 85.

Below: This picture was shot with a ring-flash, which creates a unique style. The ring is mounted around the lens, so surfaces are lit from every side, filling shadows and giving bright catchlights.

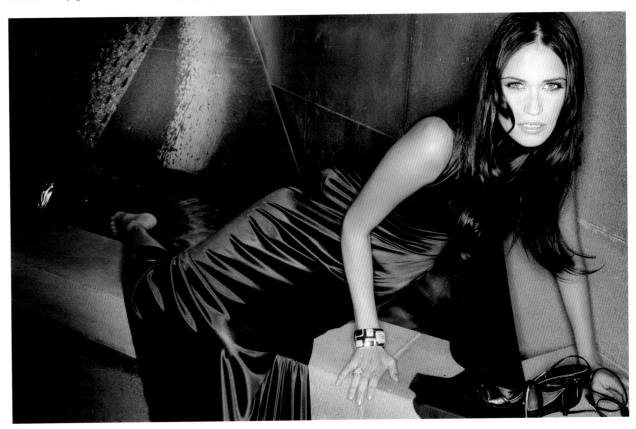

CONTINUOUS LIGHT

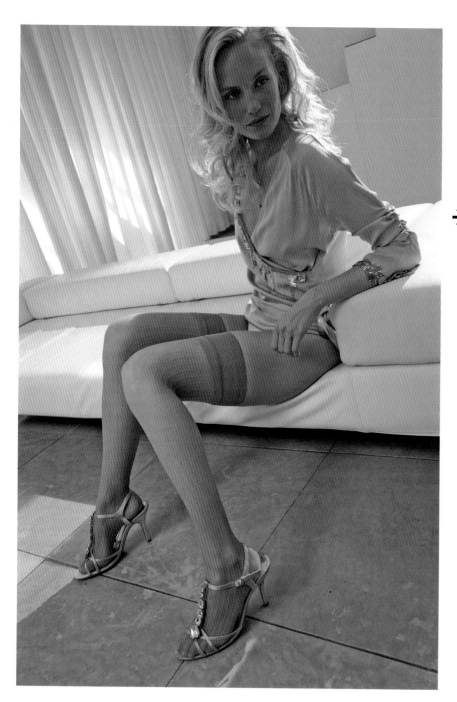

Above: Because this is a product shot and will be cropped, it is only important to light the section of the image that will be used by the client — the stockings.

Right: The advantage of HMI lighting in a shot like this is the reliability. You can use reflectors to tweak the light for each individual shot, but you can shoot all day under the same conditions too.

The advantage of using continuous light is that it's on all the time; you don't have to wait for flash heads to recycle, so you can shoot faster. You can also see what effect you're getting as you shoot without having to refer to the camera's LCD screen. I use HMIs, which are the lights used on movie sets. They're very powerful lights and are run from an industrial transformer. I hire HMIs for a small number of shoots each year.

→ HMIs can be used as a spotlight or a floodlight and give a very good replication of daylight. The downside of using them is that they are big, heavy, and cumbersome — the head itself is around 2ft (60cm) across. They are not the sort of lights you would want to move around too much on a shoot.

For this hosiery advertisement shot, I used two 2,500-watt HMI lights. I arranged them to make it look as though daylight was coming into the room. I used one light to create a backlighting effect, which is coming from behind and to the right of the model. You can see that it's spilling through onto the floor on the left of the frame. I used the other light bounced off a wall to give some overall light to the room. I also used two zebra California Sunbounce reflectors to bounce a little extra light onto the model's legs and face.

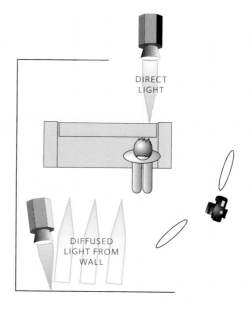

DIRECT LIGHT

DIFFUSED LIGHT FROM WALL

SHOOTING IN BAD WEATHER

Many people would peer outside on a murky, slightly rainy day and give up all thoughts of taking pictures. However, it is possible to get good shots in these conditions. I'd usually avoid shooting in heavy rain, but it can be done if you put your model under an umbrella and you make sure you protect your equipment.

→ Every situation you're working in will be different, but usually the light levels are low so you'll need to adjust your ISO settings. Light from an overcast sky is soft, and often good for shooting knitwear. It's also a low-contrast light so you'll often need to lift it at the post-production stage in Photoshop.

There are no great lighting secrets to this picture of a girl made-up to have a doll-like appearance. I simply took the model into my garden and set up a black backdrop. The sky was very overcast with no sign of any sunlight and light rain was intermittently falling. You can see a few droplets on her face where it's hitting her makeup. Although heavily diffused through the cloud, the daylight was giving slightly unattractive shadows on her skin, so I used a white reflector directly below her face. The low light levels made it necessary to shoot with the aperture wide open at ISO 400.

Large reflector below shot

Left: The unedited shot straight from camera. A relatively high ISO value can still provide a brightly lit shot even if it is only lit from the most diffuse of all possible lights, an overcast sky.

Right: Pictures can be shot in adverse conditions, providing you have the technical skill to overcome them. Having countered the problems in camera, it's possible to add even more drama digitally.

LIGHTING

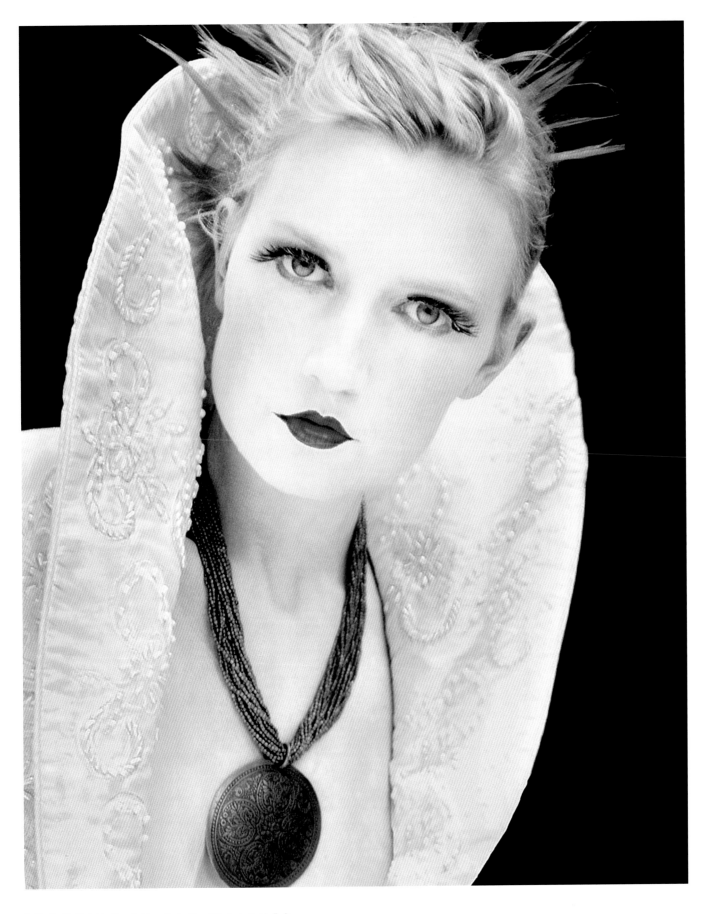

SHOOTING IN BAD WEATHER

DIFFUSION SCREENS

Using diffusion screens is one way you can shoot models in bright sunlight in the middle of the day. By placing them between your model and the sun, you block out the harsh quality of the light, giving you a flattering light with which to work. They give wonderful beauty lighting. I love using them and almost all of my location shots have been achieved with just a couple of diffusion screens and reflectors. I also use diffusion screens in the studio for softening continuous lighting such as HMIs.

→ Diffusion screens are made from a strong translucent nylon material produced in a variety of sizes, but I use a California Sunbounce Pro Sun Swatter, which is a little over 6ft × 4ft (130cm × 190cm, to be exact). They can be erected on a long pole and held above the model if you're working outside and the sun is directly overhead. You can buy screens in material of different thickness that alter your exposure by 1, 1½, and 2-stop differences. You can buy them in different textures and they can be bought in a clear or dappled light variety.

The swimwear shot to the lower-right was taken on a beach in Australia, with a 1.5-stop diffusion screen. You can see that the light on the model is bright and even. I took my exposure reading from the model. However, because I was cutting down on the power of the light on the model by 1.5 stops, it meant I was overexposing my background and slightly burning it out. Far from being a problem, this has advantage of making your model and the garment more prominent in the image.

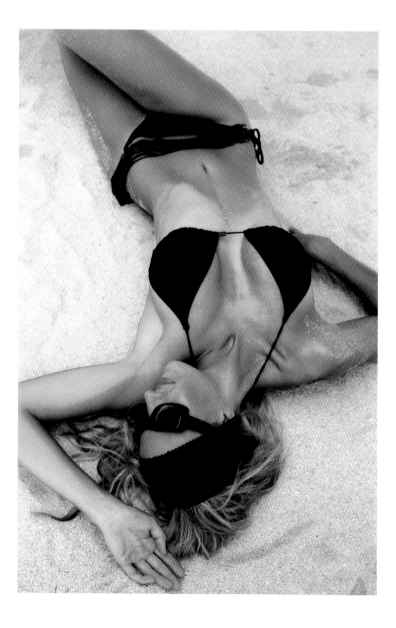

Left: This whole frame of this shot was taken in the diffusion screen's shadow. You would get a similar result shooting on a cloudy day.

LIGHTING

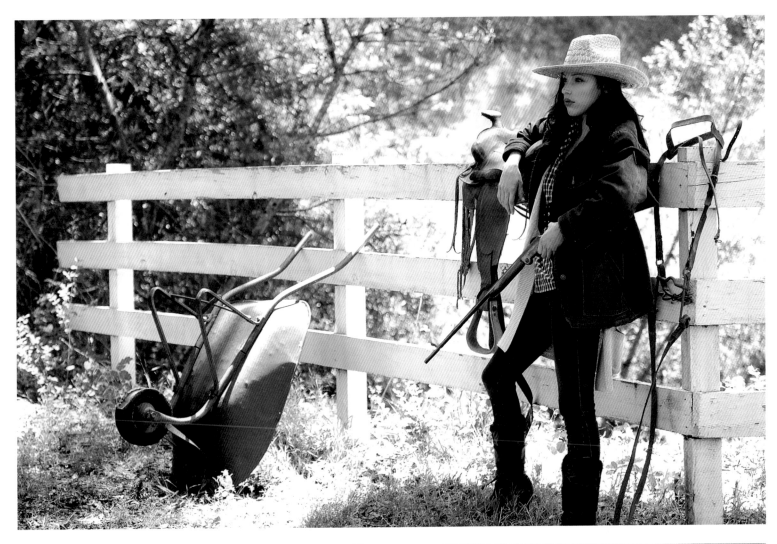

Above: Like the shot beneath it, the diffusion screen creates a difference between the model's light and that of the environment behind her. Exposing for the model is crucial.

Right: When you know the background, which falls outside the diffusion screen's influence, will be well lit, ensure that any foreground matches. Here a reflector was targeted at the sand in front of the model.

DIFFUSION SCREENS

REFLECTORS

Reflectors can be anything you use to bounce light onto your subject, whether they're sheets of white card or professional-quality reflectors that are available in a variety of colors, shapes and sizes. They can be used to reflect flash or daylight and can make a big difference to your shots.

→ Reflectors can be held by your assistant, but ensure that they know the correct way to hold them. If you're working outside without help, reflectors can be placed on lighting stands, with sand-bags to weigh them down.

Different colored reflectors will result in different qualities of light on your model. For example, gold reflectors give warm tones and white ones give color a neutral hue. Professional-quality reflectors are usually different colors on either side to give different effects. I use California Sunbounce reflectors, which are available in different reflection levels and a range of colors. I mostly use either the white or the zebra reflectors (that give a slightly softer light) in 3ft × 4ft (90cm × 120cm) or 4ft × 6ft (120cm × 180cm) sizes.

In this case, there was a flash positioned outside the window to simulate sunlight. I combined this with soft silver reflectors to bounce some flash light on her. To determine the exposure, I took an incident light reading with the lightmeter pointing towards the camera and picking up the light bouncing from the reflector. I aimed for a natural-looking effect, but one that still showed the important details in the dress, such as the pearls and sequins.

Right: Positioning flash outside the window enabled me to keep shooting later in the day, even when the strength of the light outside was not as much as I had hoped it would be.

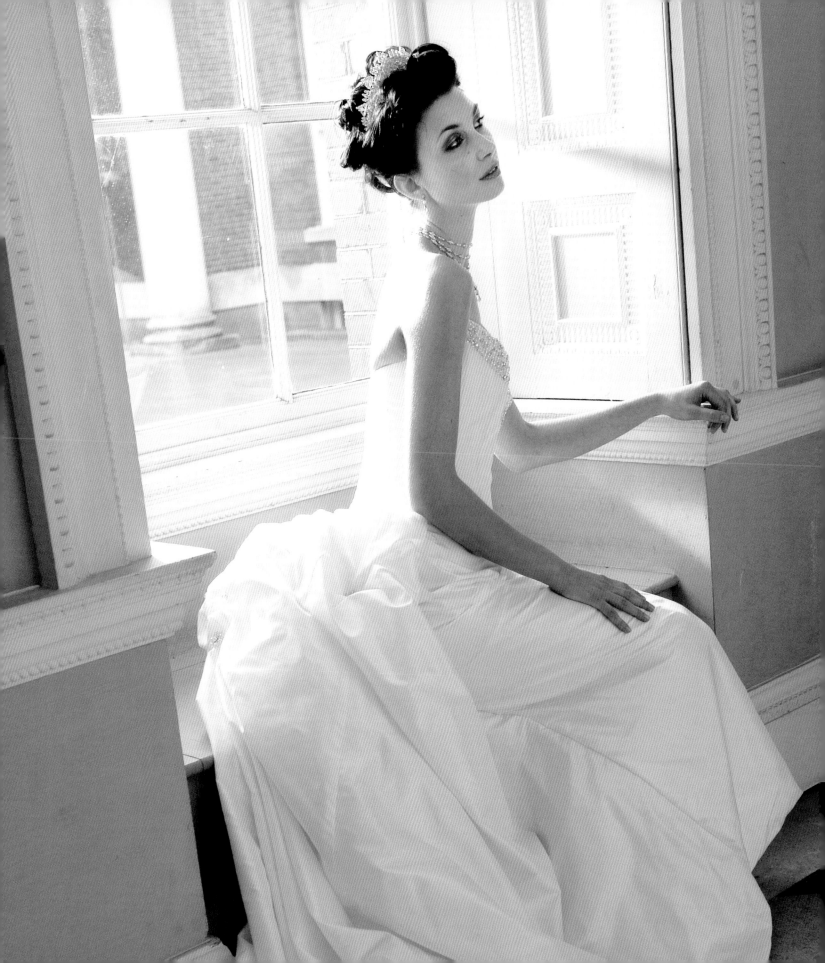

PRODUCTION

So the day of the shoot arrives. If you have taken my advice from earlier in the book, you will have done your preparation thoroughly. You will know what equipment you're going to use and the tempo that you're going to set on the shoot. You will have assembled your team and selected appropriate models for the kind of shoot you're going to do.

If you're shooting on location, you will have researched it thoroughly. You'll know which areas you're using for your shoot and the time of day you're going to be there. You will have decided how you're going to deal with different interior and exterior lighting situations. If you're in a studio, you will know what lighting setups you're going to use and which backgrounds and props you will need. Your team will know what you're planning to achieve and what you'll expect of them.

This chapter deals with the production of fashion images — from the things you need to do on the day of your first shoot, to how you tackle a professional advertising, editorial, or catalog assignment. It includes sections on fashion image composition, how to direct models, and how to get energy in your pictures. I also offer important technical advice on image file storage, metering, exposure, and managing your time on a shoot.

This is the stage at which all your careful preparation bears fruit in the images you produce. You're ready to begin.

THE DAY OF THE SHOOT

On the day of your shoot, arrange for your team to arrive at your planned meeting place, whether a studio or location, in good time. If you're shooting outside, one late member can mean losing the early light. All garment pressing should have been done the previous day, to save time on the day of the shoot.

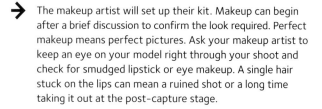

The makeup artist will set up their kit. Makeup can begin after a brief discussion to confirm the look required. Perfect makeup means perfect pictures. Ask your makeup artist to keep an eye on your model right through your shoot and check for smudged lipstick or eye makeup. A single hair stuck on the lips can mean a ruined shot or a long time taking it out at the post-capture stage.

At the same time, the stylist should make sure the clothes look good, especially if you're shooting outside on a windy day. You should also make it your business to look out for clothing details, as your stylist may miss something. You don't want to be disappointed in your shots for the sake of a tiny detail that could have been corrected.

While the model is being prepared, which can take an hour or more, you should take the time to think about your shooting order. If you're on location, make a plan of what garments you are going to shoot in specific areas and at what time of the day. I personally only shoot in two main areas in the morning and two in the afternoon. Moving locations can lose valuable time, so you must build this into your schedule.

If you are working in a studio, you need think how you want to arrange your set and your lighting. You'll need to tell your assistant which lights and background to set up according to the mood and tempo you have in mind. Think about how your images are going to be used. Aim to shoot a variety of image choices for your client and explore all the angles.

Imagine how you want your shots to look. Think them through carefully, so you know exactly what you're doing when you start shooting. Confidence is the key to gaining respect from your model. If you are uncertain, they will sense it. Therefore you should get the shoot's technical aspects arranged and checked before your model goes on set.

At the beginning of your shoot, put any tear sheets that you're using in a good position and use the poses as a starting point. When you're confident that you have all of the technical things right, your shoot can begin. You won't produce good work if you're worrying about lighting and exposures, or if you're under pressure to shoot quickly because you are running out of time.

If you have planned every detail and are confident in your equipment, team, location, exposures, and lighting, you can relax and concentrate on what is happening between your model and your eye.

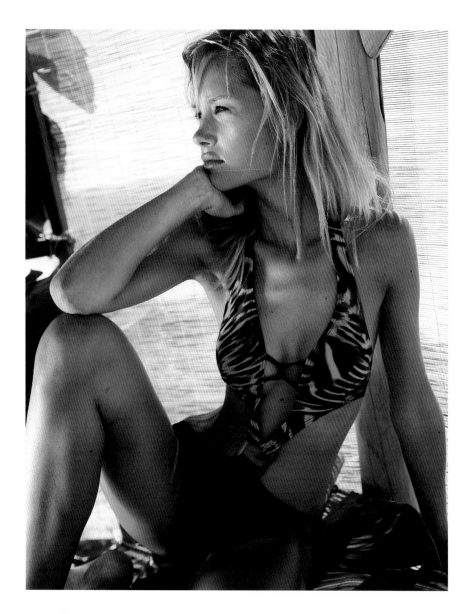

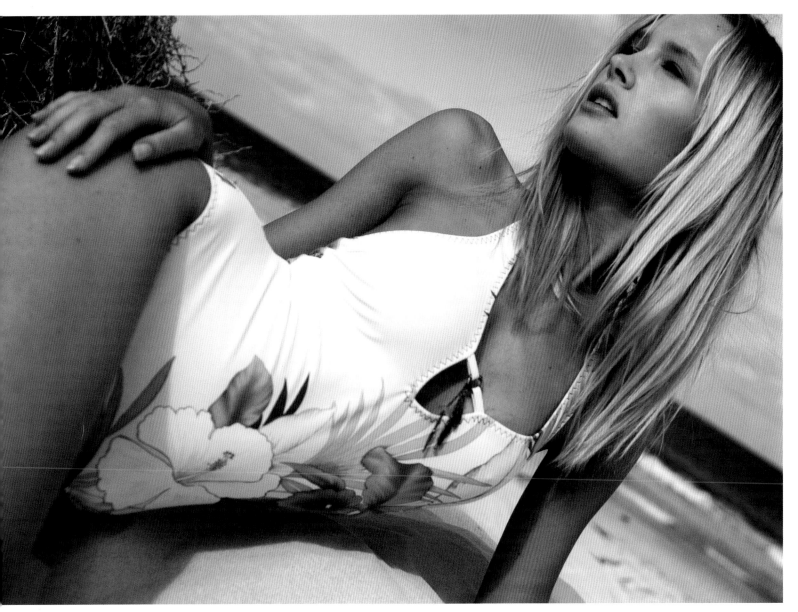

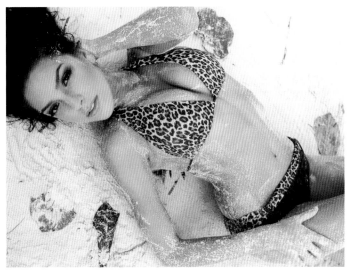

Opposite page: This shot required a lot of planning and effort, as we had to build the set on the day before the shoot.

Above: My team had to be at the beach location and ready for the shoot by 7 AM for this shot.

Far left: This looks like a simple shot, but it required a huge amount of effort to create this effect.

Left: I was on location long before my other team members, so that I could find the right part of the beach to shoot this image.

IMAGE FILE MANAGEMENT

Image file management is about creating an organized filing system that helps you find your pictures quickly and easily at any time. It's also about backing up your images so that if one piece of equipment fails and the contents are lost, you've got another copy somewhere else.

Being organized about your image storage is important right from the beginning of your career as a fashion photographer. If you're just starting out, you should get into the habit of keeping clearly labeled folders of your original and processed files on your computer and backed up on CD or DVD.

→ If you're working professionally and doing a number of shots for a client over a day's shoot, you must get your image file management organized at the beginning of your day's shoot. If you don't, you can easily get into a real mess. After you've set up your studio and lighting, and while you're waiting for your model to be styled for the first shot, you should create a folder for the shoot.

I tend to create a folder on my desktop as a link to my secondary hard drive. Inside I'll place the folder for the day's shoot with the client's name and the date of the shoot. Within that folder I'll create one folder for test shots, then one for each shot taken on the day, perhaps named with the garment name or code number. Inside each "shot" folder, I place sub-folders containing around 50 images so that they don't take too long to load. Fashion photography is all about working fast and working efficiently, so you don't want long breaks while you wait for large numbers of images to load in your browser.

If you're using memory cards, I'd suggest shooting on 512MB, 1GB, or 2GB cards. This size of card gives you a reasonable number of image frames to get your shot and they are relatively fast to download. I'd also advise shooting Raw files and a medium quality JPEG that can be burned onto CD. That means your client can leave the shoot with a proof of each image taken during the session.

If your computer has a firewire port, buy a firewire memory card reader. They copy your image files across much faster. A 1GB card will load in 1-2 minutes, compared with 10-15 minutes using USB card readers.

You should also aim to keep three copies of all your files: one on your main computer, one on a secondary hard drive, and another on CD or DVD. Save two sets if you have the data storage space. Losing your images is a disaster, so back up your images carefully. In the past I have lost images due to both my laptop crashing and external hard drives failing and not having back-up copies. Don't wait for it to happen to you — clients are not interested in hard-luck stories.

Below: Keeping copies of your images on a secondary hard drive stops you losing images if one item of equipment fails, and a drive like this makes burning archive discs very easy.

Right: When you're shooting large numbers of images, it's essential to establish a filing system that allows you to find them quickly and easily. I keep my images in a separate folder for each shoot.

CLIENTS' NEEDS

Every client has different needs. As a fashion photographer, you will have to understand their business needs and be aware of the ways in which your own skills, talents, and management abilities can be used to meet them.

When shooting a commercial project for any client, you have to achieve their objectives for the images. They have to sell their garments or create a demand for their brand. They will have commissioned you to produce images that will achieve this objective. Therefore, your fashion images have to live up to these expectations. If they don't, you will lose your clients very fast.

Left: Your pictures are largely determined by your client's needs. This is a standard catalog shot — a picture that's bright, simple and easy on the eye.

→ There is little point in shooting fashion images that you personally want to produce. You have to think about what you produce as being a combination of your creativity, talent, production skills, combined with your ability to judge what can be achieved in a specific time frame and budget. Some clients will totally rely on you to advise them and produce what is right for them. You have to build up the knowledge and skill that this responsibility requires.

KNOW YOUR MARKET

You have to be very aware of the markets in which you're working. Research the markets that fit your style, knowledge, and production skills and you will have no problem in providing the kind of work your clients expect.

Start by looking very carefully at the fashion business in general. It has many facets, and each one of them will need images that serve a particular purpose. You will see basic differences by looking through magazines and catalogs. Browse through them and think what particular images tell you, and therefore the purpose behind them.

The purpose may be to sell the items on the pages. Alternatively, it may be an editorial image shot to make the magazine's readers aware of a fashion trend. In this case, it's not about selling the particular garment — it's about creating an impression. In some cases, fashion advertising images may have been shot with a double purpose: to influence the viewer about a certain brand, but also to influence the viewer to buy that specific garment or accessory.

It's also worth spending time visiting fashion trade fairs. They are set up so that fashion brands and manufacturers can show their latest collections to the retail industry. It's very big business, and a lot of money is spent producing new images of every fashion collection. This usually happens twice every year. Fashion is a fast-moving business, so there are always going to be new fashion collections that need to be shot.

When you're in a shopping mall, take the opportunity to look carefully at every fashion retail window display. Look at the way these images have been shot and what they are telling you. After you have analyzed every type of fashion image you find, and related them to the market that is displaying them, you will understand what is required of the photographer that is commissioned to shoot these images.

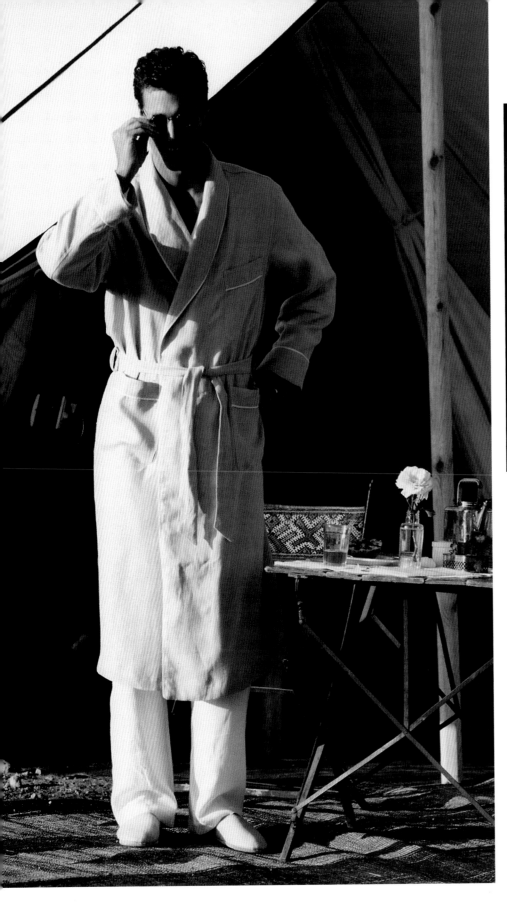

Left: This is a more sophisticated image than the basic catalog shot and is intended to showcase luxurious travel accessories.

Above: Trade catalog images, such as this picture of a bodice on a wedding dress, need to show the detail in a garment.

CLIENTS' NEEDS

BRIDAL WEAR SHOOT

One of the key things about shooting fashion is to *show off the garment*. Your picture has to sell the garment, either directly off the page in a catalog, or to sell the *idea* of the garment as an example of a particular style. When you're composing your shot, the clothes are of paramount importance.

This shot shows the kind of composition that works well. It's a "lifestyle" bridal-wear image showing a happy face and suggesting that if you wear this dress, you're going to look and feel like this model. I would have shot this model in many different ways, concentrating on the features of the dress and trying to draw attention to them.

In this image, the background sets the scene, but it's not drawing your attention away. The model's head and arms hold you in the shot and keep you focused on that central part of her dress. I have used the arms to frame the bodice and particularly the appliqué feature on her waistband. You've always got to be looking for these features. When I'm shooting I keep moving around the model and when I find this kind of composition I work around it.

This image is technically a left-hand page. She's slightly biased to the left of the frame, but her face and the energy in the picture are pushing toward the right. This would be perfect for leading you into a picture on the right-hand side of the spread.

–
–
–

Right: This shot is actually half of an image shot for a double-page spread, but the composition also works as a single page shot.

Far right: The shapes created by the model's arms and legs help to hold the reader's attention on the picture.

COMPOSITION

All photographers know about using compositional "rules," such as the rule of thirds, to give strength to their pictures. They are as valid in fashion photography as in any other kind of photography. Fashion pictures must be comfortable and balanced for the viewer, and hold the viewer's attention. You also sometimes need to keep the eye of the viewer on certain parts of the image. This can be achieved by controlling the composition and by careful direction of the shapes that your model makes.

→ When you're shooting fashion photographs, you also have to remember other factors when composing your pictures. Your composition is often determined by the way those pictures are going to be used. For example, if you are shooting for an advertisement or a magazine feature, you have to allow for text on the images (see Allowing for Text, pp.106–107). Similarly, you have to be aware of how one picture relates to another, both in printed magazine spread and your own portfolio (see Shooting for Balanced Spreads, pp. 108–109).

For every garment on a shoot, you have to take a number of shots of the same gown, to be used in different ways. For instance, if I'm shooting one particular dress, I'd take shots of the whole dress, three-quarter length shots, a close-up, and a horizontal shot if possible. The client may want an image as a cover shot, an atmosphere shot, or a shot to drop in on the page. I would also do the shot with a bias to the left, a bias to the right, one with the model facing the camera, and others facing to the left and to the right. This gives the client the choice of using the pictures as left and right hand pages. Your client sometimes doesn't know where they're going to use the shot, so you have to use your initiative and cover all the angles.

If you take a look at any magazine feature or advertisement, or any catalog or leaflet, you will nearly always see text on the pictures. This text may be the magazine's title on a cover shot, a headline on the opening page of a fashion story or feature, a strap line for an advertisement, or a simple caption giving information about the clothes featured in the shot. In some magazine features there may be longer sections of copy

→ When you're shooting fashion, you have to consider that an art director will need to put text on the shots. If there's no room for text, your pictures may not be used. Take a look through as many magazines as you can, so that you're familiar with the amount of text used in a particular publication, and where it goes. Your portfolio should include plenty of pictures that incorporate negative space into the compositions. In that way, any potential client will immediately see not just that you know how to compose a picture well, but you have also understood how the pictures will be used.

Like many aspects of shooting fashion pictures, allowing for text is one of those skills that you have to learn and incorporate into your technique. Don't think about it too much, to the extent that you neglect directing your model and technical concerns, but keep it in the back of your mind while you're shooting. With practice, you won't even realize you're doing it. This will allow you to concentrate on the moment and let your creativity make the pictures great.

Left: I shot these images as potential cover shots, so left space for headlines and text around the model's face.

YN ASHWORTH
alwear

www.lynashworth.co.uk
01580 761948

...by by Bruce Smith b.s@mac.com

EXAMPLE

LYN ASHWORTH DRESS

This image was shot for a bridal-wear catalog and I knew I had to allow for text on the image. Any gown has certain parts more important than others, so when you're composing your picture, you've got to think, "What's the most important part of this gown?" With this garment, the waistline, neckline, and bodice are the most important parts and should be the center of the shot. Neither the chair nor the background are dominant. The model is a pretty part of the picture, but she's really just an accessory.

When you're composing a picture, you should aim to create some kind of shape — a circle, triangle, or rectangle — to hold that picture together. Careful positioning of legs, arms, hands, and head can make a massive difference to your pictures.

When you're looking at this picture, your eye goes from her face, down her left arm, down to the text, through the folds of fabric, back up to the waistline and round to the neckline. Your eye won't be taken out to the left hand side because her arm bends back in toward the center. If her right arm was going out of the picture, your energy would go straight out to the left. This shot would still work, even without the text, because there's a comfortable balance between the model and the background.

Left Again, I composed this shot to allow text to be placed in the space. Without text, it looks odd. Only once the text is added does it make sense.

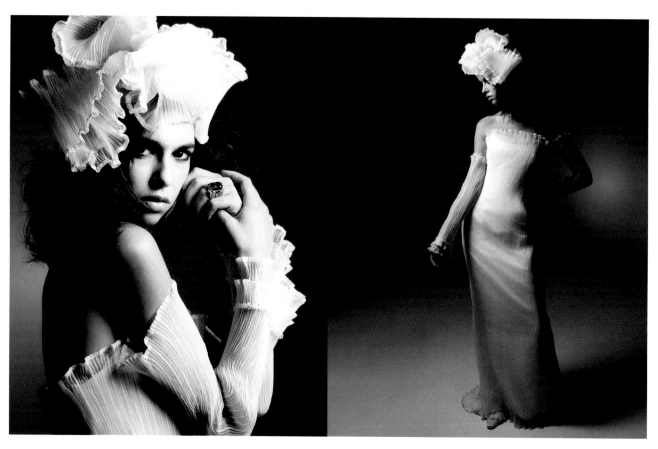

Left: These two images were taken during the same shoot and they would make a good balance if used across a spread together. First of all, look at the picture on the left, and the way the model's hands are quite close to the right-hand edge of the picture. She has an eye-catching and intense expression, and the picture would (and has) made a cover shot in itself. Here, you can see that this picture goes well with the image on the right, which has plenty of space around it. If the model had been on the left of the frame in the second picture, it would disturb the balance of the pictures.

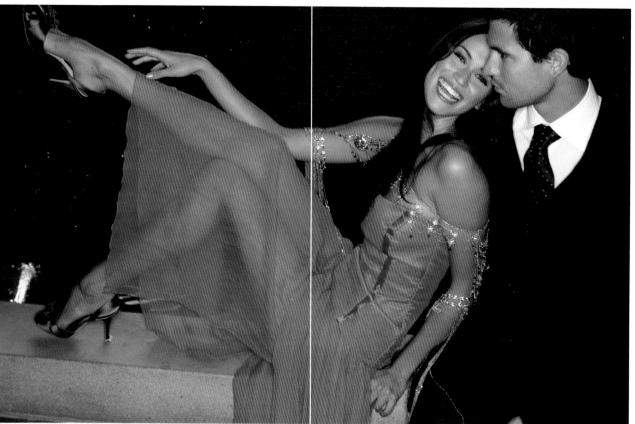

Below left: This is an example of a composition that's suitable for a single image going across a double-page spread. I have avoided placing anything vital in that center area, because it would be lost in the gutter. In this case there's a guy in the picture, but the picture's not about him, it's about that dress. As the two faces are on the right-hand side, I've needed to balance the composition on the left side. I've done this by asking the model to lift one of her legs and composed the picture with the foot in the top left corner. I've also placed the hand and forearm in that area.

If I'm shooting a dress that shows a model's arms, I'll do my utmost to make sure those arms are helping me with my composition. They've got to help lead the eye into the picture. In this case, if the model's arm had been straight, it would lead the eye out of the picture. Also, if both the girl's legs had been down and the hand had been out of sight, it would have left a gaping hole in the composition. As it stands, if you start off at the foot, the hand helps take your eye along the dress, up her thigh to their faces, then down her arm to the dress again, making a circle that holds you in the picture.

SHOOTING FOR BALANCED SPREADS

Look at any repetitive designs, such as those you find on wall tiles. The design of each element is very carefully considered, so each tile will balance the next one, even if the design is the same. A badly designed tile will not step and repeat successfully and will look awkward to the viewer. In the same way, your images have to work together, either when published or displayed in your own portfolio.

You have to balance the object (in fashion pictures, the model) with the negative space around it. The object and the negative space have to relate to each other and balance like weights on a scale. When you're working with more than one picture, you may need to break a compositional rule on one picture for it to balance with the second.

TWO SINGLE IMAGES
For instance, you may be shooting for a magazine, catalog, or brochure that will, when open, show two single pages or a double-page spread. You're not just working with the composition of one image and the way the object relates to the negative space around it. You're working with both images and how the objects relate to the combined negative space across the spread.

A single-page image can have a bias to the left, right, or center. However, if you put two images with a bias to the left on a double-page spread, they will look uncomfortable together. By using an image with a bias to the right together with an image biased to the left or center, the joint composition will look comfortable when you view the two pages together.

DOUBLE-PAGE SPREAD
When you're shooting a horizontal image to be used over a double page spread, you have to consider where the center line (the "gutter") is going to fall. You don't want the gutter running right through an important part of the image. Here you're just working with a single picture, but all the elements still have to balance.

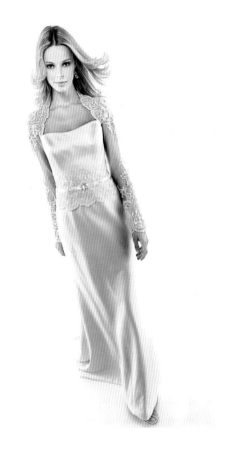

Right: When you put two pictures together like this, the negative space has to balance for the spread to work.

CREATING ENERGY

To give you an insight into ways in which you can transform the levels of energy in your pictures, let me tell you about my own experiences.

Many years ago, when I was developing my style and building up my portfolio, I became despondent about the lack of excitement in my pictures. Looking at other photographers' work, I could see a lot of movement and energy in their shots and I realized it was the energy — or lack of energy — in my shots that was disappointing me.

I tried a new approach in my work. In the studio I started to play music that reflected the emotional levels, the mood, and the rhythm of the shots I wanted. I started to direct a lot more, verbally and visually. I found that by doing the poses and the expressions in my face that I wanted, my models seemed to mirror mine. If I acted crazy, they acted crazy. If I laughed, they laughed. If I pulled a sad face, they pulled a sad face — which always made them smile.

Right: You get out of a picture what you put into it. Here, I made the model laugh and the result is a fun picture.

→ **BODY LANGUAGE**

In my earlier work, I found I was missing great shapes that models were making, because they were moving too fast. To avoid this situation I asked my model to move in slow motion, as though they were in space. This technique is especially useful when working in the studio using powerful flash lights that need a second or so to recycle. Now, not only would I get the shots I wanted, I also wouldn't get blank frames every other shot due to shooting before the flashes had recharged.

I found that asking models to make body shapes and poses that they wanted to do resulted in more natural poses. I could then direct and guide them around those poses. After the first couple of shots I found that my models would get into the rhythm and the tempo that I had set.

USING DIFFERENT LENSES

For years, I had been shooting fashion pictures using medium-length telephotos lenses. Sometimes I was so far away that my models could not hear me directing them. Now I decided to start shooting with wider lenses. While moving in closer to my model, I noticed a big difference in the expressions in her face and her body language — they changed as I got closer. This new approach created a much better flow of energy and communication between my model and myself. I could see and control so much more in my pictures.

Since this experiment, I have been adapting my directions to my models in much the same way, changing my energy levels to match the levels that I want in my pictures. If I want a nice soft and gentle feel, I express this in my voice and my manner and my body. If I want high energy, I do high energy.

I keep telling my models that they are looking beautiful and that the shots we are getting are fantastic. It's important to keep up a positive feeling when you're shooting. It does not matter if you are getting 99 shots out of 100 that you may not use. As long as you get that one amazing picture from your shoot, you will have done a great job.

I strive to make my shoots exciting for myself, my model, the other members of my team, and, most importantly, for my clients. As a photographer, you are the conductor, your models are your orchestra, and your clients or viewers of the pictures are the audience. So you have to direct and entertain. Your performance will be reflected in the results you get.

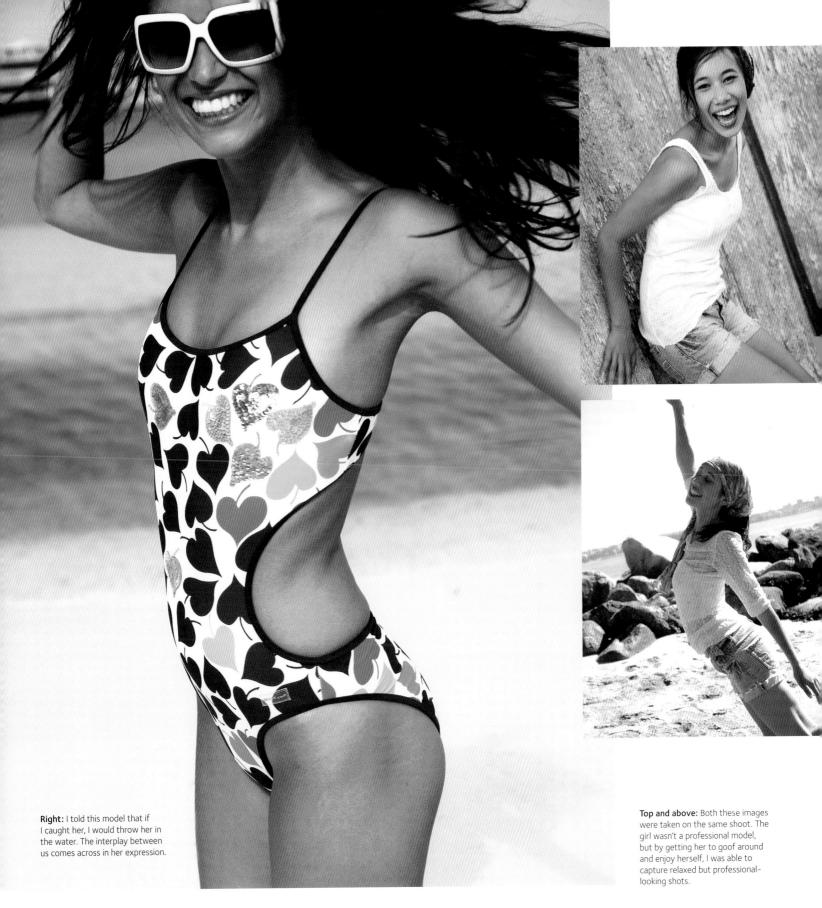

Right: I told this model that if I caught her, I would throw her in the water. The interplay between us comes across in her expression.

Top and above: Both these images were taken on the same shoot. The girl wasn't a professional model, but by getting her to goof around and enjoy herself, I was able to capture relaxed but professional-looking shots.

CREATING ENERGY

DIRECTING YOUR MODEL

Directing your model is perhaps one of the most frequently discussed aspects of shooting fashion. People often ask me how I direct my models. My answer is that there are no specific words and no particular lines of direction. The most important words are those of encouragement and enthusiasm (see Creating Energy, pp. 110–111).

→ When you have taken the brief from your client, or when you have your own concept for fashion images, you should know the atmosphere, the tempo, and the energy level for the shoot. You should keep in mind what feelings and emotions you and your client want to evoke. Good casting is vital. It's even more important that the photographer has a connection and a good rapport with the model. If you don't have a connection, you won't be able to communicate what you need for the shoot to work

Models are usually the last to know what a given fashion shoot will be about. They might not know until the morning of the shoot, so spend time with them prior to shooting. Tell them about the feelings, tempo, and emotions that are required and show them the tear sheets that have been used for brief meetings. You should also show them your portfolio and explain, using images as examples, the feelings, emotions, shapes, and poses that will be required of them.

Before you start shooting, think through your shots. Confidence is the key to gaining respect from your model. If you're uncertain, they will sense it. Get all the technical aspects of the shoot done and checked before you start, so you're not fiddling around with exposures and camera settings with your model on set.

At the beginning of your shoot, put your tear sheets in a good position and use the poses as a starting point. Then get your model to go through their repertoire of poses. Keep your directions positive. Avoid interrupting the shoot — it drains energy from your model and yourself — and watch for the moment when your model warms up and begins to enjoy being shot.

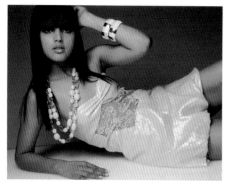

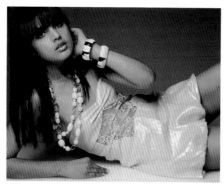

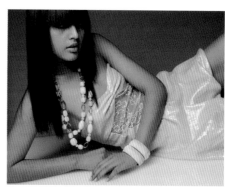

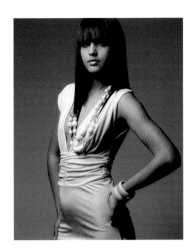
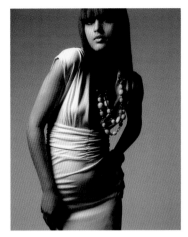
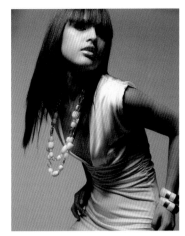
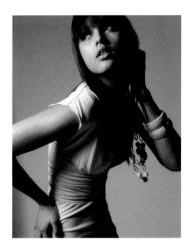

When you know what you're aiming to achieve, you have to direct your model accordingly. You might want a superior or aloof look, or a sulky pout, or you may want them to reflect joy or sadness. Instill these emotions and feelings in your model.

The one thing you shouldn't do is to simply ask for the emotion you want the model to display. For example, if you want a model to appear sexy in a fashion image, the last thing you should say is "Be sexy!" or "Give me a sexy look!" You have to make your model feel sexy, and then it will show in the pictures. It's the same with any emotion.

You will gain the ability to encourage these emotions while you are testing. There is no technique that is right or wrong and there's no quick and easy way to learn how to do it. However, it's a very important skill. The way you direct is unique to you and a very big part of your style. It's something that will only become apparent in your images after many shoots.

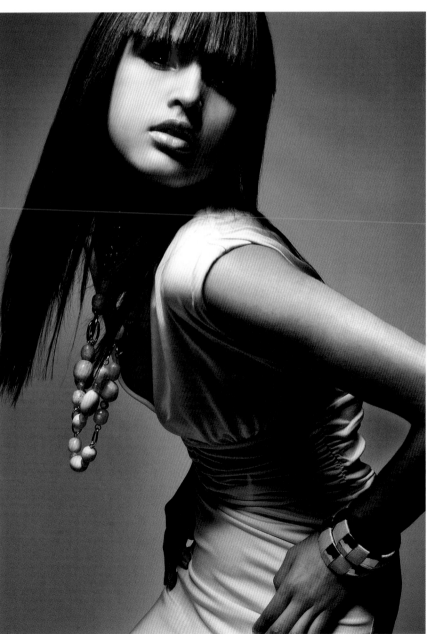

Above & right: This sequence of pictures shows how the model started the shoot (top left) and the range of shapes I asked her to make with her body. If I hadn't directed her, she wouldn't have moved and all the shots would have been the same as the first one.

Left: When you've got your model lying down, you still have to carefully control where she's putting her arms and the shapes she's making with them.

When I first started studying photography, we spent a whole day every week working on sensitometry — that is, understanding how photographic material reacts under different conditions. To find out how it reacted, we experimented with underexposure and overexposure. We went seven stops either side of the "correct" exposure. Then we looked carefully at how these experiments affected highlight and shadow detail as well as contrast. In that way, we discovered for ourselves that photographers can choose how they want an image to appear.

→ When you're on a shoot and you use your light meter to take an incident-light reading from a subject with an average brightness range, you will be measuring the overall amount of light falling on that subject. You'll get an average reading. If you expose for the scene at that reading, you will get detail in your highlights and detail in your shadows, assuming they're within the dynamic range of your sensor.

However, the nature of photographic material, whether digital or film, means that there's a limit to the brightness range that it can record. For example, if you're looking outside on a bright, sunny day, you will see a ratio of anything from 500:1 or 1000:1. That is, the lightest parts of the scene are 500 or 1,000 times brighter than the darkest areas. Your digital chip will only record a brightness range of around 125:1. Compressing the information in this way results in a loss of detail in the lightest and darkest areas of the image. Therefore you, as a photographer, have to make a choice regarding the best exposure for that subject.

In difficult lighting situations you have to decide whether an image will be better if you make it lighter or darker. You can choose to overexpose, which will result in increased shadow detail but lost highlight detail. Or you can underexpose, which will increase your highlight detail but lose the shadow areas.

When you're shooting fashion, where details of clothes are often vitally important, you need to start with correctly exposed images. You need to be in control of your lighting ratios and keep them within the boundaries of what your camera's sensor can record. If you're using studio lights or on-camera flash, you can control your lighting ratios by either increasing or decreasing the power output. If you're using natural light, you can allow or limit the strength of the natural light. If you're using mixed lighting, you have to balance all forms of lighting that you may be using for your shoot.

As a general rule in fashion work, you should aim get the best possible image at the time of shooting, by adjusting your camera settings or lighting. That will give you the maximum latitude at the post-production stage when deciding what detail is seen in your final images.

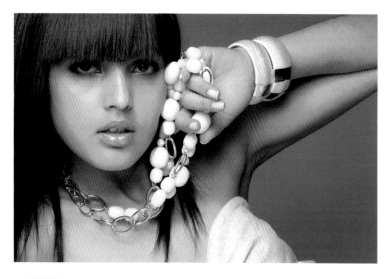

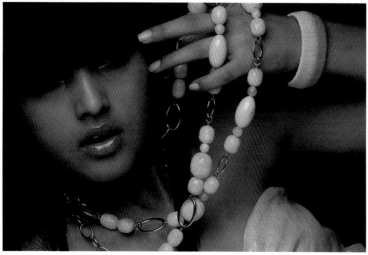

Left: When you're on a shoot, start with correctly exposed images, but it's up to you whether you make a creative choice to underexpose or overexpose the images.

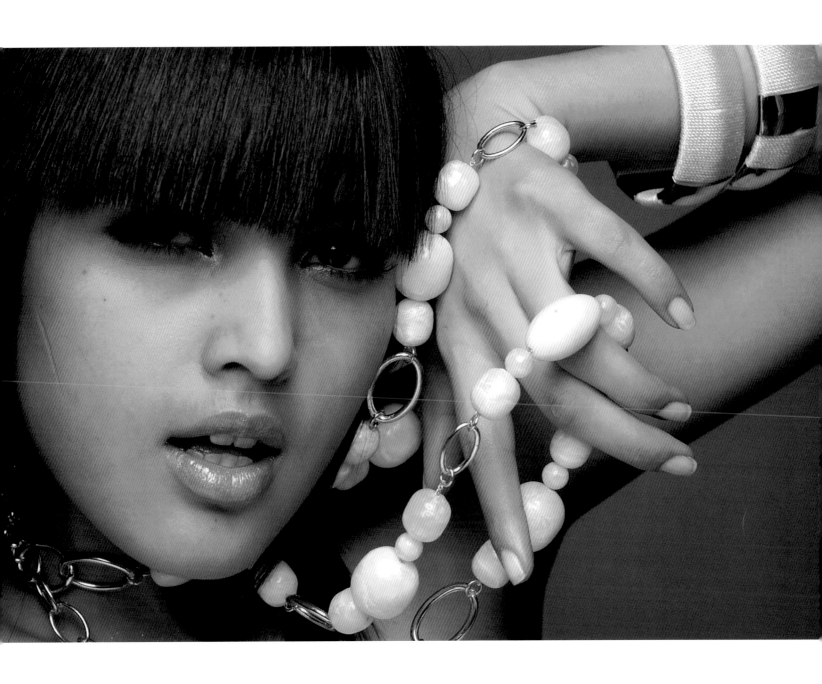

Above: For me, this is the ideal exposure for this picture. However, some photographers would shoot it darker or lighter, according to the mood they want to create.

EXPOSURE CHOICES

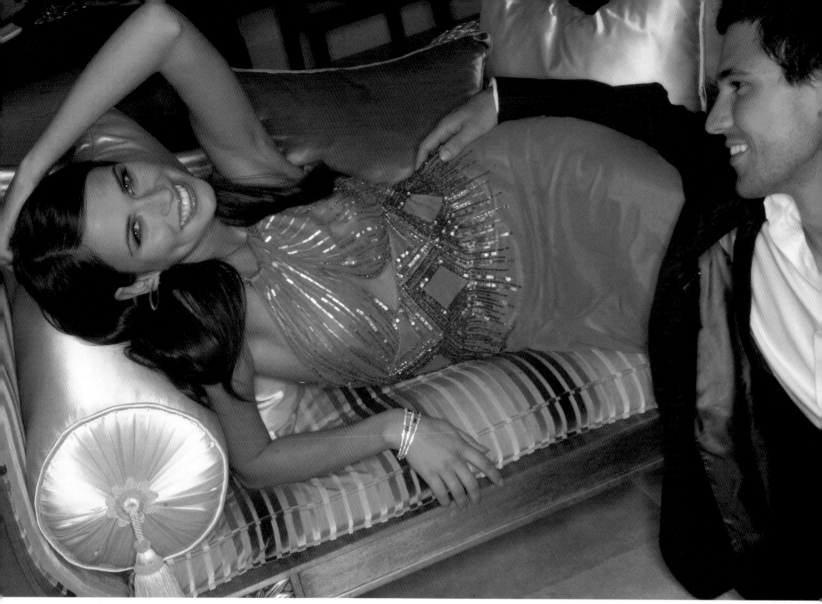

Correct exposure

Underexposed

Overexposed

P R O D U C T I O N

METERING

Accurate light readings ensure correctly exposed fashion images that render detail in both highlight and shadow areas. There are two means by which you can take light readings: You can use the light meter inside your camera, or you can use a hand-light meter/flash meter.

Below: Taking a light reading with a hand-held meter is likely to give you a more accurate exposure than your camera's built-in meter.

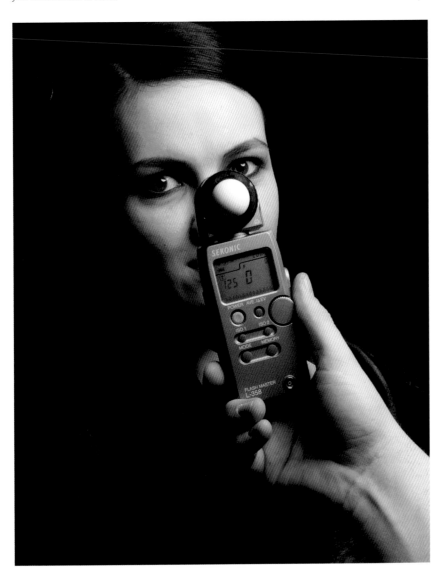

→ IN-CAMERA METERS

Your camera's metering system is taking what is called a "reflected" light reading. This is a reading that measures the amount of light being reflected from your subject. This type of reading can be misleading, depending upon the lightness or darkness of the subject area that your meter is seeing.

When using this system to take light readings you need to know the best part of your subject from which to take readings. A mid-tone or mid-gray area, or the model's face (except if they have very light or very dark skin), is a good place to start. I often place my hand in the same light as my model and take my reading from the palm of my hand. This usually gives a good average reading for the picture, though occasionally it needs a minor adjustment.

If you want to take a reading from a small, but important part of your subject, you can choose the spot meter setting. If the important area is larger, use the "center-weighted" setting. Or, if the whole of the area of your images has mixed levels of light, use the matrix metering setting. In-camera meters can usually determine correct exposure very accurately, but can be fooled, and do not work with external flash.

HAND-HELD LIGHT METER

It's best to take meter readings using a hand-held light meter/flash meter with an invacone attached for taking incident light readings. "Incident" readings are taken with the invacone pointing towards the light source. This ensures you are getting a good average light reading from wherever it is used, especially if you have directional light coming from either side.

In most situations where light of different strengths is hitting your subject, take your first measurement from the highest light source and a second reading from the lowest light strength. If your readings are more than six stops different, you will have a problem with losing highlight or shadow detail. Therefore, you will have to adjust the power of one of your light sources so that you reduce the range of difference in your readings to 6 stops or less.

For instance: you take a reading from your main light source (the one that's hitting your model's face) and it reads 1/125sec at ƒ8. Keeping the same shutter speed, your reading from the darkest part of the subject is ƒ2.8. Next, the reading from the highlight hitting your model's hair is ƒ22. So the exposure range for the subject runs from ƒ2.8 to ƒ22, which is six stops difference between the shadow and highlight readings. If you follow the light reading and expose for 1/125 sec at ƒ8, this will ensure that you do not burn out your highlight detail and you will also see plenty of detail in the shadow areas of your image

WHITE BALANCE

The human brain is very good at adjusting to changes in color balance. If we know an object is white, we will see it as white. Digital technology, both in your DSLR and in image-editing software programs, doesn't have the same degree of latitude as the human eye and brain. Nevertheless, it does allow you to effectively compensate for color shifts in your images

→ Your DSLR camera's white balance removes color casts in your photographs and gives you realistic, corrected color. You can also manipulate the white balance and use an unrealistic color cast for creative effect. However, it's best to start with getting your images as "color neutral" as possible.

To achieve neutral color in your images, you must understand how the camera's sensor renders the color in different lighting conditions.

Shaded areas during daylight will give blue light, while full daylight from direct sunlight gives neutral light. Flash gives a slightly blue light, but Tungsten lighting (domestic light bulbs or Red Head continuous lighting) gives red/orange light. Meanwhile, fluorescent lighting is very green or sometimes magenta.

In fashion photography, if you are shooting a large project of 400 outfits, you don't want to have to spend days making color corrections to the images. Clients will not pay for this additional work. Therefore, it is best to get your white balance correct every time.

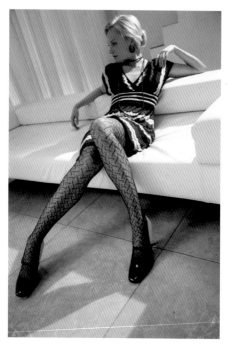
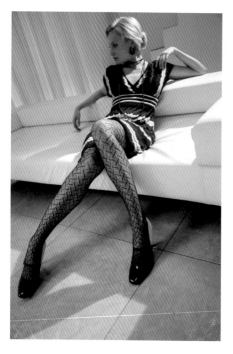
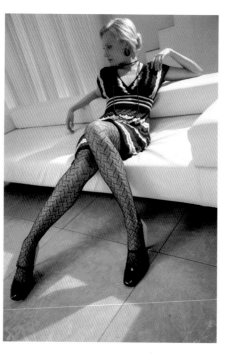

WHITE BALANCE SETTINGS

You should refer to your camera's instruction manual for exact instructions on how to use the white balance adjustment. However, most cameras have fixed settings for correcting white balance:

AUTO WHITE BALANCE

Your camera decides on the correct white balance. It can be unreliable.

CUSTOM WHITE BALANCE

Using a mid-gray card, you can measure the color of light source and preset the white balance to this reading.

KELVIN

You can choose the degrees Kelvin that corresponds most closely to the color of the light source you are using.

TUNGSTEN

This is a preset white balance setting for shooting in Tungsten lighting, which is very red/orange.

FLUORESCENT

A preset white balance for shooting in fluorescent lighting, which can have green or slightly magenta cast.

DAYLIGHT

A preset white balance for shooting in daylight/sunlight which is neutral white light.

FLASH

This preset is for shooting with either on-camera flash or studio type flash lighting. This light can vary in hue. It's generally similar to daylight, though it can be slightly more blue.

CLOUDY

A preset white balance for shooting in cloudy or overcast conditions, which is a very blue light.

SHADE

A preset white balance for shooting in the shade without direct sunlight. This is also a very blue light.

GretagMacbeth™ ColorChecker Color Rendition Chart

Above left: Taking your light reading from a gray card gives you a mid-gray point and helps you set a correct white balance.

Left: These are the effects you get from shooting with different white balance settings: correct right balance (left), shooting using the tungsten white balance setting in daylight (center) and shooting with daylight white balance but using tungsten lighting (right).

ACHIEVING CORRECT COLOR

I always shoot a gray card at the beginning of my shoot and use this as a double-check to ensure I have correct color rendition in my images. Shoot your digital image files with the white balance set to custom white balance. You can then process images as shot, or adjust lighting conditions in the processing program.

SHOOTING RAW AND JPEG

As a general rule, I shoot Raw images in preference to JPEGs. A JPEG is a compressed image that is processed in-camera, resulting in an irretrievable loss of information. A Raw image, sometimes called a "digital negative," is a much bigger file and contains much more metadata. Raw images give you much greater shadow and highlight detail and offer more latitude in contrast and color balance. However, they require post-capture processing, such as white balancing and color grading, for them to be useable as images.

→ When you're shooting fashion for a client, the choice of which format to use is determined by the way the images are going to be used. For example, if you're shooting a large number of images for a catalog, your client is going to want those images as fast as you can provide them. Neither you nor your client are going to want to spend a lot of time processing images from Raw to useable files. Raw files are simply too big and too detailed for the client's needs. They also slow down your shooting speed as there's more data to write to the memory card.

In that situation, you have to provide them with JPEGs. If every image you use is going to be reproduced at A4 size, the images will look fine on the page. However, you have to make sure that you get your exposures, color balance, and contrast correct in-camera, so that the images are ready for reproduction with only minimal processing. The other advantage is that you can shoot JPEGs faster, which is important in fashion work, and they take up less data storage space.

Opposite: Using a standard digital SLR, a JPEG would be fine for a single magazine page, but not big enough to go over a spread. If reproduced at too large a size, (center) the picture begins to break up.

Low Quality JPEG — 0.18MB

High Quality JPEG — 4.2MB

Raw — 8MB (Built in compression is used, the pure data would be 72MB)

The chart below lists how many photos you can fit on a memory card, assuming a 2 GB capacity and an 8-megapixel DSLR. This is only a guide because the actual capacity varies according to the type of pictures you are shooting. Images with plenty of detail, and shots taken at higher ISO speeds use more memory than simple images or those exposed at lower ISO sensitivities.

FILE TYPE	FILE SIZE	IMAGE SIZE	NUMBER OF PHOTOS
Small JPEGs	0.8MB	1936 × 1288 pixels	1479
Medium JPEGs	1.5MB	2816 × 1888 pixels	862
Large JPEGs	2.8MB	3888 × 2592 pixels	516
Raw	8.4MB	3888 × 2592 pixels	200
Raw + Large JPEGs	12.5MB	3888 × 2592 pixels	111

These days, most professional DSLRs will allow you to save an image as a Raw file and JPEG at the same time. That gives you the opportunity to provide the client with JPEGs but keep the higher-quality Raw image if it's needed, though it does slow down your shooting speed. However, if you're processing a Raw file, make sure you do it in the proprietary Raw conversion software. Processing using cheaper software packages can prevent you from achieving an image's full potential.

MANAGING YOUR TIME

When shooting commercial fashion photography, you have to be able to produce a sufficient number of shots of outfits during a shoot day, in order to be financially viable to the client. Most of my clients will expect between 15 and 25 shots to be done with in a one-day fashion shoot.

On a shoot day, everyone will arrive at 9 AM and most hire studios close at 6 PM. You will need to have finished shooting, have your gear packed, and be out of the studio by that time, so you can avoid any overtime costs. This gives you eight hours to produce the images that will make the shoot worthwhile for your client

You cannot say to a client, "Sorry, I messed around with the lighting so much on the first shot that I didn't manage to shoot everything on the list." You would lose your client very quickly. Therefore, you have to be able to manage your time and your team so that you are commercially viable and you can give your clients value for money.

Below: You have to allow for changes of clothes, hair, and makeup between shots. For this shot, the hair and makeup artist worked as fast as possible, but we still had little time for the final pictures.

→ A TYPICAL DAY

If you start at 9am and finish at 6pm, you have eight hours in which to do the shoot. That might sound like a long time, but that precious time soon gets used.

> You need to allow for 1–2 hours of lighting, set preparation, or creating your background. This can be done while waiting for hair, makeup, and styling to be done. This will, on average, take around 1 hour 30 minutes, depending on the complexity of makeup and hairstyle.

> If your client asks you to produce 20 shots of completely separate outfits, that's 20 changes for the model. If each outfit change takes 10 minutes (which on a normal shoot is fast), that adds over three hours to the shoot. Even if you have two models (so you can shoot one while the other gets changed) that would still add almost two hours to the shoot.

> Everyone will expect a lunch break of at least 1 hour.

> Between every shot there will be image file transfer time. In my own work I may shoot 100–150 image frames (or 1-2GB) for each final shot. This adds up to around 20GB of filled memory cards, and that data has to be transferred onto my computer. This will take around 2-3 minutes per GB, so another hour of your day is used on image transfer.

> You will review the images with your client as your shoot progresses. Let's say you take 5 minutes looking through your shots to make sure you have the definitive shot. If you're doing 20 shots, that uses another 1 hour and 40 minutes of your day.

This all amounts to 6 hours and 50 minutes of your shoot time being used on doing things other than taking photographs. Even allowing for some of these activities overlapping, it leaves you with just a few hours to produce 20 amazing shots — less than ten minutes per outfit. This is not taking into account any delays that may occur for any number of reasons.

As the photographer, you are responsible for completing the assignment, no matter what anyone else does (or does not do). Time management is vital; you have to manage yours down to the very last minute.

HOUR	JOB

SETTING UP

10.00 AM

SHOT 1

11:00 AM

SHOT 2

12:00 PM

SHOT 3

1:00 PM

LUNCH

2:00 PM

SHOT 4

SHOT 5

3:00 PM

SHOT 6

SHOT 7

4:00 PM

SHOT 8

SHOT 9

5:00 PM

PACKING UP

6:00 PM

CONTINGENCY TIME

7:00 PM

Left: This table gives you an idea of how a days shoot might work out. Notice I have allowed more time for the early shots as it usually takes a bit of time to get up to shooting at full speed.

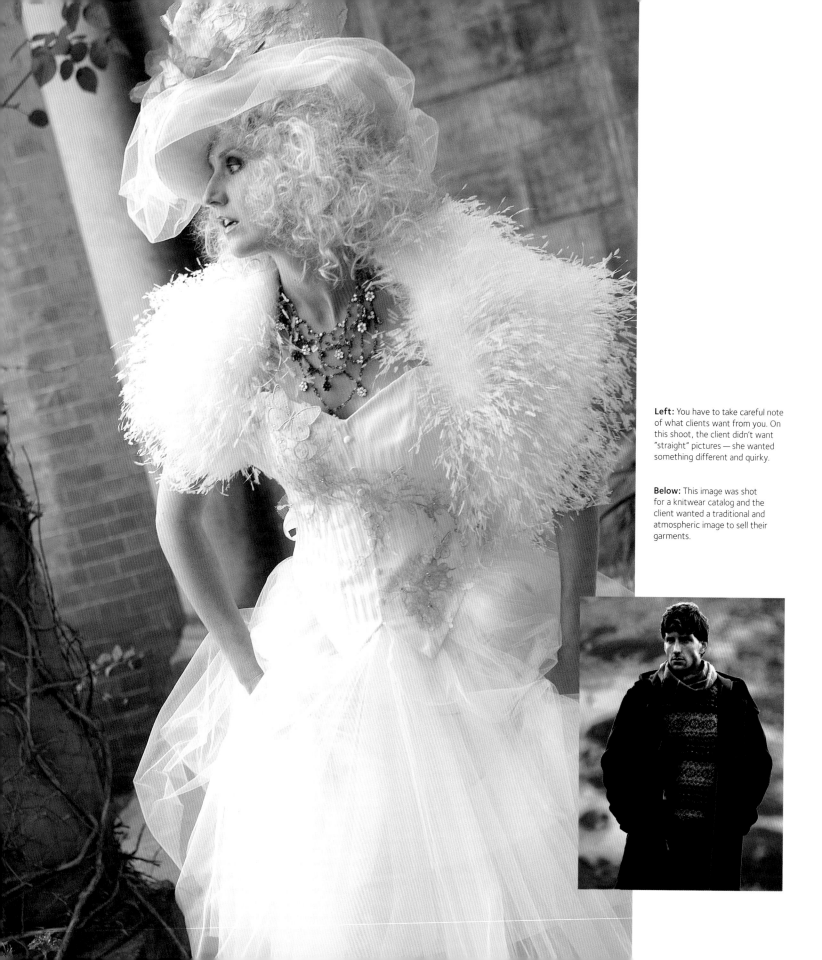

Left: You have to take careful note of what clients want from you. On this shoot, the client didn't want "straight" pictures — she wanted something different and quirky.

Below: This image was shot for a knitwear catalog and the client wanted a traditional and atmospheric image to sell their garments.

REQUIRED SHOOTING: CLIENTS DIRECT

Clients are manufacturers, fashion designers, or other commercial clients. They are the end users of your pictures. Shooting for clients direct means being commissioned by a client and dealing with them without the intermediary of an advertising or PR agency.

Clients sometimes choose you to shoot for them because they have seen your work elsewhere and liked it. Alternatively, you may have been recommended to them by someone else in the industry, or they may have seen your promotional materials or website. There will be something about your work — maybe even the style or look of one or two pictures in your portfolio — that they like and believe it will help sell their product.

→ After being commissioned, you should first ask a client what they liked about your work and which pictures convinced them to hire you. Once you know the kind of images they have in mind, it gives you a benchmark for working out your budget and how much you're going to charge for the pictures.

When you're putting together a costing, you have to research what images the client has used in the past. Look at the client's website; look at the quality of the models they've used, the standard of the hair and makeup. See whether they use studio or location shots. Draw up a list of all the elements a shoot would involve and put them in your budget for the shoot.

The most important thing to determine is how the pictures are going to be used. Then you have to tailor your photographic style to fit the client. For example, you may be asked to shoot a catalog of stock items for a commercial fashion house that produces the clothes sold by a major store. They will simply be straightforward pictures of clothes and the range of colors that are made.

Alternatively, if you're working for a designer label company, you could be shooting for an image brochure. You will still have to show some detail in the clothes, but the main focus is in creating a look and a lifestyle that people will want to buy into.

However, most clients want to sell directly off the page, as in a catalog (see next page). A manufacturer making thousands of dresses is going to want a lot of shots done in a day. He's not interested in creativity, he wants to see details and stitching. The bottom line is that he wants to sell thousands of dresses and he wants your pictures to help him achieve that aim.

Whether you're doing a large number of shots of low value garments, or a small number of shots of high value garments, you have to instill confidence in a client and convince them that you can deliver what they want. If they want 24 shots or more done in a day, you've got to be able to come up with the goods.

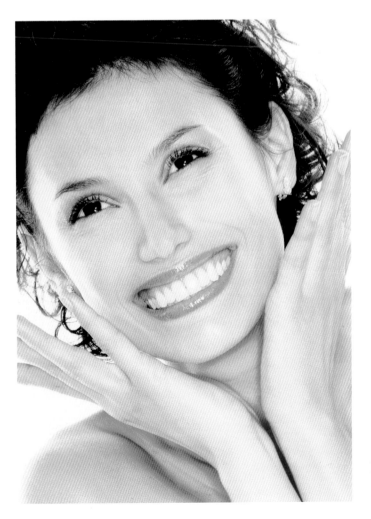

Left: I shot this image to go on the cover of a bridal wear brochure. The picture had to be bright and eye-catching and to convey a feeling of excitement.

CLIENTS DIRECT SHOOT

I was commissioned to do a shoot for Sasso, a company that specializes in bridal wear accessories such as marabous and jewelery. A second client, Sharon Bowen, designed the gowns and it became a combined shoot on behalf of Sharon Bowen and Sasso.

→ I found that the pictures were going to be used for an image brochure, rather than a catalog, so that gave me the license to be creative in my setups. It wasn't going to be about selling garments; it was more about selling the brand and influencing people to buy the brand. It was about creating an atmosphere. In that sense, an image brochure shoot is similar to an editorial shoot. I knew that I had to show some detail in the garments and accessories, but details were not as vital as they would have been in a catalog shoot.

The idea was to shoot a series of pictures that created an image for their product. I was given the job of creating pictures based around an eccentric, but elegant aristocratic lady. The brief was simply to go as crazy and as wild as I could, so I had a free hand to interpret it as I wished, within the limits defined by the style of the garments.

I had worked previously with a model who had an Edwardian look, with very pale skin. She was also very slim and tall, and ideal for the gowns. I recommended her to the client. We used an English stately home as a location and I shot the model wearing a number of different gowns and accessories. I used various interior and exterior locations around the house, making use of architectural features and shooting mainly with natural light and reflectors.

Below: These images are all from the same shoot and show the kinds of image that was required. The clients were delighted with the final results.

Opposite: I recommended this model to the clients as I had worked with her before. She had exactly the right kind of face for the "eccentric aristocrat" theme.

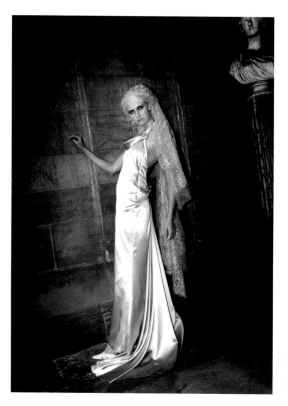
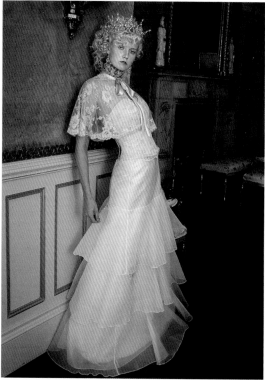
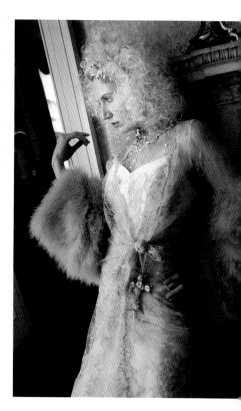

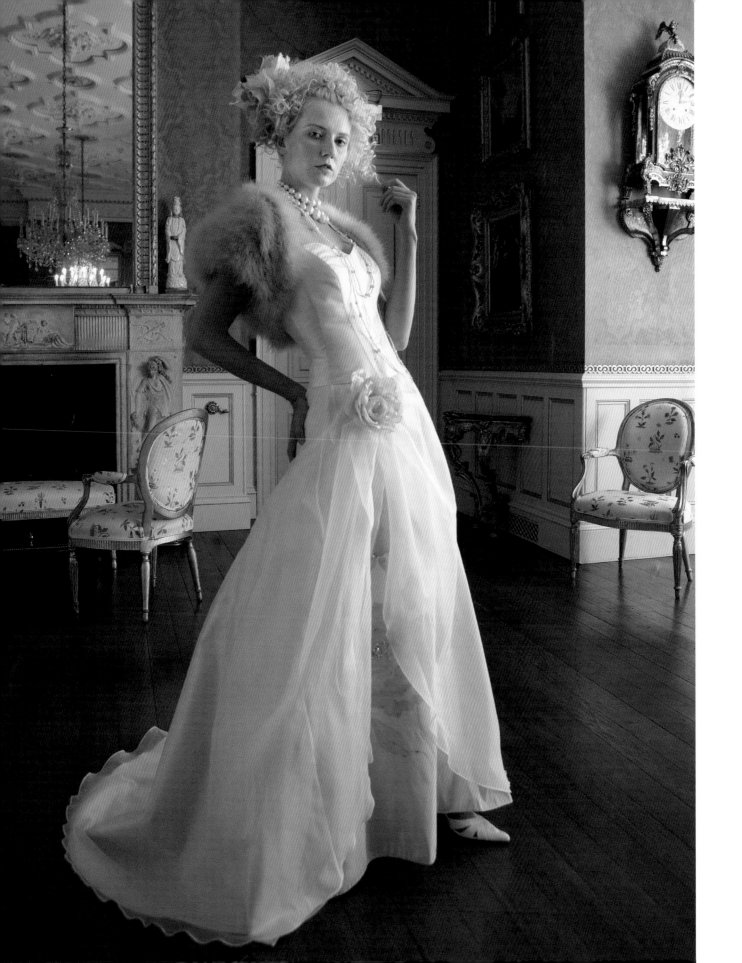

REQUIRED SHOOTING: ADVERTISING

When you're commissioned to do an advertising shoot, the decisions on what images are required have already been made. The agency will have determined the philosophy behind the advertisement. They will know who they think will buy the product and how they plan to persuade them to buy it. Advertising images are carefully constructed and they often contain a psychological message. Your job is to pick up on the agency's brief very quickly and achieve their objectives with the images.

Below: I was given a specific brief for this shoot: to show the product being advertised — in this case, a stylish pen — reflected in the model's eye.

→ The art director will have designed the concept for the advertisement and produced a "visual" showing how he wants the images to appear. Once it has the client's approval, it has to be followed in minute detail. That applies not only to the atmosphere and emotion that needs to be evoked, but also to small details within the pictures. That "visual" is usually mocked up with stock pictures.

With the approval of the client and other members of the creative team, the art director picks the photographer that he believes will best fulfill the brief. Photographers are commissioned to shoot because the agency will have already seen something in their portfolio that's similar to the images they want. They are buying the photographer's technical expertise, their confidence, and their experience.

The art director will work with you on the shoot and ensure that all details are correct. Together with the art director, you will research an appropriate location for the shoot and decide what props are needed. You also need to source models that fit the brief and know how to get the best out of your models on the day of the shoot.

The brief is usually very specific, but you can also be asked to do one shoot then provide several variations around it, in case something else works slightly better. You may also have to provide slightly different images for overseas sales.

It's exacting and demanding work with big responsibility. The client will often have invested a great deal of money in advertising their product. Your images might be seen by hundreds of thousands (or even millions) of people, both nationally and internationally. For that reason, advertising fees are a lot higher than most other types of photography. You can get more money for doing one shot than you would for an intensive day's work doing 24 shots for another kind of client.

However, the high rewards and status make advertising photography a highly competitive area in which to work. It's very unlikely that a young photographer starting in the business would be offered advertising shoots. Unless you're very lucky, this work only comes after gaining years of experience and becoming well-known in the industry.

Above: For this advertising shot, the client wanted a moody image showing someone getting sensual enjoyment from eating their ice cream. I lit it sparingly to concentrate attention on the woman and her dessert.

ADVERTISING SHOOT

I was commissioned by a specialist healthcare advertising agency to produce advertising images for a product called Zelma, a skin growth accelerator for people who have cuts and sores that don't heal.

→ When I went to see the agency for an initial meeting, I was given an outline of the shoot's requirements. First, I took time to fully understand the brief and the strategy behind it. The images had to show models who looked like medical staff appearing to endorse the product. The location had to look like a professional clinic. The copy line and brand name would specify the product and its selling points; the images simply had to create an impression that backed up the words.

I was shown the design layout for the advertisement, which had been mocked up with stock pictures and approved by the client. I was asked if I could produce pictures that matched them.

First, I found a modern location that captured the intended spirit — one that had plenty of glass and chrome and spotlights. However, to make the location look like a high-tech hospital, I needed a stylist to get all the necessary medical props that you'd find in a clinic. Then I had to take time casting the right models. I wasn't looking for beautiful models; I had to find models who could convincingly portray professional medical staff.

During the shoot, I had to reproduce the visuals almost exactly, even to the point of including an out-of-focus line in the wall and where lights were positioned in the ceiling. I also had to shoot variations for the different countries in which the advertisement was going to be published, which involved wardrobe and hair and makeup variations. The resulting images convincingly portrayed medical staff at work and both the agency and the client were very happy with them.

Left: The original shot, taken with a depth of field shallow enough to soften the background.

Above: These are images from the Xelma advertising campaign. Every aspect of these images had to be as the client wanted, from the model to small details in the background.

Left and far left: I set up the shot and tested the background before I brought the models in.

REQUIRED SHOOTING: EDITORIAL

Shooting editorial fashion is about creating a fantasy around a current clothing trend to both interest and influence the viewer. If you want to shoot fashion for magazines and newspapers, you've got to follow the very latest developments in that world.

→ Fashion trends change rapidly. If a celebrity is seen wearing a certain color or type of garment, it can become very popular overnight. As a fashion photographer, you've not only got to know what is currently fashionable, you also need to know what's coming up in the future — the looks that are going to filter down from the catwalk to the high street. Your portfolio must contain up-to-date images of the latest trends. If your images look like pictures from magazines four years ago, you're not going to get an editorial job.

At an early stage in your editorial career, when photographing for smaller magazines, you'll find that they will expect you to be the inspiration behind the pictures. To get work from these magazines, you've got to get appointments with fashion editors, show them your portfolio, and express your ideas. Put the emphasis on the fashion stories you've already done, published and unpublished. They're looking for the photographers to make their magazines look good. If you're a very creative editorial fashion photographer they will keep using you.

For some of the bigger circulation magazines, a fashion editor might contact you to say they have seen your work and invite you in to discuss a project. They will be confident that you know what it takes to produce a fashion story of 8–12 images, with possibly a cover image included. That story could be about a particular kind of garment or an accessory that's currently popular. It might be about stripes, or glitter, or just one color. At the top end of the market, a monthly magazine such as Vogue will have a big budget, which often means working with top models in expensive locations.

Editorial fashion has a more edgy look than catalog or advertising work. The models usually have more striking features and catwalk models are often used. The pictures have to arrest the reader's attention.

Editorial shoots usually happen quite quickly. Catching a fleeting trend requires speed and there may not be a lot of time to plan your shoot. For example, you may get a phone call from a fashion editor in the middle of the week to ask you to shoot the next day, so that the pictures can be published at the weekend. They will have picked the clothes for the shoot and sometimes you're not even told what you're going to shoot before the day itself. You arrive to find that the studio's booked, the clothes are there, the hair and makeup artist is booked, and you just get started.

Whatever the magazine or newspaper, the fashion editor will expect you to be creative in your interpretation of the brief. However, you don't have a totally free hand; you still have to produce pictures that are going to suit the magazine, so do your research and get to know it well before you start shooting.

Above: This is an image from an editorial shoot for *Arabella* magazine. I was asked to produce pictures for a particular story, ones that showed well-dressed people having a good time.

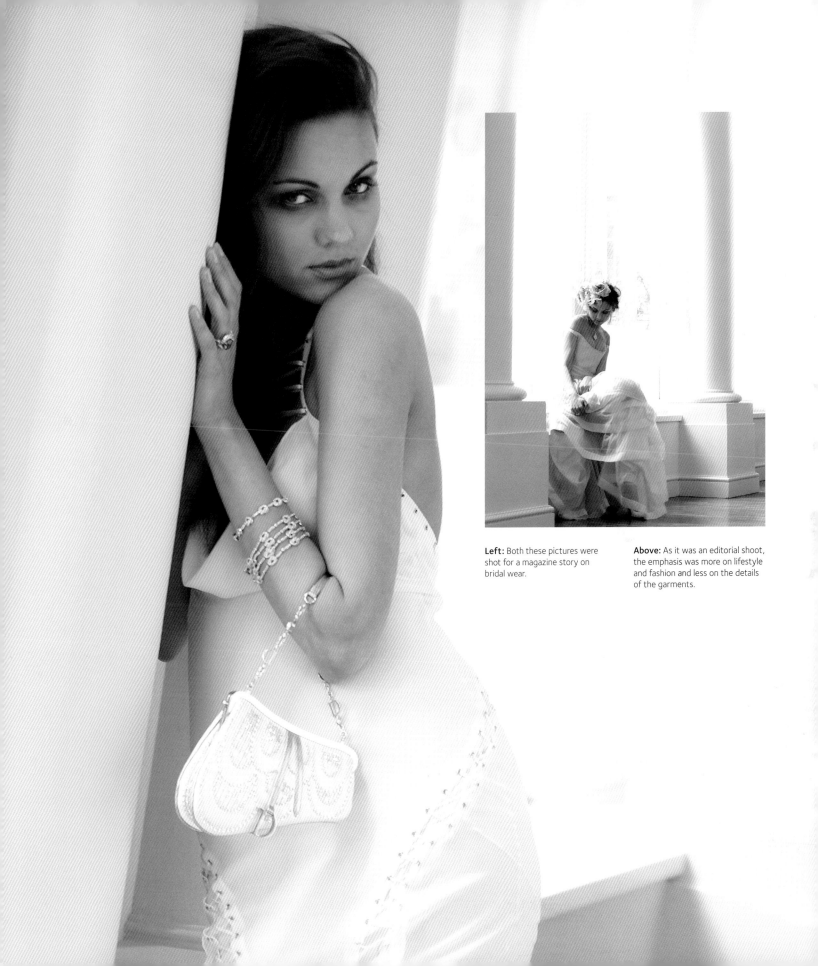

Left: Both these pictures were shot for a magazine story on bridal wear.

Above: As it was an editorial shoot, the emphasis was more on lifestyle and fashion and less on the details of the garments.

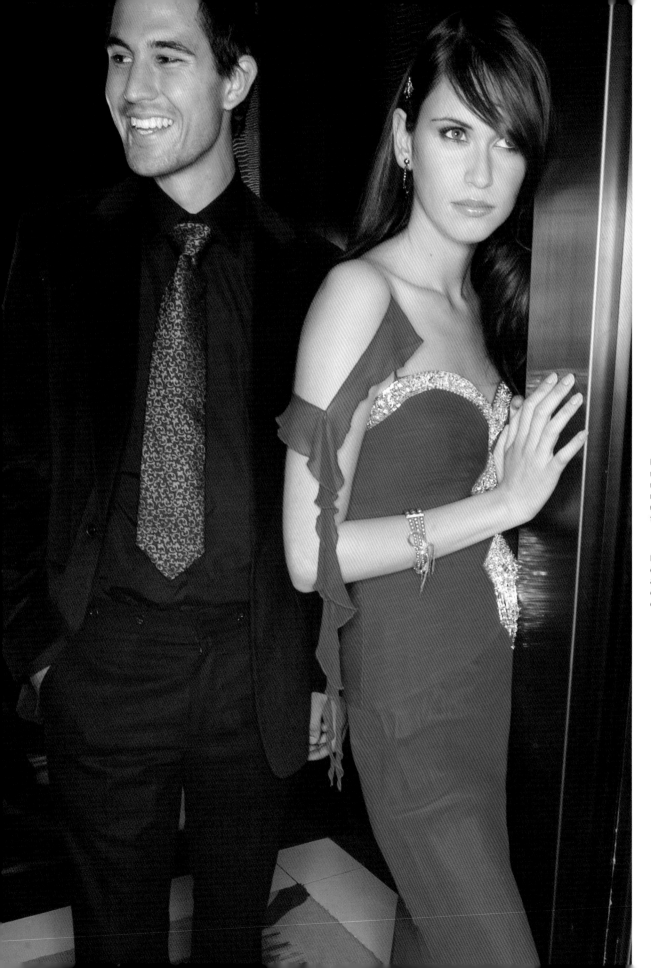

Left: An editorial shoot can be more about the character of the models and the setting. Magazines might be helping their readers understand where they might wear the products they're reading about.

Right: Editorial, more than catalog, will expect you to provide an alternative style, and if you concentrate on editorial work you can build a recognizable style.

EDITORIAL SHOOT

In complete contrast to advertising work, editorial shoots usually give photographers quite a lot of creative freedom in how they interpret the brief. The magazine's fashion editor will have seen and liked your work and you are literally being brought in to create some interesting pictures. One example is a fashion story I was asked to shoot for the launch issue of *Arabella*, a glossy Middle Eastern lifestyle magazine.

→ The fashion editor had already selected the clothing, which was a selection of different cocktail dresses. The pictures had to be glitzy and glamorous. They had to portray a young female celebrity having a great time, while her boyfriend was annoyed that she was getting all the attention.

The magazine's fashion editor and I went to research locations and found a very luxurious apartment building that had only just been finished. One of them was a show apartment that had been nicely furnished and it was ideal for the shoot. We chose a sexy young model and a handsome young man to appear as her boyfriend. The boyfriend was an accessory to the story, but it was important that he had the right look.

I decided to shoot the pictures using ringflash, so that the models were brightly lit and looked like celebrities. I set a high tempo for the shoot and directed the model to be full of energy in the pictures, while asking the male model to appear distanced and sulky. The location also offered gardens and waterfalls, one with a background of black granite, to use as exterior locations. The result was a story that looked colorful and exciting and one that provided the highlight of that issue of the magazine.

Below: A ringflash; a diffused flash that fits around the lens of the camera and conceals shadows, gives this striking low-contrast style which suited this shoot.

There are several types of catalog for which you might shoot fashion pictures: the consumer mail order catalog, the trade catalog, and the image catalog or brochure. Catalog images can be very simple shots taken against a white studio backdrop. However, they can sometimes involve location work or quite complicated sets and backgrounds, which give the pictures variety and interest.

→ A catalog shoot is usually produced from a shooting trace, which has been determined by the catalog company's design department. Catalogs are very carefully assembled; the company's designers will know the way people look at a page, and how certain items, on certain pages, placed in certain positions, will sell better than others. These factors will influence how you shoot the pictures. For example, you have to make sure that people are looking at the right part of the picture. If you're selling a blouse, you have to make people look at the blouse and not the shoes.

Mail-order catalogs are produced in a variety of different styles, but they all have the same purpose: to sell directly off the page. The garments are the most important thing — their style, cut, color, and length — and they have to be shown clearly and very accurately.

If you are working on location, you may shoot a complete collection in one place. Various techniques are used, but the pictures are often shot using large diffusion screens. The backgrounds are usually blown out of focus so they're not a distraction.

Left: These images were shot for a trade catalog, so had to show detail in the garments as well as the length and cut of the dress.

Style 9228 £209.00

Style 9280 £215.00

Should you be interested in becoming a Margaret Lee stockist contact Mark on 01245 425558 or email mark@margaretlee.co.uk

Margaret Lee

Catwalk feather collection

Sasso

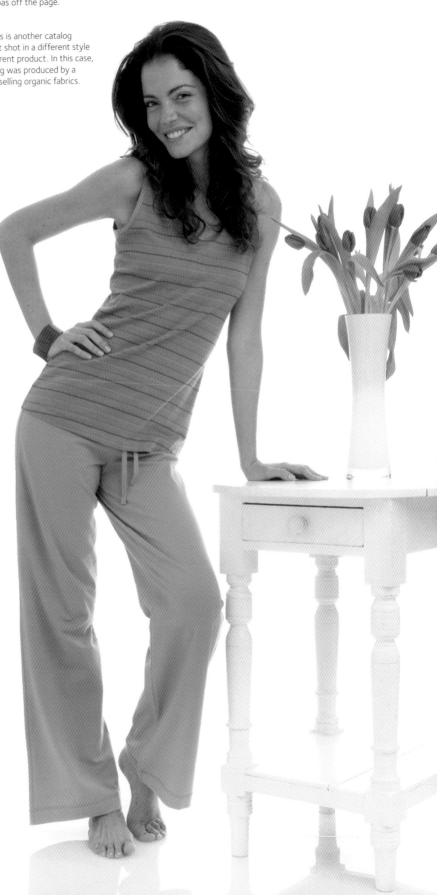

The same can be said for trade catalogs, which manufacturers use to sell their garments to retailers. There are also other trade catalogs that sell garments such as uniforms and work clothes to industry and corporate organizations.

The way the pictures are used determines the type of model you use. A mail-order or trade catalog model has to make the clothes look good, but they shouldn't take the viewer's attention, so you wouldn't use a striking catwalk model. Attention must be concentrated on the clothes, so the model will be attractive, but in a girl- or boy-next-door way.

A photographer that's commissioned to shoot mail-order or trade catalogs will often be shooting many pages during one shoot. This could involve either studio or location shoots anywhere in the world for several weeks at a time. The work is well rewarded, but can be very boring as you're often doing a lot of repetitive pictures.

Designers and manufacturers also produce image catalogs or brochures purely with the aim of creating interest in the label or brand. They're often shot by editorial photographers who have a more edgy, journalistic approach, or who are used to shooting "lifestyle" images.

All of these markets are very lucrative areas in which to work. Consumer catalogs are produced twice per year, at Spring/Summer and Fall/Winter. The fees can be quite high and regular bookings occur if you're very good at producing images that sell garments very well.

CATALOG SHOOT

I had been commissioned to shoot for the Estes bridal-wear catalog in the past and the company approached me for a new shoot. We had previously photographed for the catalog in a studio, then once on location in a classical English stately home. This time, the shoot was to take place in a more contemporary-looking location to give a fresh and modern appearance to the pictures.

One of the main criteria for choosing a location is whether it can provide enough variation; you have to avoid the pictures looking too similar to each other. You also have to assess whether you are going to be struggling for backgrounds. Look at what props and furniture are on site and whether you can do a reclining shot, either with your model on a chair or leaning against a wall.

We chose a large, minimalist interior location owned by a London-based locations company. It had plenty of furniture, such as huge low-level sofas, which were perfect for the model to recline on and show the wedding dresses' full potential.

I had around 24 dresses to shoot and aimed to get plenty of variety in each shot. I arranged the shoot so that we photographed four dresses in each area that we worked. This avoided wasting time by moving the lighting around too often. I used a mixture of daylight and continuous light, which worked well and gave the catalog a bright, natural atmosphere.

Below: It's important to light the fabric so it's texture is obvious to those browsing the catalog what it is — they will not get to touch it.

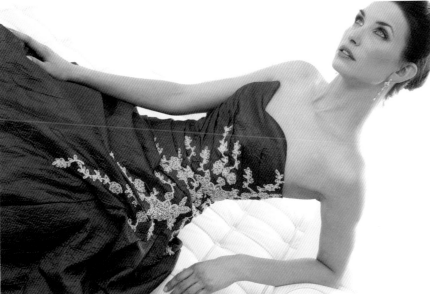

Right: The model is positioned so that slightly more light falls on the background and the shot is exposed for her.

Far right: With a dress like this it is important to make sure there is a pleasing pattern of folds and creases visible to the camera.

Left: The light-colored surroundings do not conflict with the subtle shading and details of the dress, ideal when you are trying to capture subtle variants on white.

POST-PRODUCTION

You've done your shoot and saved copies of your images. Now you have to take time to complete your work on these images and submit them to your client. This chapter looks at what you need to do in this important final stage, from selecting your images, to making post-capture adjustments. All your hard work can be ruined by poor image editing and post-production work, so you have to ensure that you maintain a professional and organized approach.

This chapter includes sections on image editing in Photoshop. I have to say that I believe that some photographers rely on Photoshop too much for correcting mistakes made at the time of shooting. Professionals should get their images as technically perfect as they can in-camera. Images should be lit correctly, exposed correctly, and color balanced.

Nevertheless, in the same way that photographers knew how to creatively print and retouch their work in the traditional darkroom, they now need to know how to get the best out of their work in Photoshop. The chapter concludes with some practical advice on using this powerful software.

I don't intend these sections of the book as a complete guide to using Photoshop; you will have to look to other books, or educational courses, to provide a full explanation. Instead, I will focus on the ways in which you can use some of Photoshop's capabilities specifically to improve fashion images.

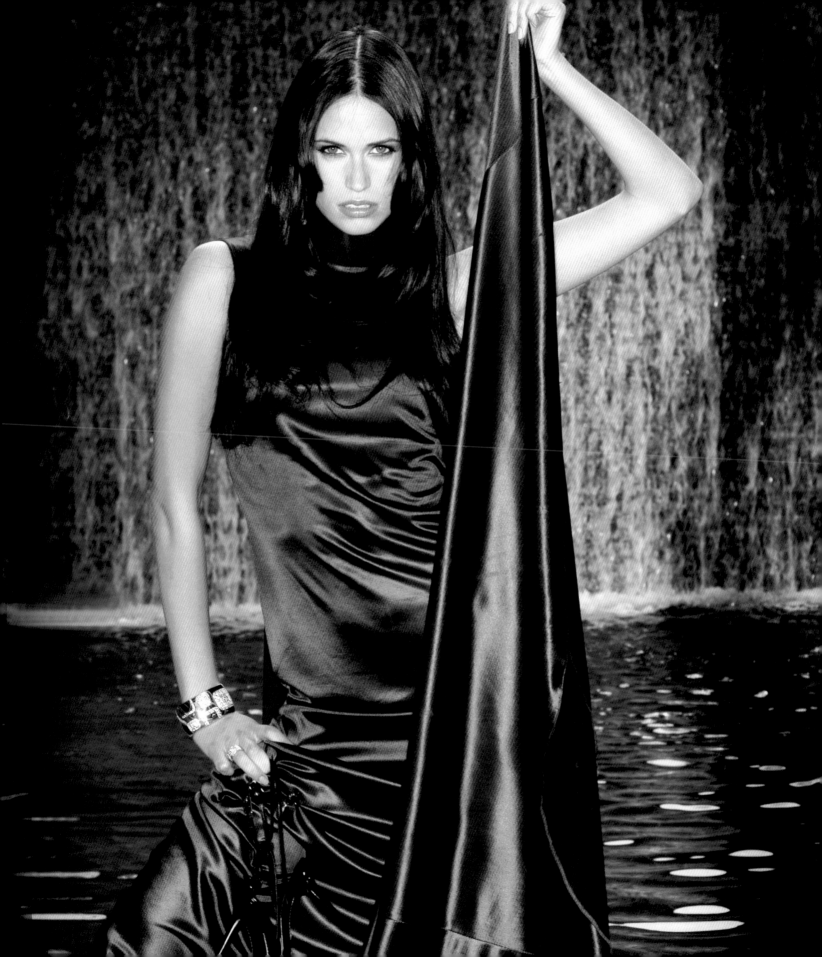

POST·PRODUCTION

EDITING

Your selection of images from a shoot can make or break a pictorial fashion story, so choose them very carefully. Editing is the first stage of the image selection process and it's the time when you weed out all the images that are unsuitable. If you've shot a lot of images at high speed, there will be many that haven't worked for one reason or another. First, take out the obvious failed shots — the images that are out of focus, ones where the model's eyes look odd, or you have caught an off-guard expression on their face.

Then you should start picking out the shots that you like — the ones with a good overall look and shape, those that are perfectly lit and show the models with good facial expressions. Right from the start, you should consider which images are suitable for left and right pages and those that have potential to be used as cover shots.

For each shot that you have been asked to take, you need to select 5–10 images that you like. There can also be frames from the same shot that could be used together on a spread. For example, you may have close-up and full-length shots that would go nicely together on a double-page spread. Edit the images with potential combinations in mind (see Shooting for Balanced Spreads, pp. 108–109).

All of the images you select need to be saved as copies. Do not work on the original files or change the original file names. When you're saving a copy, use a name or

➜ abbreviated name to put at the end of the original file name. This will enable you to return to that digital original if necessary. Also, when you get requests for copies or alternatives, you will not find yourself — like I have done in the past — searching endlessly through your image files.

SHOULD YOU EDIT?

Some clients will expect you to edit your images before submitting them, while others expect to see everything you've shot. On one occasion I was asked to shoot a fashion story for a newspaper supplement and sent them an edited selection of the pictures. Shortly afterward I got a very angry message saying that I shouldn't have edited the pictures. At no point was I advised that I shouldn't edit, but I was never asked to shoot for that publication again.

On the other hand, there have been occasions when I have sent original unedited files to a magazine, expecting the editor to get back to me with the selection of files that they wanted checked and retouched. But they haven't got back to me. Instead, they have used a poor selection of shots and published them without any retouching. The final printed story looked very bad.

Neither situation I've described benefits your career as a photographer. If you edit when you shouldn't, you won't work for that publication again. If your story is published but looks bad, you will not gain any additional work as a result and you won't want to put it in your portfolio.

The lesson to be learned is that when you're asked to shoot a fashion story, it's very important to check each client's policy on editing images.

Left and right: Keep your image file names running consecutively. I have lost hours of time looking through image files, because I have had my file names start at 0001 for each shoot.

SUB-EDITING

When you're doing the final edit of the images from a shoot, you should select down from your edit to around ten images that you know work very well together. These are some of the points you have to consider when making your final choices of image:

> Do the garments look good?
> Is the exposure perfect?
> Is it sharp?
> Is it well lit?
> Are there any awkward dust spots on the images?
> Does the model's facial expression convey the right mood?
> Do the shots meet with the client's brief?

You should also consider how the images are going to look when published. You have to look for images that work well as left and right-hand pages and aim to provide a variety of close-up, three-quarter, and full-length shots. This will give an art director plenty of scope to choose where the shots will be placed, and to know that there is space for text (either headings and sub-headings, or blocks of text). If you have already been provided with a layout, you should make sure the images meet these requirements.

When you're showing the images to your client, you should do some basic post-production in Photoshop to show how the shots and story can be enhanced, given some retouching time. You could maybe do a couple of variations, perhaps de-saturating the images to show how they would look in black and white.

Sometimes you won't need to do any retouching of the final images. If you're shooting for high-end magazines, they will do all the retouching as a matter of course. It's the same when shooting with an advertising agent. However, most small magazines and nearly all direct clients will publish the files you give them without any retouching. Always make it clear to your clients that Raw digital files need post-production and establish who is going to do it. If you are required to do all the retouching, allow half an hour per shot for managing the files when you're doing your budgeting. You should also allow half an hour to an hour per shot to make the images look their best.

Once the final selection has been made, you should resize the images to fit the publication's page size. If the image needs to be cropped, or it needs extra background adding to the sides, top, or bottom of the frame, you should do it now. Consider the balance of your spreads and which images work best together. When you're choosing a single shot for a double-page spread, remember to bear in mind where the gutter will fall.

A published fashion story is your showcase and can lead to further commissions, so it has to display your work at its best. This applies not just in terms of the images' technical quality, but also to their content and the way the pictures combine to form a consistent story.

Left: Once you've selected your favorite image, open it in Photoshop. If you were shooting Raw, you will need to use the Raw conversion tool.

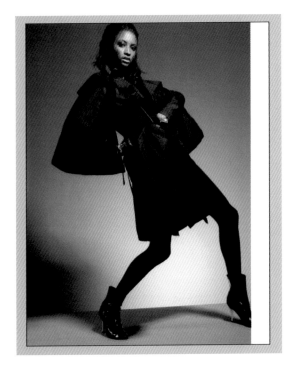

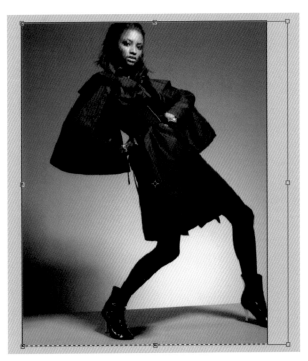

Above and right: To prepare for the final page, use the Canvas Size tool to increase the page dimensions to match the publication. Afterward, use the Transform tool to increase the size of the picture to fit—it's OK to slightly alter the proportions.

Canvas Size	
Current Size: 26.1M	OK
Width: 8.503 inches	Cancel
Height: 11.93 inches	
New Size: 27.6M	
Width: 9	inches
Height: 11.93	inches
☐ Relative	
Anchor:	
Canvas extension color: Background	

Above and left: A final step before sending off an image is to sharpen it using the Unsharp Mask. Concentrate on the focal point of the image.

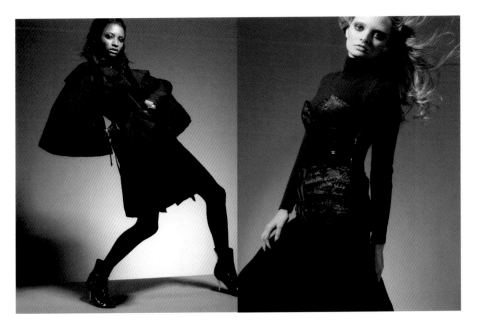

Left: Magazines will often juxtapose two images on a double-page spread like this. Look for pictures that will work well together.

PREPARING FOR PRESS

Preparing your images for reproduction is an important final step on the road to a published fashion story. Of course, in some cases you won't have to do any preparation. As I've previously mentioned, some clients will expect you to simply provide unaltered files from a shoot and they arrange all post-production work. However, in many cases you will be expected to provide finished images that are ready for press.

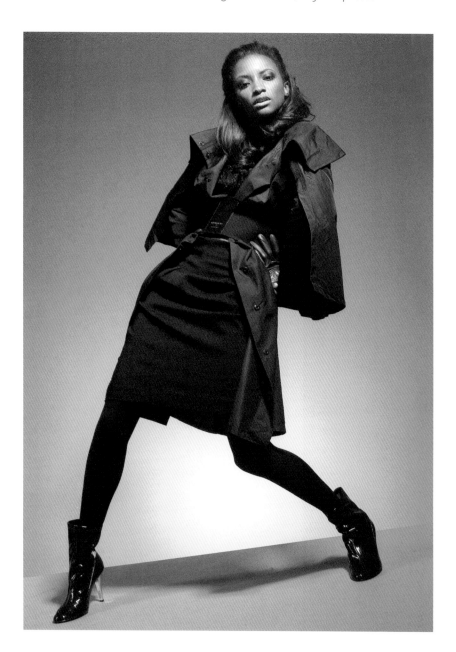

→ Once you have finished retouching the images that you're sending to the publication, you have to save them in a usable format. This format varies, depending on where the images are going to be used. If images are being reproduced on the internet, they have to be saved as JPEG files in sRGB color space. They should be 72ppi (pixels per inch) and sized to the dimensions at which they're going to be viewed.

As a general principal for print reproduction, you should give your client the highest possible quality image. If you save the image as a JPEG, you're compressing it and reducing the quality. The idea is that a JPEG subtracts non-essential data, but it is also taking away essential data. Therefore when your client re-opens the file and increases the size at which they're viewing it, they may see artifacts around the outside. It's far better to save your image as a TIFF. It's going to take up a lot of storage space, but it's going to be the best possible quality image from your original file.

Leave your images in the color profile that you've worked on in Photoshop (usually Adobe 1998). Magazines and newspapers are printed in CMYK (which stands for Cyan, Magenta, Yellow, and a black Key), so files should be formatted in that color model.

If your pictures are being reproduced in a magazine or brochure, ask them what file size they need. They may specify that they need the images at 300dpi at the size they're going to be reproduced, or ask for a minimum file size (e.g., 24MB for a single page, 48MB for a double-page spread). Whether you're working on an image that's going to be used in print or on the internet, make sure your monitor is calibrated for accurate reproduction. Use a high-quality monitor and keep it calibrated using a colorimeter.

The way you get your images to the client depends on the volume of images you're sending. A CD or DVD is acceptable for most publications. Some clients will have their own FTP server to which you can log on, find the relevant folder and simply drop the images in. Alternatively, if you're a Mac user, you can use iDisk to store images online and your client can download them from that location.

Whatever way you choose to get your images to a client, make sure they are delivered at the file size they require and in good time for the deadline.

Left: This picture, which is saved at a resolution high enough to use on a magazine page, is a 26MB, RGB file, but 35MB once converted to CMYK as there is a fourth channel.

Right: Photoshop's mode menu allows you to convert the image from RGB, which is how your camera will have recorded it, to CMYK, the preferred press format. Check with your client whether they want you to do this or would rather do it themselves.

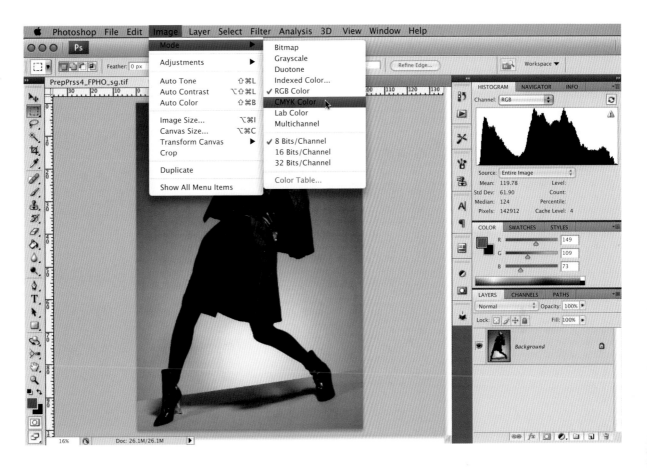

Above: Once you have converted to CMYK, you will need to save the image. TIFF is the most widely accepted format in the industry.

Left: TIFF stands for Tagged Image File Format, and the "tags" in question refer ro a number of sub-formats. Make sure you choose None or LZW in the compression option as these are the most standard options.

COSMETIC PHOTOSHOP

Although I personally prefer not to get involved in retouching, it is an inevitable part of modern fashion photography. Whether you choose to do it yourself, have an assistant do it, or leave it to the client is up to you, but always remember that it is a separate task, above and beyond the photography, and as such needs to be billed for. Never fall into the trap of doing the client's work for them. That said, when you're preparing work for your portfolio, there are times you'll need to do it yourself. In this and the following pages I'll review the most common Photoshop procedures that will help make your work stand out. This is not a Photoshop manual and there is far, far more to the program than we can possibly look at in these pages. If you find you have an affinity for digital editing, by all means explore it.

→ The classic Photoshop trick is to remove spots and blemishes on the skin, and most books will tell you to use the Clone Stamp tool — often erroneously called the Rubber Stamp tool — to do so. Actually, as Photoshop has developed over the years quicker, more useful tools have been added that greatly accelerate the process. The Clone Stamp should only be a fallback when the Healing Brush and Patch tools fail you.

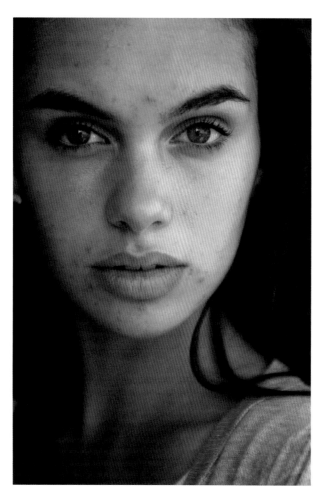

Before: This model has been test-shot without any makeup. Using just the Healing Brush and Patch tools we'll add some digital concealer.

1 Open your image in Photoshop and duplicate the image layer by dragging the layer named Background onto the New Layer icon at the bottom of the Layers panel. This protects you against any mistakes by preserving the original layer underneath, and means you can quickly refer back to the original by briefly turning off the copied layer onto which we'll be working.

2 Select the Spot Healing Brush tool. This is a "smart" tool, in that it only needs you to tell it where the blemish is, not to identify an area to clone from as other tools do. As soon as you select it the mouse pointer turns into a circle, representing the size of the area that the tool will affect. Using the [and] keys you can change the size. Adjust it so that it is a little larger than the blemish you want to remove.

3 You can also adjust the Hardness of the brush. It's a good idea to slightly soften its edges — you can do this using the Brush Picker drop-down in the Tool Options Bar. Then simply click on the blemish and it will be replaced with the texture of the surrounding skin. Most of the time this is all you'll need to do, but if you'd prefer to specify the area that the replacement skin texture is sourced from you can use the Healing Brush tool. That tool works the same way except that you must hold the Alt key and click on a source area before you brush over the blemish.

4 If you need to repair a larger area a quick solution is the Patch tool. With this tool you can click with the mouse and draw an outline around the area you wish to cleanse. Check that it is set to Source mode in the Tool Options Bar—that means that you will be able to specify a new source area for the patch you've marked.

5 With the patch complete, simply click inside it and drag. Watch inside the original patch area and you'll see that the new target area appears in the area you marked in the last step. When it is filled with an area that has the smooth texture you want, release the mouse. It isn't essential that the color matches precisely, because Photoshop will handle this.

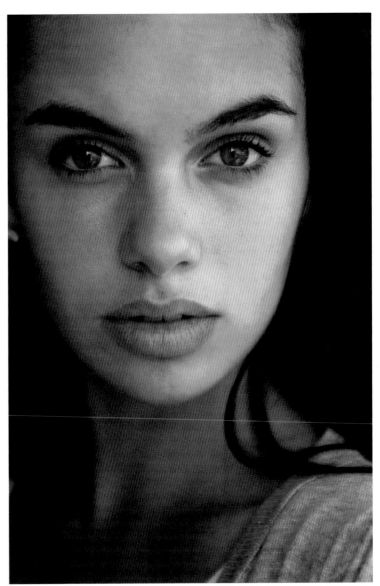

After: In the original image, the eye was drawn to the blemishes. Now the model's beautiful eyes and lips are, as they should be, the center of attention.

A WIDER ANGLE

The one danger of my fast-paced style of work is getting a shot which is tantalizingly close to the client's needs without quite meeting them. It doesn't happen often, and there are usually plenty to choose from, but in this case they wanted to use this shot for its piercing look, but the crop was a little too close.

→ As I mentioned at the beginning of the book, it's sometimes necessary to shoot with a camera that has a fast buffer, which means I shoot as close as possible to ensure that no pixels are wasted. If you're working with a medium-format camera it's possible to allow more room for editorial crops, but the downside is that they aren't usually as quick to empty their memory buffers.

In circumstances like that, it's possible to be a little creative in post-production, and in this case, in order to widen the picture to the necessary page size, I simply duplicated the hair from the right side of the image to the left. With some deft use of the brushes, the result is completely convincing.

Before: The starting picture is where we left off at the end of the previous spread, but too narrow for the requested page size.

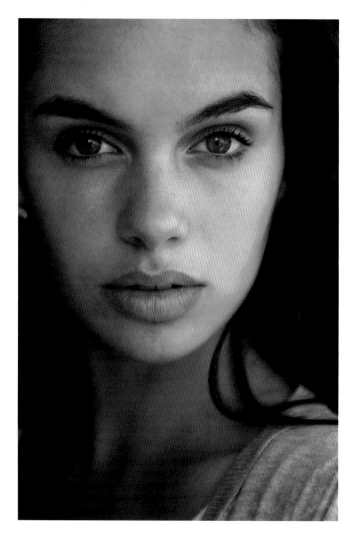

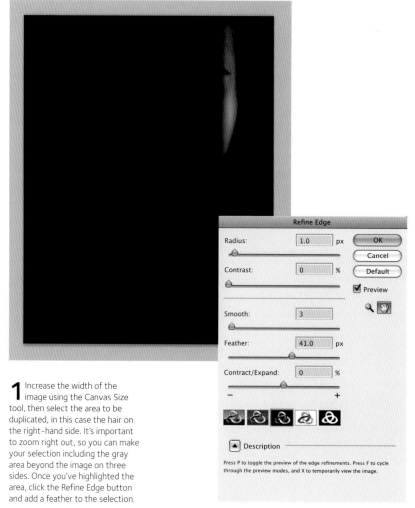

1 Increase the width of the image using the Canvas Size tool, then select the area to be duplicated, in this case the hair on the right-hand side. It's important to zoom right out, so you can make your selection including the gray area beyond the image on three sides. Once you've highlighted the area, click the Refine Edge button and add a feather to the selection.

2 Copy the highlighted area onto a new layer using the Via Copy method. This duplicates the pixels onto the layer above, while leaving the originals on the layer below. With the Transform tool, drag the copy to the left and drag the right-hand side over the left to flip the copied pixels. To help position the new layer, set its opacity to 70% in the layers palette.

4 Return to the top layer and set its opacity back to 100%. There are likely to be some awkward edges, so create a layer mask and paint out the areas that don't look right. In this case the side of the face needed to be removed, as it was lit incorrectly.

3 Temporarily switch off the new layer and return to the lower layer. I chose to duplicate it, and on the duplicate paint in the lower-left area. This needs to be black as — given the subject's pose — she cannot have two shoulders facing out and this area would be in shadow.

After: To complete the effect, a second duplicate of the hair is added, but this time a little further down. It is masked so that some of the potentially distracting dark area in the lower left now has some of the hair which would fall naturally.

Fashion, and by extension photography, is all about color, and viewers will be drawn in by bright and exciting use of color. If you're concentrating on the model's face — perhaps you're shooting for a makeup brand — then you'll need to make sure you bring out the colors the client wants to see, and that can be achieved surprisingly quickly in Photoshop.

Before: The original image is slightly underexposed in order to avoid the risk of blown highlights. The downside, however, is slightly flat tones that need a digital boost.

1 The first step is to add a Curves layer to the image to control the contrast. Drag the control point from the top right corner along the top until it lines up with the right-most peak of the histogram below; this has the same effect as using the levels tool. Now, to keep the image contrasty, adjust the curve so that it peaks near the upper-midtones. This brightens the lighter areas of the image.

2 The Color Balance tool is the best way to control the overall appearance of the picture. Here the overall image has a strong yellow and a cyan cast thtat I'd like to eliminate, since the aim is to exaggerate the strong yellow makeup. Using a Color Balance layer, select the Midtones option and move the Yellow-Blue slider into the Blue zone until you feel you've negated the effect. Tweak the other sliders until the skin tone looks natural.

Cyan	Red	+10
Magenta	Green	+5
Yellow	Blue	+27

After: Once I was happy that I had the tones right, I brightened the eyes and removed the hair to create this striking image.

3 To alter the yellow tones only, add a Hue/Saturation layer and then select Yellows from the drop-down. You can even specify which colors to adjust by clicking the button next to this drop-down then clicking and dragging over the model's lips; Photoshop then selects the color range automatically. Now you can slightly adjust the Hue slider to make the lips redder and, perhaps more importantly, increase the Saturation slider to strengthen the makeup.

Yellows		
Hue:		-8
Saturation:		0
Lightness:		0

15°/45° 75°\105°

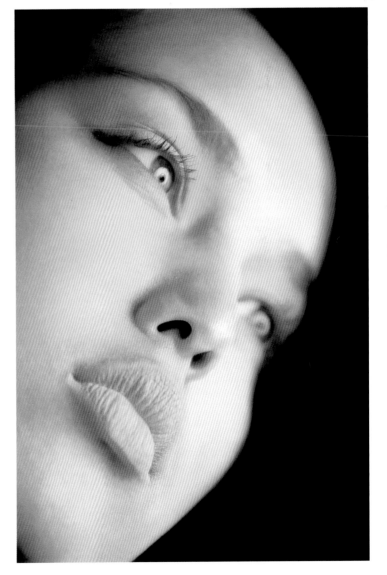

NIP AND TUCK

One thing that you might find yourself needing to do is to make a garment just a little bit more flattering. Obviously there are limits, not least because you don't want to misrepresent either the clothing manufacturer or the model, but in pictures like this there's the possibility of a minor change which can make the picture.

→ For this shot, the bodice was tied quite loosely, which meant it didn't fit the model quite as snugly as it could have. Combined with the angle of the shot — I'm shooting only a little above her waist height — and the pose this doesn't do her shape justice. Not only that, but the dress itself, with a lot of highlights, could do with a little something to clarify its detail without darkening other areas of the picture.

Before: The model's natural curves have been straightened out by a slightly loose-fitting bodice, and the bright lighting has all but washed out the detail in the dress.

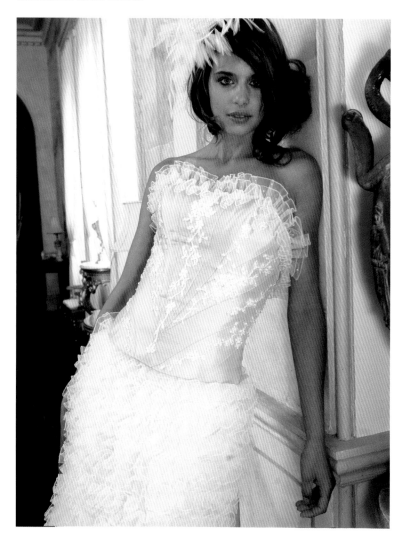

1 The Shadow/Highlight tool is my first port of call. Although it's automatic settings are a little too strong, I reduce the Shadows amount to less than 10% and nudge the Highlight amount up to 7–10%. This is enough to bright the detail back to the highlight areas, and It works especially well on the fine stitching because, unlike the Curves tool, Shadow/Highlight deliberately enhances areas of local contrast.

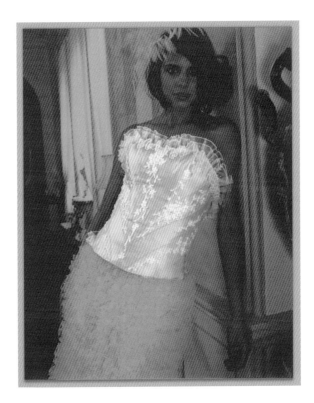

4 Now I duplicate the original layer, beneath the newly adjusted bodice, and using the Clone Stamp tool, extended the original background. The great thing about this is that you can't slip up and paint over the bodice because the adjusted layer is above the one you're working on. This was easier on the side facing the camera; any further on the other side and her arm would have appeared too wide.

After: The result is a very subtle adjustment, but one that better depicts both the model and dress.

2 Now I select the bodice region using the Quick Selection Tool. It is a good idea, in this procedure but few others, to make the selection slightly larger than the target area using the Refine Edge options. Copy this area to a new layer.

3 On the new layer, use the Liquify filter to gently reshape the bodice. I have nudged the waist inwards on both sides using the Bloat tool. I find it easier to push from the area outside the actual selection, as shown. I also slightly flattened the stomach with just a couple of clicks of the Pucker brush set to its lowest Brush rate. This was necessary to keep the shape balanced.

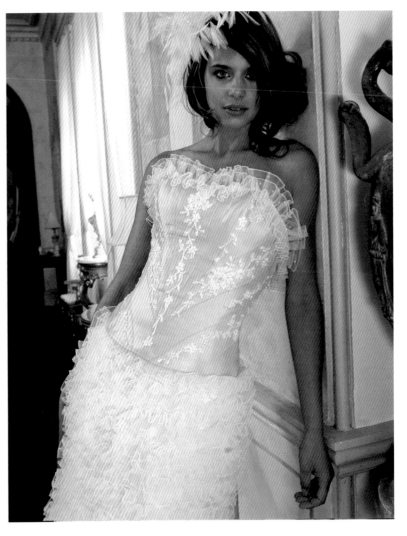

PHOTOSHOP SELENIUM TINT

A lot of photographers ask me how I get my classic selenium-like images, assuming that I use a complicated process or an expensive filter. Nothing could be further from the truth. Everything you need to create a convincing selenium-toned image is available in just a few clicks using some of Photoshop's most basic tools.

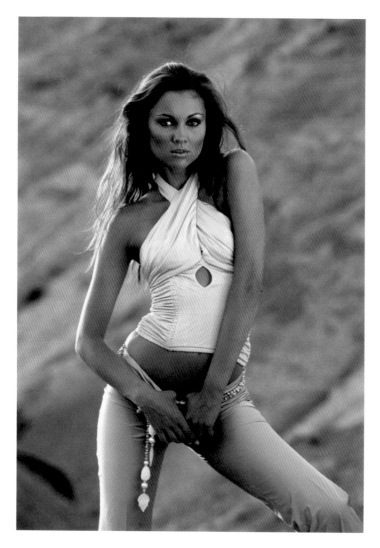

Before: This is a great shot, captured in the evening light, but it could work just as well, if not better, in mono.

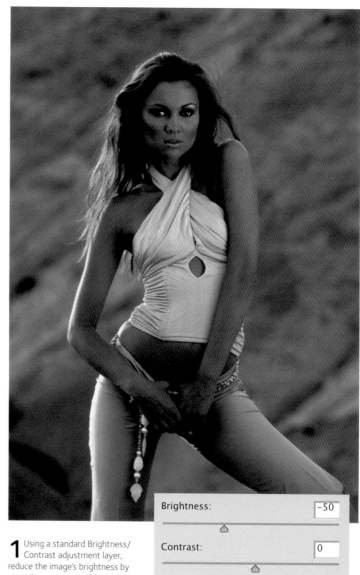

1 Using a standard Brightness/ Contrast adjustment layer, reduce the image's brightness by a good amount, say -50.

Brightness:	-50
Contrast:	0

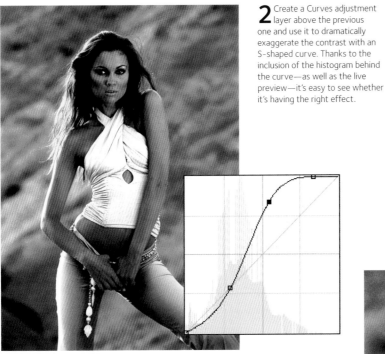

2 Create a Curves adjustment layer above the previous one and use it to dramatically exaggerate the contrast with an S-shaped curve. Thanks to the inclusion of the histogram behind the curve—as well as the live preview—it's easy to see whether it's having the right effect.

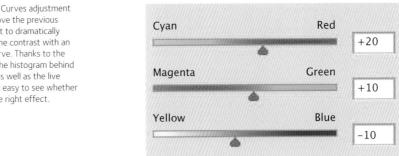

Cyan ———— Red	+20
Magenta ———— Green	+10
Yellow ———— Blue	-10

4 The selenium tint is simply a matter of adding a Color Balance adjustment layer and adjusting the sliders so that the Cyan/Red is +20, Magenta/Green is +10, and Yellow/Blue is -10.

After: The resulting image has the classic look of a traditional film print, and is achieved in moments without the need for expensive Photoshop plug-ins.

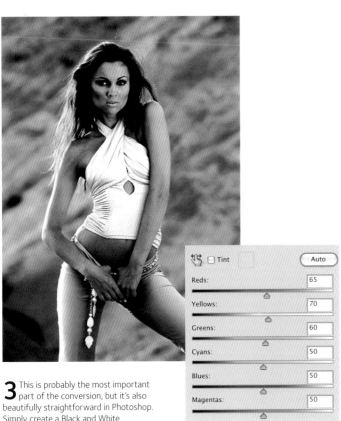

Tint	Auto
Reds:	65
Yellows:	70
Greens:	60
Cyans:	50
Blues:	50
Magentas:	50

3 This is probably the most important part of the conversion, but it's also beautifully straightforward in Photoshop. Simply create a Black and White adjustment layer, click the Auto button in the pop out panel, then tweak the sliders to emphasize the color groups that need a boost. Personally I thought that the model's skin benefited from an increase in the Red slider.

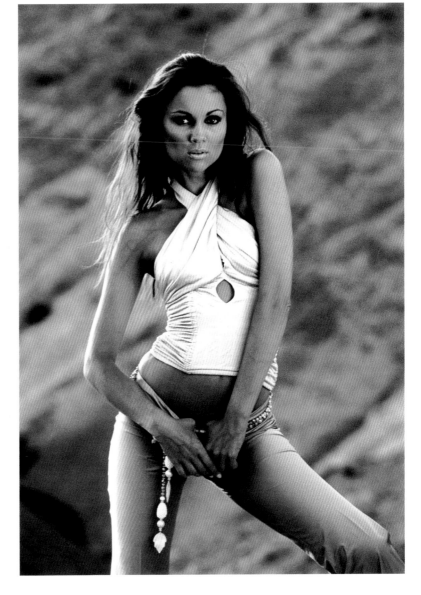

MARKETING

Fashion photography, as I've emphasized in this book, is a highly competitive business. There are many more aspiring fashion photographers than working fashion photographers. To become one of the successful ones, you have to have ambition, drive, and determination as well as technical skill and creative talent.

It doesn't matter how good a photographer you are if nobody gets to see your images. Marketing your work is vitally important to both getting established and maintaining your position as a fashion photographer.

In this chapter, I give an insight into the ways in which potential clients source photographers and look at the ways in which you can bring your work to the attention of key people. Those methods include networking, cold calling, circulating your Z-Card, setting up a website, and getting your name in photographers' directories.

I also take a detailed look at portfolios. Your portfolio is a crucial weapon in your marketing armory and it needs to be both professionally presented and targeted toward the market in which you want to work.

When you're getting established, the personal touch is still very important. Therefore, I've included advice on getting appointments with people that can help, advise, and hopefully employ you. Persistence is important here, but so is maintaining a polite and professional approach.

I conclude with a look at the various markets for fashion pictures and some general guidelines on fees and licensing your images.

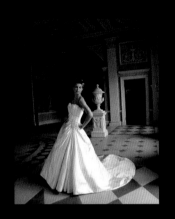
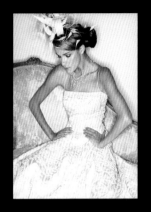

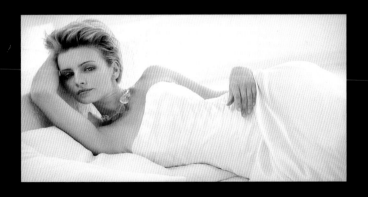
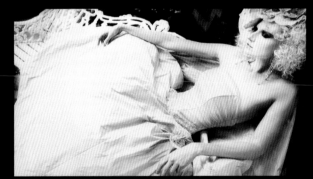

bruce smith
PHOTOGRAPHER

MARKETING YOURSELF

When a client is looking for a photographer to shoot an advertising campaign, a magazine fashion story, a brochure, or a catalog, they will usually choose photographers who they have worked successfully with in the past. If they are looking for someone different, they will ask another editor or art director in their company if they know anyone suitable. If this inquiry does not find them one, they will look in photographers' directories, or files of Z-Cards that have been left by photographers after an appointment or sent speculatively.

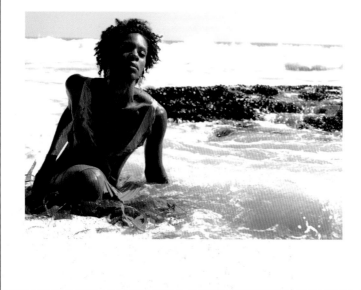

→ Z-CARDS

Every client who is booking photographers will have pictorial references such as Z-Cards (also known as "comp cards") for photographers who shoot in a style that they like.

Your Z-Card is an important marketing tool as it is one of the first ways in which any potential client sees your work. It is usually a postcard-size double-sided printed card, displaying your pictures and contact details. Your Z-Card has to reflect your market, your style, and your ability. It's important that it is well-designed and printed on high-quality cardstock. You should update it regularly, every 3–6 months.

Send your Z-Card to as many potential clients in your chosen field as possible. You must follow up on any Z-Card mailing with a telephone call. Establish whether it arrived and ask their reaction to your work. If you have a website, ask if they have visited it. The best way to show your work is still by the old appointment method. It gives you an opportunity to show and talk through your portfolio images, and the personal touch is often the most effective. So do your best to get an appointment (see Appointments, pp. 168–169).

DIRECTORIES

In the USA and the UK there are several published directories of professional photographers in which any serious photographer should have their work featured. They include *The Contact Book*, *La Book*, and *Select*. They show your pictures, your agent's details, the kind of work you do, and specific credits. You need to showcase your best work and it's important that these pictures are examples of the kind of work you want to do. However, once you're called in by a client to show your work, these directory pictures must be backed up by your portfolio. It's expensive to get into these directories, but the rewards can easily outweigh the cost.

WEBSITES

When you are contacting potential clients, a website is an essential tool for getting your work seen. The site doesn't need to be expensively designed, but must look professional, display a good range of your best pictures, and give an insight into your strengths as a photographer.

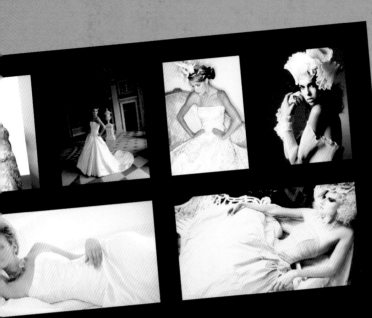

bruce smith
PHOTOGRAPHER

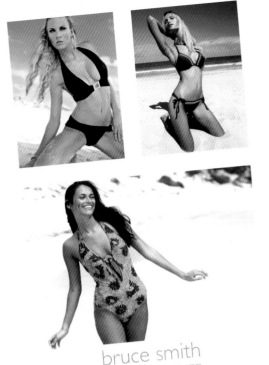

bruce smith
PHOTOGRAPHER

Swimwear Photography
bruce smith

bruce smith
PHOTOGRAPHER

Opposite page and this page: If you want to work in a variety of fields, you have to have different Z-cards for each of these fields. It's no use sending out Z-cards featuring bridal wear shots if you want to do swimwear shoots. These are some of the different Z-cards I have used in marketing my own work.

TESTING AS A MARKETING TOOL

When a photographer, a model, a stylist, and a hair and makeup artist set up a fashion shoot for their portfolios, this does not include a client. It's part of the "testing" procedure in which everyone new to the business builds up a body of work and experience to offer a potential client.

Testing gives everyone involved the opportunity to try out different ideas such as new lighting setups, new styles of clothing, or approaches to doing hair and makeup. A test shoot is produced without any charges and the photographer gives prints to everyone involved. For the photographer, testing is the way to initially source models and build up a portfolio (see pp. 28–31).

→ Testing also has an important marketing function as it's a good starting point for getting your work seen. It lets others involved in the fashion photography business show your work indirectly to clients that you may well never get the opportunity to see. Good models, hair and makeup artists, and stylists will be showing their portfolios to lots of potential clients. They will also be showing your pictures, and those clients may see something they like in them and contact you.

To ensure your pictures are used in these portfolios, you should listen to what models and model bookers, stylists, and hair and makeup artists want your pictures to show. Ultimately they will want pictures that showcase their skills and attributes and show their work in the best possible light. Initially you may find it difficult to find stylists and hair and makeup artists with whom you can test. However, once you begin to get established and you become known for producing good quality test pictures, you will find it easier.

The best way to start testing is to visit a local model agency to discuss your fashion photography ideas, and to show some samples of your work to the models bookers. A booker will explain to you what sort of fashion images they want in their models' portfolios. Model agencies are always taking new models onto their books who need test pictures, and more established models who need their portfolios updated.

Every model will have different needs regarding their test pictures. However, they usually want simple, clean, well-lit shots — good beauty shots, good body shots, and shots that showcase the model's range of attributes and abilities. You normally have to provide a testing service free of charge for the first couple of tests. If you produce excellent pictures, a model booker may then request that you shoot model test pictures for which they will pay.

When you're shooting model tests, you may want to produce offbeat and quirky images that appeal to you personally. However, these types of shots may not work well for the model. Therefore you should set aside your personal ideas and consider the needs of the other people involved, so you can make use of this opportunity to get your work seen.

Left: If you're aiming to establish yourself through your "testing" shots, you need to shoot the kind of images the model, stylist, or hair and makeup artist wants in their portfolio.

Left: This shot, and the one on the opposite page, show the same girl in different ways. Styling and shooting a model very differently shows their versatility — and yours.

DEVELOPING YOUR INDIVIDUAL STYLE

Your individual style is your signature. It develops naturally from your personal influences and interests. It's formed by the combination of all the choices you make as a photographer and all the elements you put in your pictures. It includes everything from your choice of subjects and the technical decisions you make, to the emotions you make people feel when they look at your work.

Left, inset above, inset below, and right: As you begin to develop your career in fashion photography, you have to develop your style in line with what is expected in different markets. The pictures on these pages show a selection of different styles and techniques I've used while producing work for different clients in the fashion photography business.

→ However, you also have to guide your style in certain directions as you begin to specialize in a particular market, whether that's editorial, advertising, catalog, or image brochure work. By specializing, you get to know that individual market well and form networks of contacts within that field, which makes it more likely you're going to be able to succeed in the business. You also become experienced in producing the kinds of image that particular market requires.

Developing your style for markets means looking at the pictures used in the area of fashion photography in which you want to work and honing your skills to produce those kinds of pictures. If you're new to fashion photography, you've got to look carefully at magazines to see how certain image styles are used for particular purposes.

You'll find the full range of images in any fashion magazine — editorial images promoting a new look, shots advertising cosmetics, skin care and health care products, and catalog-style shots selling "off the page." Look at the way the pictures are lit, the way the models look and pose, the kinds of location used, and the mood the shot conveys. Are the images idealized or realistic?

There are clear differences between advertising, editorial and catalog pictures (see the Required Shooting sections in Chapter 5, pp. 124–139). The way a picture looks is determined by its purpose and the way it's being used. Is it selling a specific product, creating interest in a brand, or simply making people aware of general trends? At the same time, there's a broad range of styles and approaches within those different categories. Editorial work, for instance, can be very "street" and edgy or, at the other extreme, very sophisticated and stylish, reflecting the range of fashions on the market.

In fashion photography, as in other types of photography, the most successful photographers are those who find a new and distinctive way of expressing themselves; those that can create an original twist on a familiar theme. There have to be elements in the pictures to which people can relate, but there also has to be something that's fresh and exciting.

Your style is the way you personally put the jigsaw puzzle together; it's something you create from the process of shooting, looking at your results, and learning from them. However, if you want to be a successful photographer, you have to be pragmatic and channel your creativity.

YOUR PORTFOLIO

The whole point of this book is to give you a starting-point to produce your portfolio (in the fashion business it's also called your "book"). It has to be a collection of pictures which reflect your personal style and level of skill as a photographer. It also has to reflect the area of fashion photography in which you are interested in working.

→ As you gain experience as a fashion photographer, you will find your interests develop toward fashion or beauty photography, either shooting for catalogs, advertising, or editorial. As a professional, you will have to specialize in one of these areas. For example, a fashion photographer may specialize in shooting catalog, advertising, or editorial work, but a catalog photographer will not normally shoot editorial stories for magazines.

Although it's not essential, you will stand a better chance of being commissioned to shoot if your portfolio relates closely to the client's particular area and style of work. It is very important that your folio fits in. If you have an appointment to see a fashion editor with only catalog pictures in your book, your meeting will be very short and you will not get to shoot for them. Likewise, if you present a client with a portfolio with a mixture of disciplines, they will categorize you as a jack-of-all-trades and a master of none. Again, your appointment will be short.

CREATING YOUR OWN "BOOK"

The physical statistics of your book should conform to the industry standard, so your book is instantly recognized as a photographer's book.

It should measure 11in × 14in (28cm × 36cm), and be presented in a very high-quality folder, usually made from leather. It should have your name embossed on the cover, with no more than 20 leaves showing a maximum of 40 images.

Most clients will be very experienced in assessing photographers' portfolios. They will often have decided if they are going to commission you by the time they get through the first six pictures in your book. Therefore the running order of your pictures is important and you should put your strongest images at the beginning. Your first image has to really "wow" the client and each image after that has to reach the standard and quality of the first.

After the first six "wow" images, start to show a range of images that reflect your ability as a fashion photographer in your particular field. Show them what you're capable of doing. Then have some more "wow" pictures to end the book, to create a favorable and lasting impression.

Left: Although there are other ways of presenting your work, off-the-shelf photo books with template based styling may detract from your images and give the impression of an amateur.

Above Your portfolio is an essential marketing tool and you should buy a high-quality folder to showcase your work at its best. As with your Z-card, it should be targeted toward a particular market.

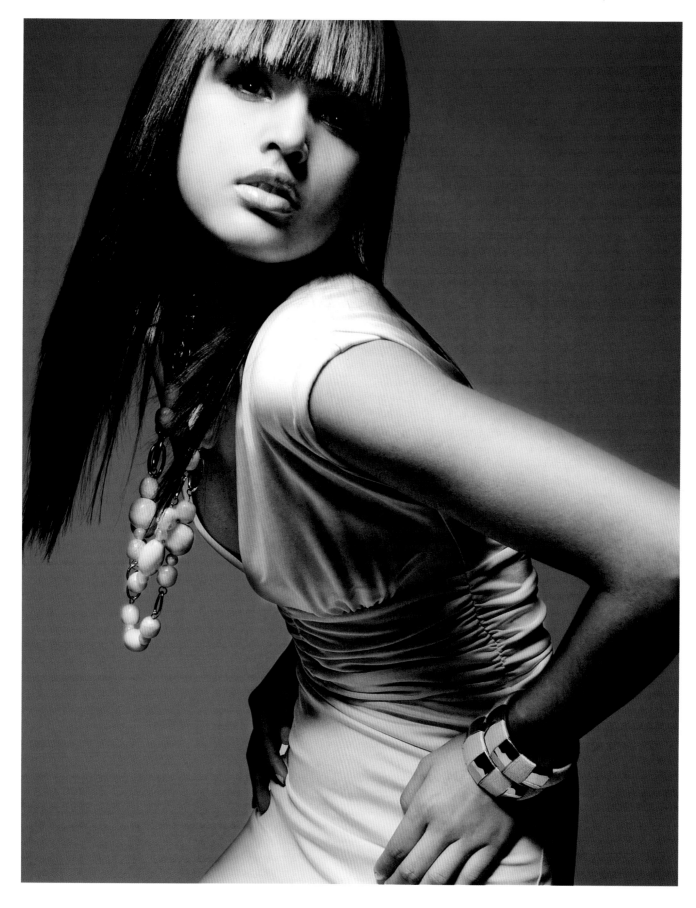

MARKETING

Appointments are about getting yourself known, networking, and making people know you're available. When you're not actually working, you should be carrying out your marketing program, circulating your cards, and going out on appointments with your portfolio. You should be seeing any buyer of photography that's going to be interested in the kind of work you produce.

The earliest appointments you need to make in your career will be with bookers at model agencies when you're testing. These meetings will get you used to going to see people and getting your portfolio assessed. People will openly critique your work and give you valuable advice and guidance.

→ Bookers are constantly looking at fashion pictures and controlling the pictures in their models' portfolios. They will know the kind of work that clients want to see. They may say your work would suit a particular publication and suggest someone that would be interested in your work. Take note of these comments and adjust your work accordingly. If they like you and your work, they will give you access to models with whom you can shoot test pictures (see Testing for Models, pp. 30–31).

Once you've built up your portfolio, you'll start going to see fashion editors on smaller circulation magazines — the ones that will be more receptive to photographers who are new to the business. Initially, you should arrange these appointments by phoning the magazine and speaking to the assistant fashion editor or the secretary. Before you phone, ensure you know the style of the publication and the kind of pictures they publish. Assess whether your work is right for that publication.

You should also take time to find out the names of people to whom you want to speak. You find this information in the magazine's masthead, which lists contact details for the publication and members of staff.

It's often not easy to get an appointment with a fashion editor, even on smaller magazines. On some publications that might take weeks or months. Quite often, instead of being offered a personal meeting, you'll be asked to leave your portfolio for the fashion editor to look at when they're available.

In that case, take your book in at the requested time and give the magazine a follow-up phone call a few days later. Ask whether they have looked at your pictures and what they think of them. If they haven't looked at your portfolio, ask them politely when they can, because you need to collect your book for other appointments.

If you succeed in getting an appointment, you must arrive on time and look presentable. Your portfolio is the most important thing at the appointment; it must be professionally presented and reflect the kind of work you want to do (see Your Portfolio, p.166).

During the appointment, you must be confident but don't exaggerate your own importance. You will be dealing with professionals who are seeing photographers' portfolios every day. They will be able to quickly assess whether you and your work are right for the magazine. You have to be able to express yourself and communicate your enthusiasm for working for the magazine — without appearing a creep.

When you're making appointments you should be persistent, keep records of phone calls you've made, and follow things up when necessary. At all times you should be polite, mannerly, and respectful to the people with whom you're dealing. Going to see these people is high on your priority list if you want to break into fashion photography.

Left: Put your strongest and most eye-catching images in the first pages of your portfolio. Busy clients will probably have decided whether they're going to use you before they've looked through the first six pictures.

IMAGE USAGE

SELF-PROMOTION
If you are testing with models, makeup artists, hairdressers, or fashion stylists, any images that are produced during these test shoots will normally only be used for self-promotion by members of the test shoot team in composite cards, portfolios, and websites. They are not to be published for fees or commissions from or by any third parties, unless you have agreed to do so with the team members prior to shooting.

PR
These are fashion shoots organized by PR companies, mainly for press releases. The aim is to create brand awareness and get their client's products and brands featured in the media, particularly in newspapers and magazines. They are not very well paid.

EDITORIAL
These images will be used in pictorial stories published as fashion lifestyle interest in magazines. They will be booked and paid for by magazines and only used in these magazines. Fashion shoots for editorials are not very well paid in themselves. However, having work published in magazines gives you credibility, so it's one of the easiest and best ways to build up your reputation. Having your work showcased in top magazines will lead to some very highly paid commissions.

→ ADVERTORIAL
These shoots will be booked by magazines' promotions departments. They are produced to look like a fashion interest stories, so it appears that the magazine is endorsing the products. However, they are paid for by the clients.

CATALOG
These shoots are for consumer mail-order catalogs. Catalogs are a good source for regular income and will normally pay a good rate to experienced photographers.

"BELOW THE LINE" ADVERTISING
Designed to promote products or services, this work usually involves shooting for printed material such as brochures for direct mail, point-of-sale posters, and leaflets. Fees are above average. As with "through the line" and "above the line" advertising, fees will normally include usage fees to cover any extra media insertions and publication in any other countries.

"THROUGH THE LINE" ADVERTISING
"Through the line" shoots are for trade press, advertising, or local press in newspapers, in-store posters, banners, and point-of-sale advertising boards. Fees are above average and can be in the higher range, depending on the client's profile.

"ABOVE THE LINE" ADVERTISING
This work involves shooting for campaigns that appear in major newspapers and magazines, TV, cinema, and Internet advertising. These forms of advertising reach a very large audience and involve very high media booking fees. Shooting and usage fees can be set higher than for the above categories.

Left: When you're shooting catalog pictures like this one, you negotiate a fee for the day of the shoot plus a usage fee.

SETTING YOUR FEES
ON THE BASIS OF USAGE

Most magazine publishing houses have set editorial and advertorial rates for photographers, either based upon the number of pages covered, or a day-rate. The larger mail order houses also have set freelance rates.

These are the approximate proportional rates of different clients, based on Advertising BTL as 100%.

> PR	25%
> Editorial	33%
> Advertorial	50%
> Advertising BTL	100%
> Advertising TTL	200%
> Advertising ATL	400%

Within this fee structure you can grant a licence for the main usage required, plus a lesser usage for a period of one year, or for one major media publication or campaign. Any further usage, such as pictures inserted in publications, published on billboards, or used overseas are calculated on the basis of set rates and negotiated around this figure. You should always take into account the profile of the client when working out fees for any fashion shoots.

CLIENTS

When providing images for clients to use, a photographer allows the usage of the images under a "licence to use" agreement. This gives the client the rights to use, but not to own, the images for a set number of times and an agreed period of time. Clients may also arrange to use images as and when they choose. In situations like this you can offer buyouts of between one and five years, but still retain the ownership and copyright. If the client still wants to use the images when the set period is over, you can renegotiate fees with the client for a further period.

You should never give away the rights to your images, unless the fees and the usage are totally agreeable to you.

Careerwear

Lloyds TSB

Above: This image was shot for a bank and its usage was limited to internal use within the company. However, other images can be used in a variety of ways and you have to negotiate usage fees at the briefing stage.

INSPIRATIONAL PHOTOGRAPHERS

So far, this book has been a practical guide to fashion photography, based on my experiences in the business, and it has been illustrated with my images. For this final chapter, I'd like to look at the work of other photographers. I want to talk about some of the photographers I personally admire and to show the wide range of styles and techniques used in fashion work today.

These guys aren't just any photographers. David LaChapelle, Barry Lategan Perou, and Rankin are some of the biggest names in contemporary fashion photography. Their work has been innovative, imaginative, and highly influential, and it has pushed the boundaries of what fashion photography is — and what it can aspire to be. I will look at the careers and personal approaches of these photographers and I hope these pages will encourage you to explore their work further.

At the same time, I want to say that although these photographers have hit the pinnacle of their profession, you don't have to achieve this level of distinction to make a good living from fashion work. Thousands of photographers specialize in advertising, editorial, catalog, or any other branch of fashion work and still enjoy an exciting, creative, and financially rewarding career without becoming famous themselves.

Nevertheless, the photographers in this chapter are here to show the benchmark to which all fashion photographers aspire. I hope their work will encourage you to think about fashion photography in a different way, and give you further inspiration for your own work.

DAVID LACHAPELLE

Of all the photographers in this section of the book, David LaChapelle makes the most ambitious and imaginative use of digital technology in creating his images. He has worked in fashion, advertising, and fine art and has been named as one of the "Ten Most Important People in Photography" by *American Photo* magazine.

→ Born in 1963, he began shooting photographs while at high school. At 18 he went to live in New York, and a meeting with pop artist Andy Warhol led to him working for the publication Warhol co-founded, *Interview* magazine. This was the springboard from which he began developing and refining his unique style. He went on to establish a reputation for often surreal concept images that showed the superficiality of fashion and celebrity. LaChapelle has now produced four books, *LaChapelle Land* (1996), *Hotel LaChapelle* (1999), *Artists and Prostitutes* (2006) and *Heaven to Hell* (2006).

LaChapelle's photographs are often extraordinary big-budget creations that require an enormous amount of digital post-production work to achieve their distinctive look. Sleek and glossy, brightly lit, and vividly colored, they are influenced by everything from Renaissance art to pornography. These hyper-real and sometimes controversial creations have included images of Kanye West as Jesus Christ, rapper Li'l Kim as an open-mouthed blow-up doll, and the Beastie Boys as workers in a cheap burger bar. LaChapelle has bipolar disorder and has said that many of his ideas come from the manic phases resulting from his condition.

His fashion work shows the same energy, invention, and sheer enjoyment of fantasy, and an impressive ability to make even the most outlandish and decadent idea come alive in his images. LaChapelle himself has claimed that his work is about "finding beauty in the banal and making the ordinary extraordinary . . . I want to enlarge the idea of reality and help people feel that anything's possible."

The LaChapelle creation shown here is a typically camp and extravagant example of his work and part of a series showing glamorous fashion models being menaced by dinosaurs. It's humorous, excessive, and the incongruity of the situation makes it eye-catching. At the same time it has been carefully arranged and lit, and the background colors blend beautifully with those in the gowns. It's still fashion photography, but nobody does fashion photography quite like David LaChapelle.

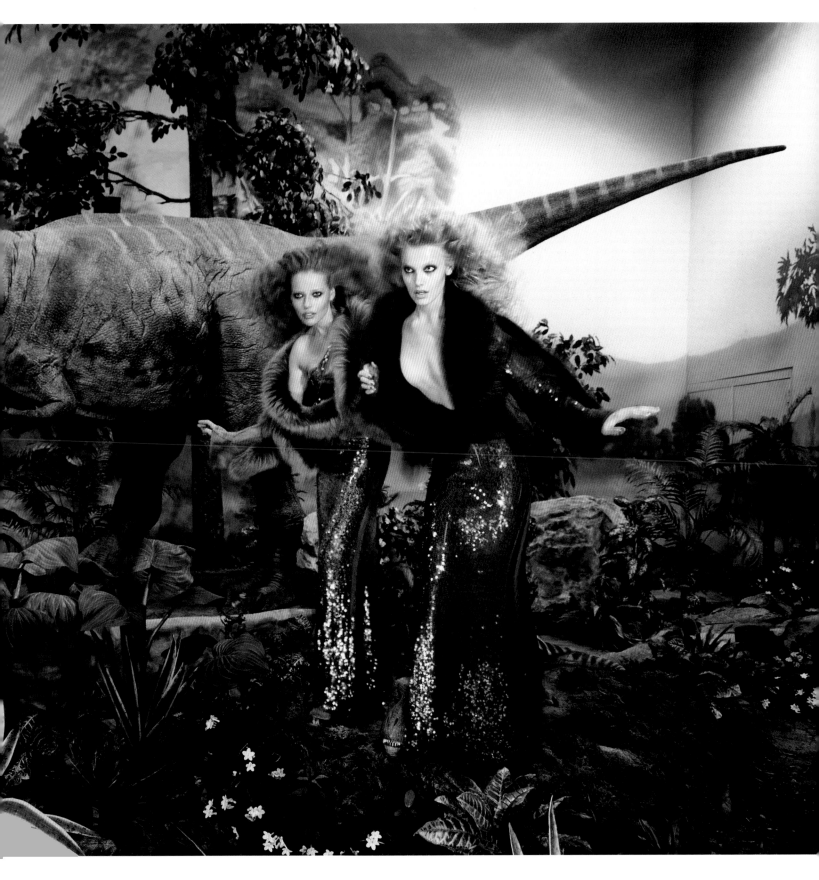

DAVID LACHAPELLE

BARRY LATEGAN

Barry Lategan was part of the generation of exciting young fashion photographers that emerged in the 1960s. He was originally from South Africa, but settled in London after completing National Service and opened his first studio in 1965. His pictures of Twiggy, taken when she was an unknown model, launched an icon of the era and kick-started his own career.

Barry went on to work as a fashion, beauty, and portrait photographer for *Vogue*, *Elle*, *Harpers & Queen*, and *Life* as well as shooting advertising campaigns, Pirelli calendars, and television commercials. He has a fascination for female beauty and his models have included 1960s icons such as Jean Shrimpton and Penelope Tree, as well as Bianca Jagger, Marie Helvin, and Tessa and Sophie Dahl.

Barry's contemporaries included David Bailey and Terence Donovan, but he has always avoided the limelight. He lets his photography speak for itself. "The great photographer Irving Penn once said to me that the artist should not be more of a hero than his work," Barry has said. "It sounds arrogant, perhaps, but I want my work to attract the attention."

Although he shoots little fashion now that he's in his mid-70s, he retains a great passion for photography. Recent images show an enjoyment of creative effects opened up by digital technology, such as creating multiple images. His work is now held in the collections of the Victoria & Albert Museum and National Portrait Gallery in London, as well as the South African National Gallery and the University of Santa Barbara.

→ I don't mind saying that Barry is one of my personal heroes. I met him early in my career and he was kind enough to critique my work in a positive way and encourage me. In fact, if it wasn't for Barry, I probably wouldn't have become a fashion photographer. I admire his professional manner and approach. When I met him, I remember asking him the secret of his success. "Keep it simple," he said, and I've tried to do that ever since.

It's difficult to generalize about a photographer who had produced a wide-ranging body of work over such a long period, but Barry's photographs all show artistry, creativity, and the meticulous touch of a master technician. He mainly shoots his fashion work in the studio and it is always beautifully lit and expertly executed. He loves using shapes and color.

Here's just one example of his work, titled *Woman in Red Coat*. It initially seems to be a simple head-and-shoulders fashion shot, but it repays closer inspection. Look at the attention to detail here: the way the background is used to highlight and complement the vivid color of the coat and hat. Look further and see the way the particular red of the lipstick is the same color as the outfit and the blue background echoes the model's eyes. All these elements help complete the image and make it a striking and highly effective fashion shot.

Opposite page: "Woman in Red Coat"
© Barry Lategan

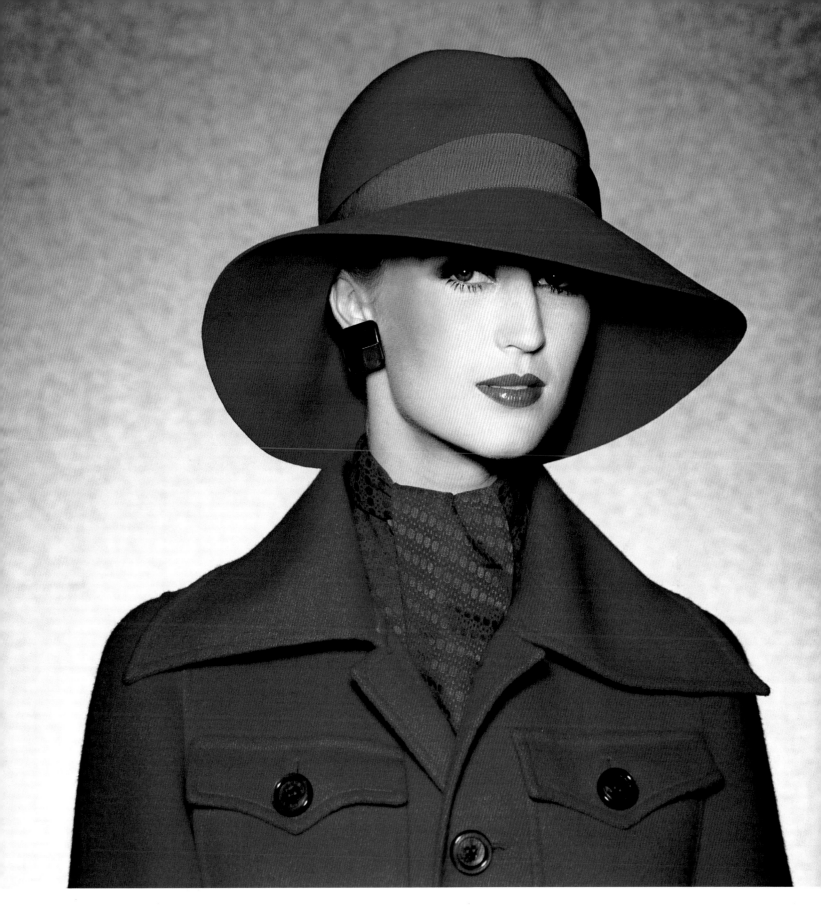

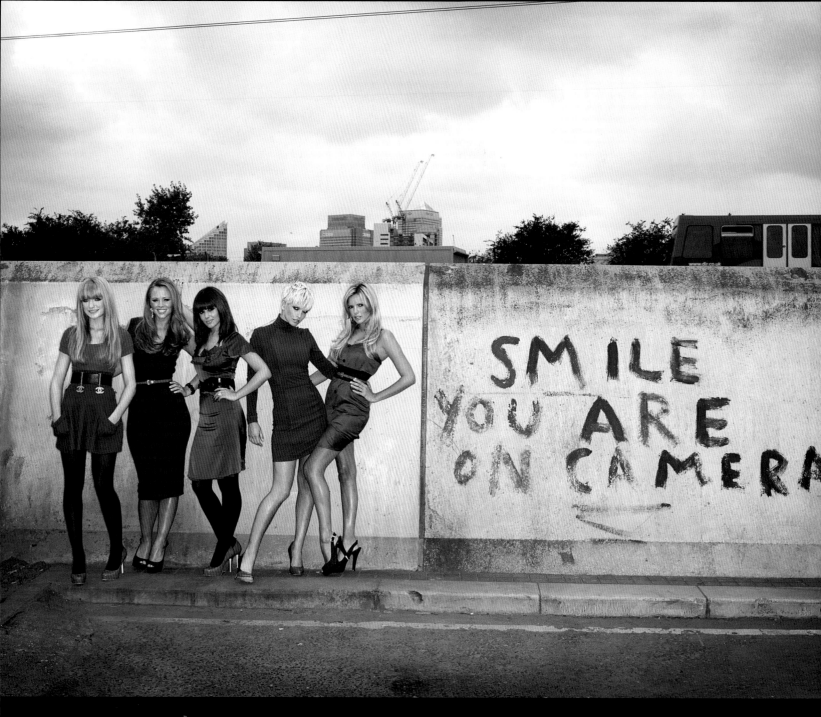

© Perou

London-based photographer Perou is part of a new generation of contemporary image-makers. He has photographed high profile celebrities including David Beckham, Jay-Z, Tom Waits, and Missy Elliott, and his work has appeared in publications such as *Vogue*, *Entertainment Weekly*, and *Arena*. His fashion clients include Vivienne Westwood and Reebok and he has also been involved in various film and TV projects; directing music promos and *God is in the TV*, a Marilyn Manson world tour documentary.

Now in his late 30s, Perou has had an unconventional career. As a young man he worked as a butler to a Viscount before gaining a degree in Photography, Film & Video Arts in 1994 and taking a job as a studio manager. He later worked as the picture editor on *Dazed & Confused* magazine before becoming a freelance photographer. Since then, he has fast carved out a reputation for delivering striking images that keep his many editorial, record company, design agency, and corporate clients happy.

Perou describes himself as having "a predilection for the alternative" and his work has a distinctive edginess about it. Poses and compositions are often provocative and challenging. He adapts his style according to the client, but the majority of his fashion work has been shot in the studio. His subjects are often brightly lit and there's usually an eye-catching element about them: he has shown his models fighting, striking angular poses, or apparently floating in mid-air.

Locations, when used, are carefully chosen to contribute something special to the images. Models in urban or industrial locations are a favorite, and one of his Vivienne Westwood shoots featured immaculately dressed haute couture models posing in a derelict and deserted factory. He wasn't the first photographer to do it, but he did it very well.

What's the secret of his success? Some would say it's his talent as an image-maker with his finger on the contemporary pulse, but Perou himself explains it in one word: "belligerence." He adds, "It's never been easy; it's always been about hard work and it still is." Photography isn't a career choice, it's a compulsion. "I want to be a photographer because I have to be a photographer," he continues. "For me this isn't a job, it's a lifestyle . . . and sometimes an affliction."

The Perou shot on the opposite page shows an alternative approach to fashion photography, in which fashion seems to have literally merged with the street. When you first glance at this urban scene, the models themselves — members of the British band Girls Aloud — look like a piece of wall art alongside the graffiti. Then you see that their legs extend beyond the bottom of the wall and realize that they are three-dimensional women and not two-dimensional drawings. The shot also works by contrasting the women with their surroundings. "I'm clashing immaculate women with grot, and the tatty backdrop accentuates the pristine, "perfect" women construct," says Perou. It's a subtle and clever shot, and I like it.

RANKIN

Rankin is a prolific British fashion, portrait, and advertising photographer, as well as a publisher and film director. His arresting, visually inventive style has been used to capture striking portraits of public figures including the Queen and Tony Blair, as well as celebrities, supermodels, and male and female nudes. Rankin is a self-confessed workaholic. When talking about his book *Rankin Works* (2000) he said, "It's not a retrospective, it's about work. I work all the time. I'm always taking photos."

He studied photography at the London College of Printing, but left college to found the cutting-edge style and culture magazine *Dazed & Confused* in partnership with Jefferson Hack in 1991. It showcased Rankin's eye for design as well as his growing talent for fashion and celebrity portraiture. Since then, the quality and quantity of his work has placed him among the world's top photographers.

Rankin has shot covers for magazines including *Harper's Bazaar*, *Vogue*, *Arena*, and *Esquire*. His many books include *Snog* (2000), *Sofasosexy: Turning a Cheap Sofa into an Object of Desire* (2002) and *Visually Hungry* (2007), a retrospective comprising 400 images from his 20-year career.

In the early part of his career he often used wide-angle lenses and ringflash to create his images, but he has since used a diverse range of techniques, both in the studio and on location. If there's one quality that all Rankin images have, it's impact.

→ That impact comes from his strong compositions, the quirky or provocative poses he draws from his models, or the creative use of lighting. "When I work with people it isn't necessarily a perfect, harmonious relationship," he says. "I try to make them feel comfortable and enjoy the shoot, but that doesn't mean that they're going to like what they see at the end of it. They accept it for what it is."

His fashion work includes images of top supermodels including Kate Moss, Heidi Klum, and Eva Herzigova in creations by designers including Jean-Paul Gaultier, Dolce & Gabbana, Christian Lacroix, Calvin Klein, and Ralph Lauren. Being fashionable in terms of photographic style and technique isn't important to him. "I think the most important thing in photography is that your work survives the test of time," he says.

The Rankin image shown here is from a series of shots of model Louise Pedersen, published in *Dazed & Confused* magazine. Like others in the series, it's a dark, moody, and subversive image. It employs dramatic black & white lighting similar to that used by photographers in the 1940s or 50s, but uses it to shoot contemporary high fashion. Rankin takes the picture one step beyond the traditional fashion image by including reference to the artifice of photography — in this case, studio lighting stands. It's the work of a talented and sophisticated image-maker.

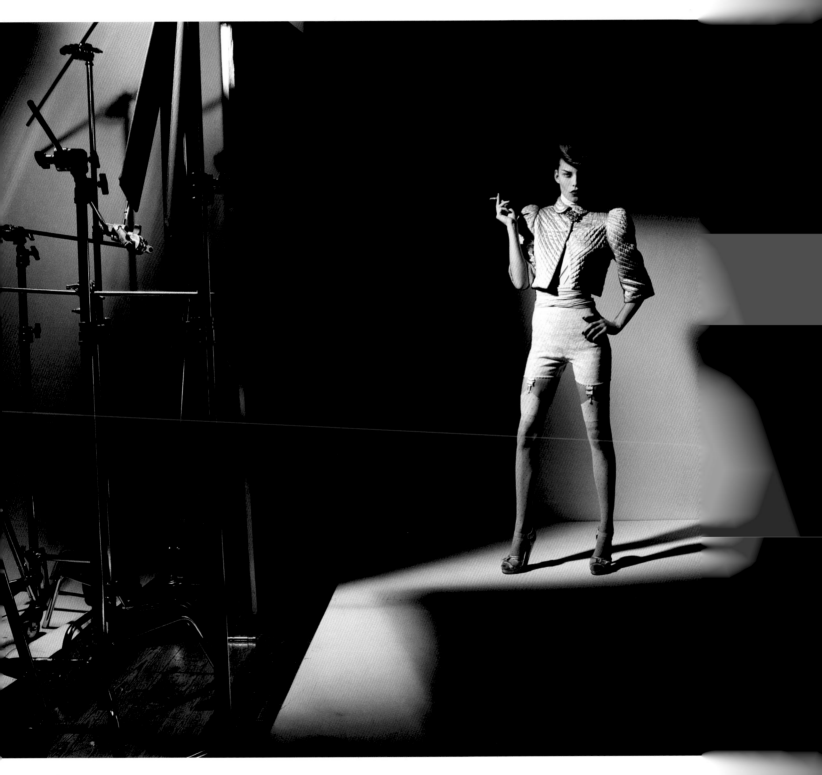

© Rankin

RANKIN

FINAL WORDS

For me, this book is about sharing the knowledge I've accumulated in thirty years as a fashion photographer. It's about passing on technical knowledge about camera equipment, lighting, exposures, metering, file management, and using Photoshop. But I hope I have made it clear that fashion photography involves much more than technical skill and knowledge.

It's about relating to people. It's about inspiring your team and dealing with clients and colleagues in a professional way. It's about getting the best out of your models. It's about knowing how to network and market yourself. And it's about managing demanding shoots that fulfill a brief, while using your creative skills to make eye-catching and memorable images.

I hope I have encouraged you to think about how you shoot pictures and to experiment and try something different in your work. I would like to think that by reaching the end of the book, you've reached the beginning of your own development as a photographer.

Once you've put the knowledge you've gained into practice, I hope you can confidently walk into any high-level model agency with your portfolio and be offered the opportunity to shoot test pictures. After that, I'd like you to be able to go into model agencies and get paid tests. Then I'd like you to go on to approach a magazine,

or a client direct, get chosen for an assignment and produce a competent set of images that fulfil the client's requirements.

Of course, a book can only go so far. Photography isn't about reading, it's about doing. For those readers who have been interested in what I've said and want to follow it up with practical experience, I'd advise enrolling on a course in professional fashion photography such as those I personally offer (you can find details on my website, www.brucesmithphotographer.com).

However, beyond what any course can teach you, the best way to learn how to shoot pictures is to shoot pictures. Only by getting out there, doing it, and learning from your mistakes will you begin to develop your style and find your own place in the fashion industry.

Don't forget that although being a fashion photographer can be an exciting, creative, and fulfilling career, it is still a business. You must sell yourself and what you can offer to get a foothold in the market and provide a top-quality service to your clients in order to thrive.

I sincerely hope that this book provides the catalyst for you to make a good start in the fashion industry. After that, it's up to you how far you want to go. I hope you go on to achieve great things and surpass anything I've achieved. Your future's in your hands.

GLOSSARY

Assistant

An assistant can be simply a friend who helps on a shoot by holding your reflectors. At a professional level, an assistant is an important part of the photographer's team. Assistants need to have a broad range of technical knowledge and abilities as well as good communication skills. They can be asked to deal with anything from digital image transfer to building sets.

Available light

The light that is available to a photographer in a given situation before supplementing it with lights or flash units. Available light can be daylight, illumination from artificial light sources, or a combination of the two.

Backdrop

A backdrop usually refers to a studio background. Backdrops can be long rolls of colored paper, such as those made by Colorama. They can also be textured canvases with mottled colors or particular scenes, or even textured metal sheets from a hardware store.

Back-lighting

A subject is said to be back-lit when the light source is behind them. This lighting situation is sometimes referred to as contre-jour, or shooting against the light. It can be an eye-catching and atmospheric effect, but flare can be a problem, and it can be difficult to get a correct exposure on your model.

Beauty dish

One of the range of accessories available for a fashion photographer to enhance a model's appearance. It consists of a circular reflective dish that goes behind your flash head, with a central opaque surface that goes over the flash head and diffuses the light.

Casting

A model casting is the process by which a model is selected for a shoot. Usually a number of potentially suitable agency models are invited and assessed by the photographer and the client or client's representative.

Client

Clients are the people that ultimately use your pictures; you sometimes deal with them directly and sometimes via advertising, design or PR agencies that the clients hire. They can be manufacturers, fashion designers, magazines, or other companies.

Continuous light

Continuous lights, such as HMIs (movie lights) are simply lights that are on all the time, in contrast to flash lights. They are large, powerful lights that can be used as a spotlight or floodlight and give a good daylight effect. They are also heavy and cumbersome to use.

Diffusion screen

Diffusion screens are large pieces of translucent material, held on a frame, that give a flattering light on your model when placed between your model and light source. They are used both on location (principally to soften harsh direct sunlight) and in the studio.

DPS

The initials refer to double-page spread, and the term usually refers to a horizontal image that is used across two pages in a magazine, newspaper, brochure, or other publication.

Fashion stylist

Fashion stylists work closely with professional fashion photographers, sometimes over a number of years. They are responsible for the style and

mood for a shoot. They select and set up the appropriate props, fashions and accessories, and sometimes even choose the models. Most work freelance and are represented by an agent.

Fill-in flash

When available light is insufficient to light your model, either because of the low intensity or unflattering direction of light, a little fill-in flash can provide the extra light needed. To use fill-in flash in a subtle way, you can take the highlight reading from the ambient light in the scene and set the power output at 1.5–2 stops below the highlight reading.

Gray card

This is a piece of gray cardboard which represents 18% gray in light intensity. You can use it to give consistent exposures in a shoot by placing it in the scene you're photographing and taking a reflected light reading. It can also be used as a reference for your camera's white balance.

Hair and makeup artist

An experienced professional hair and makeup artist is another essential part of your team and will make a huge difference to your pictures. They will know how to make your model's hair look perfectly groomed, use makeup to emphasise good facial features and make skin look flawless.

HMIs

Powerful studio lights used on film and photographic sets. Most photographers hire them for occasional use. See Continuous light, above.

Infinity cove

An infinity cove is a mobile or fixed background with no corners, constructed to give the impression that it goes on for

infinity. It can be a large white wall and floor or a complete three-sided room and ceiling. It's usually painted white.

JPEG

A JPEG is a compressed digital image. It's an acronym for Joint Photographic Experts Group, the body which created it. A JPEG is a compressed image that is processed in-camera, resulting in an irretrievable loss of information. JPEGs provide perfectly adequate quality if the image is being reproduced at magazine size or less. They are often used for catalogue or magazine work. They take up less storage space than raw files (see below).

Light meter

Your camera's inbuilt light meter takes a 'reflected' light reading, i.e. it measures the light being reflected from your subject. To get a good overall exposure, meter from a mid-tone area. A handheld light meter takes an 'incident' light reading, i.e. it measures the light falling on its sensor. It's best to use the meter's invacone pointing towards the light source. Used correctly, a handheld meter gives you a more accurate exposure.

Masthead

A masthead panel is a list of editorial staff on a magazine. It usually also includes details of the publisher, address, email and phone numbers. When you're making an approach to a magazine's fashion editor, it's more professional to use their name rather than their job title. It gives the impression of having a genuine interest in the magazine.

Modifier

This is a general term used to describe pieces of photographic equipment that alter or modify

the light from your flash. The purpose is usually to soften the harshness of direct flash light. Modifiers include diffusers, reflectors, umbrellas, barn doors, softboxes, and Octa lights.

Monolight

A monolight is a large flash unit, used in studio work or indoors on location. Their features vary according to model and price, but include a modelling light and flash strobe in the same unit. They are usually used with modifiers to soften the light.

Octa light

Octa lights are 8-sided umbrellas, up to 6ft wide, with a diffusing cover. They work in the same way as a softbox. The advantage of using them is that they offer a particularly large light source. It's a great light for fashion as you can light the model evenly in full length shots. You shoot either with or without the diffusion material, depending on the effect you require.

Poly board

A poly board is a large lightweight board, made from polystyrene, usually measuring around 8ft x 4ft x 2in. They are often painted black on one side and white on the other and are designed for studio work. You can use them either as flags to cut light down by having the black side facing your subject, or by using the white side as a reflector.

Portfolio

Your portfolio is an essential item when you're marketing yourself and going for appointments. It should be a collection of images that displays the quality of your work and reflects the kind of work that you want to do. The industry standard size is 11in x 14in, with no more than 20

leaves, and it should be bound in a good quality cover with your name on it. It should contain a maximum of 40 images.

Proof

In fashion photography, a proof is something you send a client as 'proof' of the work you've done. It's usually a small JPEG of each of the shots you've taken, and it's only used for viewing, selecting, and editing. The files can be provided as a contact sheet proof, individual print proof or digital proofs.

Props

Props — short for properties — can be anything that's used on set, such as furniture, curtains, flowers, or anything you'd use to create atmosphere. They shouldn't be confused with fashion accessories such as jewellery, belts, bangles, and beads. However, both props and accessories would be sourced by your stylist.

Raw file

A Raw image, sometimes called a 'digital negative', is a minimally processed file and contains much more metadata than a compressed file such as a JPEG. Raw images give you much greater shadow and highlight detail and offer more latitude in contrast and color balance. However, they require post-capture processing, such as white balancing and color grading, to be useable as images.

Reflectors

Reflectors can be anything you use to bounce light (either flash or daylight) onto your subject. This is usually done to brighten shadow areas on the model's face or garments. Reflectors can be simple sheets of white card or two-sided professional quality reflectors that are made in gold, silver, white, or 'zebra' (which

gives a softer effect). They are available in a variety of shapes and sizes.

Ringflash

A ringflash, as the name suggests, is a circular flash unit that fits around the lens. It gives even, virtually shadow-free front lighting on your model. It takes practise to use ringflash effectively, and the light can be quite harsh unless it is diffused. Ringflash units are expensive, so you would probably hire one if you're on a budget.

Shooting trace

This is a visual plan for a shoot, provided by an advertising agency or designer. It is usually provided for a catalogue shoot or an advertising campaign. It comprises of sketches showing how the pictures should look on the final layout. If a client supplies a shooting trace, you are expected to follow it exactly.

Snoot

A snoot is a light modifier. It's a cone-shaped tube, placed over the end of a light. It's used for controlling the light and directing it onto a particular area of your subject. Snoots are often used for putting backlight onto a model's hair or giving a spotlight effect on a background.

Softbox

A softbox, as the name suggests, is an enclosure made of diffusing material used for softening the light from a flash head. Softboxes vary in size but all work in the same way, by fitting over the light and ensuring that all the flash (or continuous light source) is diffused, giving a less harsh and more evenly distributed illumination on your model.

Testing

When a photographer, model, and hair and makeup artist are

starting out in their business and developing a portfolio, they are said to be testing. If you arrange a shoot with a model on a test for pictures (TFP) basis, it's usually done free of charge. The benefit is that everyone involved in the shoot gets pictures for their portfolios. When you have built up a good relationship with model bookers, they may ask you to do paid model tests.

White balance

A camera's white balance removes the color casts you find in your photographs, for example when shooting a scene lit by Tungsten light, which gives a yellow hue. Using white balance correctly gives you realistic color. It does so by adjusting the red, green, and blue in an image, allowing neutral colors to be correctly reproduced.

Z-Card

A Z-Card or "comp card" is an important marketing tool. It's usually a postcard size double-sided printed card showing your contact details and some of your images. It has to reflect your style, market, and ability. Your Z-Card should be sent to potential clients as part of your marketing program, and followed up with a phone call. It should be regularly updated.

USEFUL RESOURCES

The internet has a vast wealth of resources which you can explore at your leisure. Here is a list of sites where you can find out about the latest equipment, find models of all levels of experience, and keep up to date with events in the industry.

Equipment and technology

www.adobe.com
Information about the latest version of Photoshop, including the option to download time-limited trial versions.

www.apple.com
Apple computers are popular with photographers; find out more about them here.

www.canon.com
As well as sitting among the top two camera manufacturers, Canon also offer a range of great printers.

www.dpreview.com
Website that offers incredibly detailed, wholly impartial reviews of camera equipment.

www.epson.com
Manufacturer of great quality inkjet printers and papers.

www.lacie.com
Manufactuer of high quality external hard disk drives including the ruggedized variety useful on location shoots.

www.nikon.com
One of the worlds leading camera manufactures.

www.sony.com
Taking the mantle from Konika Minolta, whose photographic division they acquired, Sony are producing some innovative digital SLRs.

www.sunbounce.com
California Sunbounce sell a range of diffusers and reflectors popular with photographers shooting both indoors and in natural light.

www.wacom.com
Manufacturer of graphics tablets—pen-like devices that allow more natural image editing.

General

www.topfashionlinks.com
Well maintained site with up-to-date links for photographers, students, and designers.

Model agencies

www.bossmodels.com
Modelling agency with offices in New York and Cape Town.

www.dnamodels.com
New York modelling agency.

www.elitemodel.com
Model agency with offices in New York, Los Angeles, Miami, Toronto, Chicago, and Atlanta.

www.fordmodels.com
Worldwide modelling agency, with locations including the East and West coast, Europe, and Brazil.

www.imgmodels.com
New York modelling agency.

www.majormodelmanagement.com
New York modelling agency.

www.wilhelminaportfolios.com
New York, Miami, and Los Angeles modelling agency.

Model sites

www.modelmayhem.com
Worldwide model community searchable by characteristics.

www.net-model.com
Worldwide model community searchable by characteristics.

www.onemodelplace.com
Worldwide model community searchable by characteristics.

Rights

www.copyright.gov
U.S. Government copyright law explained.

www.ipo.gov.uk/copy.htm
U.K. government intellectual property guidelines (copyright section).

Skills and learning

www.123di.com
Mac or PC based teaching software that explores every aspect of digital photography.

www.brucesmithphotography.com
Sometimes I offer tutorials and courses via my website.

www.Profotos.com
Fee-based site linking service to help promote your work.

Events

www.londonfashionweek.co.uk
Twice-yearly fashion event for retailers and press.

www.mbfashionweek.com
New York Fashion Week, presently sponsored by Mercedes Benz. This may change, so check search engines.

www.spfw.com.br
São Paulo Fashion Week official site.

www.style.com/fashionshows
Vogue magazine's up-to-date fashion show listings and reviews.

INDEX

STANDARD MODEL RELEASE

When working with models, it is essential to obtain their written confirmation that you will be the owner of the pictures taken. Here is a standard legal text which you can adapt for your purposes.

In consideration of my engagement as a model, and for valuable consideration hereby acknowledged as received, I hereby grant _____ , his heirs, legal representatives, and assigns, those for whom _____ is acting, and those acting with his/her authority and permission:

a) the absolute unrestricted right and permission to copyright and use, re-use, publish, and re-publish photographic portraits or pictures of me or in which I may be included, in whole or in part, or composite or distorted in character or form, without restriction as to changes or alterations, in conjunction with my own or a fictitious name, or reproduction thereof in color or otherwise, made through any and all media now or hereafter known for illustration, art, promotion, advertising, trade, or any other purpose whatsoever.

b) I also permit the use of any printed material in connection therewith.

c) I hereby relinquish any right that I may have to examine or approve the completed product or products or the advertising copy or other matter that may be used in conjunction therewith or the use to which it may be applied.

d) I hereby release, discharge and agree to save harmless _____ , his/her heirs, legal representatives or assigns, and all persons acting under his/her permission or authority, or those for whom he/she is acting, from any liability by virtue of any blurring, distortion, alteration, optical illusion, or use in composite form, whether intentional or otherwise, that may occur or be produced in the taking of said picture or in any subsequent processing thereof, as well as any publication thereof, including without limitation any claims for libel or invasion of privacy.

e) I hereby warrant that I am over the age of majority and have the right to contract in my own name. I have read the above authorization, release, and agreement, prior to its execution, and I fully understand the contents thereof. This agreement shall be binding upon me and my heirs, legal representatives, and assigns.

Print Name:_____

Signature:_____

Date: ____/____/_____

Address:_____

Witness:_____

ACKNOWLEDGMENTS

This book is the result of over thirty years experience as a fashion photographer, and I'd like to thank some of the people who have helped me during my career, both professionally and personally.

First, I'd like to thank my mother, Maureen. She was the first person to make me to think critically about my pictures and has really helped me to achieve something.

Next, I want to thank one of the great fashion photographers, Barry Lategan. Barry was very encouraging to me early in my career, and he has been an inspiration to me ever since.

Thanks too to Louise Kiesling, who is one of my longest-standing clients and a very dear friend. Thanks, Louise, for having faith in me and for helping me to see the world.

In the course of writing this book, I have had assistance from experts in their field who have given me the benefit of their experience. In particular I'd like to thank Maxine Henshilwood of Oxygen Model Management for her insights into model testing. I also want to thank two people I've worked with over the years, Lucy McKeown and Kimberley Watson, for their contributions on hair and makeup and fashion styling respectively. Thanks also to Frank Walters, Creative Director of Paling Walters, for his friendship and support, and his thoughts on what advertising agencies want from photographers.

Special thanks go to David Clark, with whom I have worked closely on this book, for his writing and editing skills.

I also like to take the opportunity to mention some of the many people I have worked with over the years: Alex Forsey, who was my assistant for eight years; my friend Patricia Velasquez, supermodel and movie star; and all the other many beautiful models I've worked with, some of whom are in this book. Thanks too to Nevs, Oxygen, and Click model agencies, as well as Hungry Tiger and Curtain Road photographic studios.

Thanks also to my fashion photography students, who I hope have benefited from my teaching, but who have also taught me a lot.

Finally, I'd like to dedicate this book to Joanne, "my angel." My life's journey of discovery has been about finding you. Thank you for coming into my life.

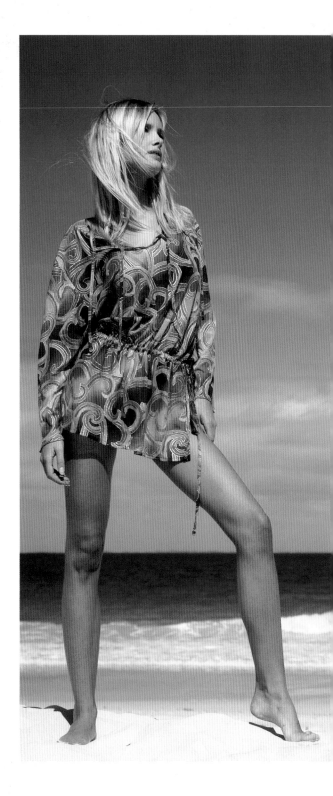